125 NATURE
HOT SPOTS
IN ALBERTA

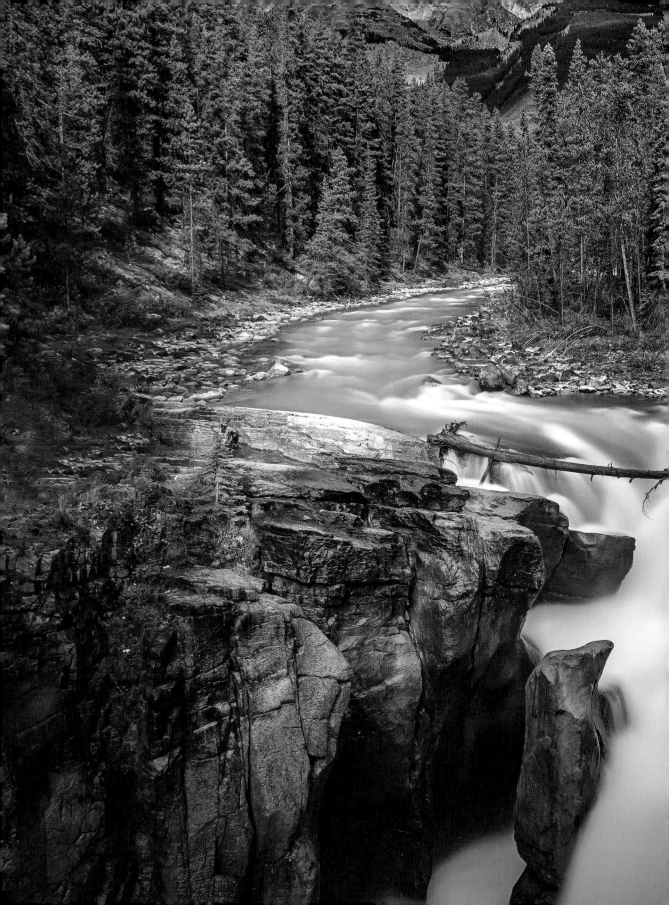

125 NATURE HOT SPOTS in ALBERTA

The Best Parks, Conservation Areas and Wild Places

Leigh McAdam and Debbie Olsen

FIREFLY BOOKS

A FIREFLY BOOK

Published by Firefly Books Ltd. 2018

Second printing, 2020

Library of Congress Control Number: 2017957510

Library and Archives Canada Cataloguing in Publication
McAdam, Leigh, 1957–, author
 125 nature hot spots in Alberta : the best parks, conservation areas and
wild places / Leigh McAdam and Debbie Olsen.

Includes index.
ISBN 978-0-228-10016-4 (softcover)

 1. Wilderness areas—Alberta—Guidebooks. 2. National parks and
reserves—Alberta—Guidebooks. 3. Alberta—Guidebooks. I. Olsen, Debbie,
1965–, author II. Title. III. Title: One hundred and twenty-five nature hot
spots in Alberta.

FC3657.M33 2018 917.1204'4 C2017-906842-3

Published in the United States by Published in Canada by
Firefly Books (U.S.) Inc. Firefly Books Ltd.
P.O. Box 1338, Ellicott Station 50 Staples Avenue, Unit 1
Buffalo, New York 14205 Richmond Hill, Ontario L4B 0A7

Printed in Korea

Disclaimer: This book is for
information purposes only.
The authors and publisher have
tried their best to ensure the
accuracy of the information in
this book. Trail conditions and
habitats may change over time.
Human-made and animal-made
obstructions or alterations to
the trails may change or affect
the conditions described in this
book. The authors and publisher
are not responsible for any thefts,
problems, injuries or accidental
misfortunes from use of the
information contained in this
book. Please remember that safety
is a personal responsibility.

Canada We acknowledge the financial support
of the Government of Canada.

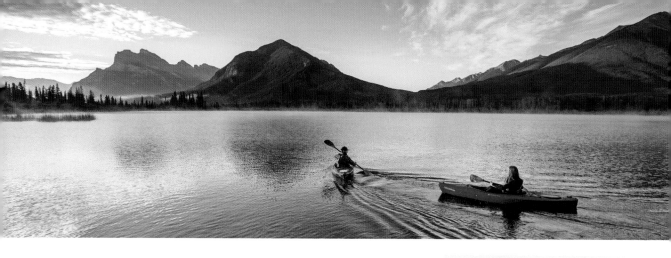

Acknowledgements

We sought the advice of many experts while researching, writing and sourcing images for this book. Special thanks to Mary Fitl, Terry Krause, Myrna Pearman, Victoria Delorme, Tim Gauthier, Catherine Reynolds, Eric Magnan, Brian Catto, Erin Steves, John Stoesser, Janelle Lane, Roger Hostin, Todd Nivins, Jesse Invik, Mark Olson, Pamela Workman, Robyn O'Neill, Jean Smith, Steve Donaldson, Don Myhre, Marva Hatch, Kelly Hatch, Judy Boyd and Todd Zimmerling.

We want to acknowledge and thank the staff of the following groups and agencies for their assistance and expertise: the Ministry of Alberta Environment & Parks, Parks Canada, the Nature Conservancy of Canada, Alberta Conservation Association, the Royal Astronomical Society of Canada, the Alberta Speleological Society, Red Deer River Naturalists, Ann and Sandy Cross Conservation Area, Glenbow Ranch Park Foundation, Tourism Jasper, Banff & Lake Louise Tourism and most particularly the staff from Alberta Parks division. We'd also like to thank the staffs from each of the hot spots included in the book.

We had many adventures while visiting these nature hot spots and met many wonderful people along the way. Special thanks to Ted Mandel, a Good Samaritan who assisted Debbie when she got a flat tire.

We'd like to thank the staff at Firefly Books for putting together such a beautiful book—especially our editor, Michael Worek, and editorial director, Steve Cameron.

Finally, we wish to thank our spouses, John McAdam and Greg Olsen, who put up with us while we were engrossed in this project and in some cases travelled hundreds of kilometres (without complaint) to visit nature hot spots with us. One book, *Parks in Alberta: a guide to peaks, ponds, parklands & prairies for visitors* by Joy and Cam Finlay, was particularly helpful as we researched our list of nature hot spots.

Dedication

To John McAdam, my soul mate and ever-willing accomplice to any adventure, anywhere, anytime.
—L.M.

To Greg Olsen, my best friend, my confidante and my favourite travelling companion.
—D.O.

⬆ **Vermilion Lakes, Banff National Park**

Previous page: Sunwapta Falls, Jasper National Park

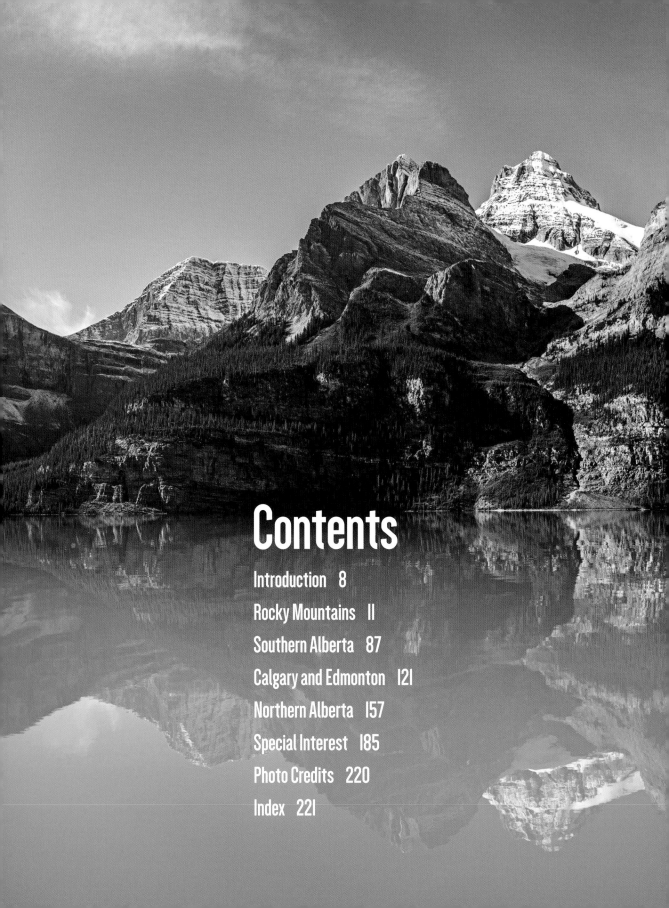

Contents

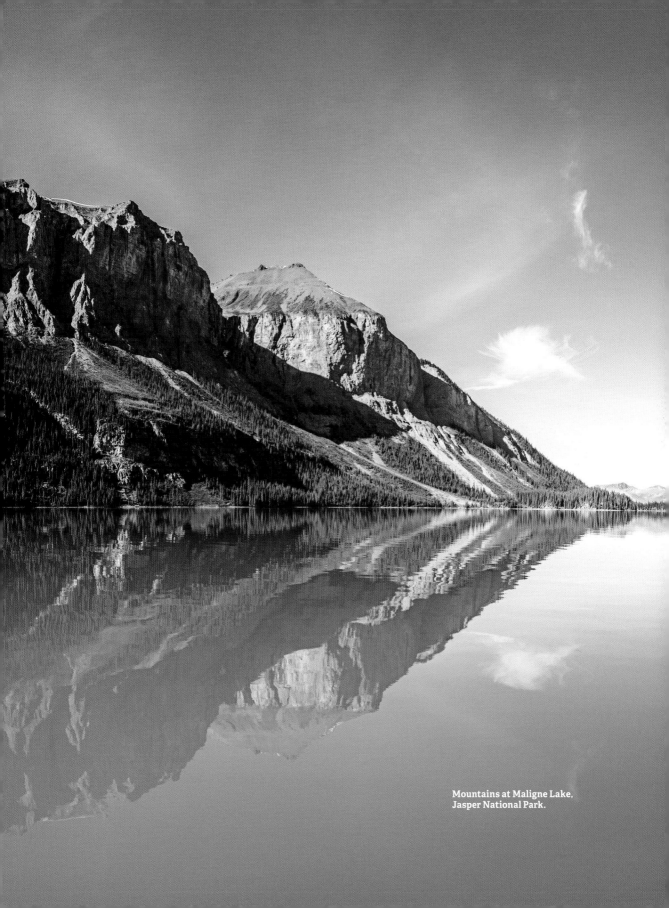

Mountains at Maligne Lake,
Jasper National Park.

Introduction

Icon Legend

These icons are featured throughout to give you an idea of the available activities at each hot spot:

- 🦆 Birdwatching
- ⛺ Camping
- 🛶 Canoeing/Kayaking
- 🧗 Rock/Ice Climbing
- 🚲 Cycling
- 🎣 Fishing
- 🚶 Hiking
- 🐎 Horseback Riding
- 🏛 Interprative Centre
- 📷 Photography
- 🚤 Power Boating
- ⛷ Skiing
- 🥾 Snowshoeing
- 🏊 Swimming/Water Sports
- 🐾 Wildlife/Nature Viewing

We have aimed to provide accurate information regarding accessible trails. Note that some hot spots may only have some accessible trails. Please confirm the availability of accessible toilets prior to departure.

Alberta, with some 27,525 square kilometres of protected land in more than 500 sites, is a nature lover's dream destination. Many visitors associate Alberta with the Rockies, but the mountain parks are just one piece of a province that is filled with spectacular landscapes. There's natural beauty to be found in mountain landscapes, grasslands, prairies, lakes, parkland, boreal forest and badlands.

The list of nature hot spots we've selected here is by no means comprehensive—rather it is a selection of top spots to experience nature. Although we are both well-travelled inside our home province, we sought the advice of many experts to narrow down the list to the entries within. The staff from Alberta Environment & Parks, the Nature Conservancy of Canada and the Alberta Conservation Association made suggestions for places to include that we would not have thought of on our own.

Writing this book opened our eyes to how much there is to see and do for a nature lover in this province. We had many adventures as we explored natural areas that were new to us. We traversed bumpy logging roads in adverse weather conditions (Debbie), cycled high mountain passes and lost a set of car keys (Leigh), got a flat tire on an unmapped gravel side road (Debbie) and paddled flowing rapids (Leigh) while researching the material for this book. We thought we knew a lot about Alberta before we began this project, but we realized that there are more places to get out in nature than we ever imagined. We both had great fun researching and working together.

In these pages, you'll find some well-known hot spots that are popular with locals and visitors as well as lesser-known sites that are true gems. In narrowing down our list, we had to leave out some wonderful destinations that were either too far off the beaten path or because we just ran out of room. The spots we included cover the whole gamut from family-friendly short outings like Ellis Bird Farm to multi-day adventures like canoeing the Peace River. We've inserted information on flora and fauna, fun trivia and interesting history, so you might learn something new about even the most beloved Alberta parks.

There are many ways to enjoy nature and the special interest section covers some of the most popular things to do outdoors. You'll find information on caving, canoeing, nature festivals, hot springs, dark skies and specialty hiking. We spent hours researching and visiting these spots to include information that is just not available anywhere else.

The book is organized by region and the entries within each section are organized alphabetically. There are hot spots throughout the entire province, but we placed a greater emphasis on natural sites that were easily accessible from Alberta's major population centres.

We encourage you to prepare in advance for any nature outing. Hazards are prevalent in natural areas and a little advance preparation can ensure a safe and enjoyable trip. Visit the destination website or call to make sure a particular park is open and check if there are any special regulations before you go. Make sure you have water, food, adequate clothing and gear for the activities you plan to enjoy. You will need to pack bear spray if you're hiking or cycling in bear country. It's always safer to hike in a group than to hike alone and it's important to let someone know where you're going, especially if the destination is remote. Many areas of the province do not have cellphone service. If you're driving to a distant spot, make sure your car is in good condition.

When you go exploring, remember that you're a guest. There are 587 different species of wildlife that make their home in Alberta or migrate through the province. There are also many rare and endangered plants so keep to prescribed trails to avoid damaging fragile flora. Respect wildlife and never feed animals. Leave no trace of your visit behind — to show consideration to other outdoor enthusiasts and the wildlife that make the land their home.

We believe that nature can heal a soul. Spending time outdoors discovering the remarkable beauty of Alberta's wilderness areas and parks has certainly helped us live happier lives. We sincerely hope you will enjoy this book and use it for years to come to help you discover new places to visit and new ways to explore nature.

— Debbie and Leigh

Nature Hot Spots and Dogs

Given the delicate nature of many of these destinations, we strongly recommend that you leave your pets at home. Even the most well-behaved dogs are capable of disrupting a sensitive ecosystem, and their presence and excrement may attract dangerous wildlife or scare animals away, which could affect your wildlife-watching experience. If you wish to bring your dog, please contact the destination in advance to learn about limitations and any precautions you must take. Please obey all signs, dispose of your pet's excrement appropriately and take additional care when meeting other people and pets.

Accessibility

Many websites for the destinations will provide information regarding universal access. Please note that this information may refer to specific trails, parking or toilets at the hot spot, and visitors with accessibility needs may be unable to experience fully the highlights we profile. Please confirm the availability of accessible facilities and trails prior to departure.

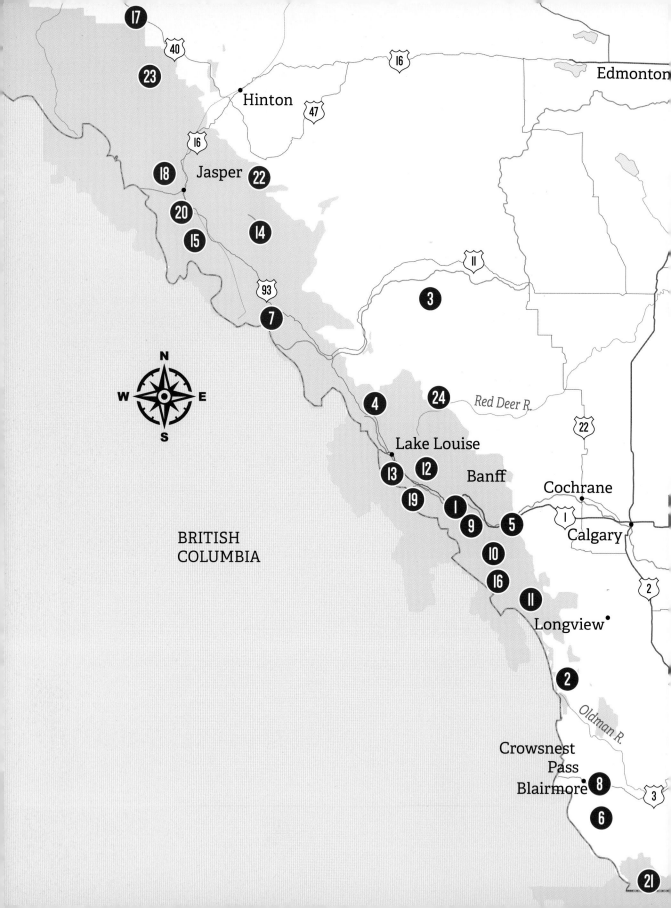

Rocky Mountains

Banff National Park and Beyond

A host of wonderful natural sites lie in close proximity to the tiny mountain town of Banff

What Makes This Spot Hot?

- Beautiful natural sites that are easily accessible—in most cases, by public transportation.
- The largest lake in Banff National Park is a 10-minute drive from town.
- You can get a bird's-eye view of six mountain ranges from the top of Sulphur Mountain.

Banff Visitor Centre
Address: 224 Banff Avenue, Banff, AB, T1L 1H5
Tel: (403) 762-8421
Website: parkscanada.ca/banff
Open: Year-round
Activities:

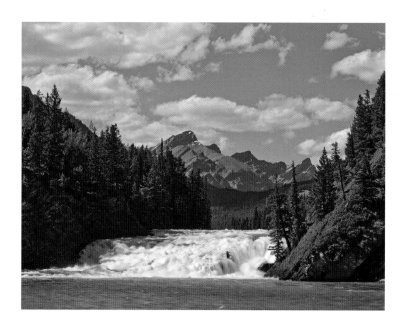

↗ **Bow Falls.**

↗↗ **The view from the top of Sulphur Mountain.**

→→ **The gondola ride to the top of Sulphur Mountain provides breathtaking views.**

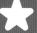

DID YOU KNOW?
You can visit pc.gc.ca/banffnow for information on the top sites in Banff National Park and tips on how to access them by shuttle, public transit or car.

Bow Falls

These waterfalls are wide and short, but very famous. They were featured in the 1953 Marilyn Monroe film *River of No Return*, and are one of the most popular tourist stops in Banff. Late afternoon or early evening is a quieter time to visit the falls.

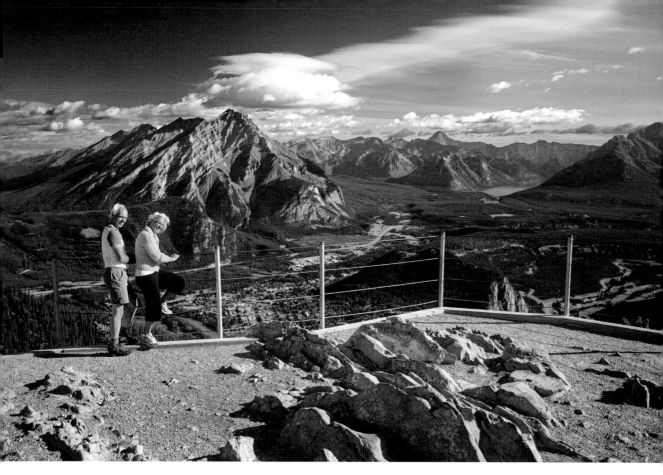

Banff Gondola

The gondola makes the view from Sulphur Mountain accessible to all. From the top, you can see six mountain ranges and stroll along a ridgetop boardwalk, take a short hike, enjoy interpretive exhibits or dine at a restaurant with breathtaking views. Some visitors hike to the top of Sulphur Mountain and take the gondola back down. You might see bighorn sheep, Clark's nutcracker and gray jays along the way or near the top. The Banff Gondola is fully accessible to people with limited mobility.

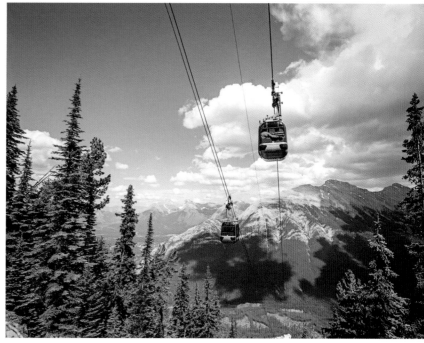

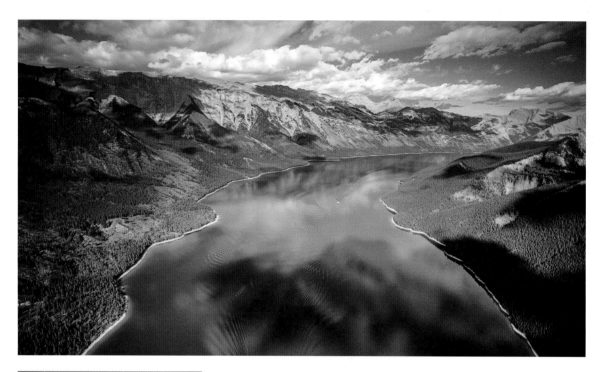

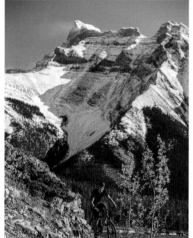

↑ This biker is dwarfed by the magnificent scenery around him.

↑↑ Aerial view of Lake Minnewanka.

Lake Minnewanka

The largest lake in Banff National Park has a rich history that dates back thousands of years. Its name means "Water of Spirits" in the Nakoda language, but the present-day lake is vastly different from the original. Over the years, three dams have been constructed on the lake: the first in 1895, the second in 1912, and the third in 1941. The third dam was built under the War Measures Act by the Calgary Power Company, who argued that the power generated from the dam would be essential to the war effort. (In hindsight, it wasn't.) The third dam raised the water level 30 metres, and flooded a town that sat on the shores.

Today that area of the lake is especially popular with scuba divers. If you're not a diver, the closest you can get to the sunken town is by passing over it on a Lake Minnewanka boat tour. The Lake Minnewanka Loop is a scenic drive that goes past the lake and offers great wildlife viewing opportunities. Look for bighorn sheep, elk, mule deer, white tail deer, foxes, wolves, coyotes and the occasional black bear.

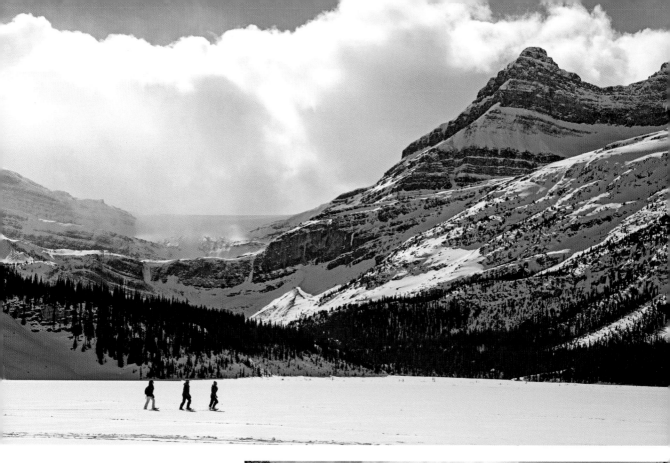

Vermilion Lakes

Sunset and sunrise are the best times to take in the view of these three lakes, located just outside the town of Banff. Enjoy spectacular views of Mount Rundle as you relax along the shores in the beautiful Bow Valley. There are hiking trails near the lakes, and it's a serene canoeing spot. Some canoers paddle down Echo Creek or Forty Mile Creek into Vermilion Lakes. Watch for bald eagles, elk and moose. In the winter, you might see methane bubbles frozen in the ice.

↑ **A canoe or kayak is perfect for exploring the lakes and rivers.**

↑↑ **Banff in winter provides a completely different experience.**

Beehive Natural Area

Established in 1987, this natural area protects old-growth forests and the headwaters of the Oldman River

What Makes This Spot Hot?

- Stunning Rocky Mountain scenery that includes the Beehive Klippe landform.
- Diverse habitats, including old-growth spruce-fir forests believed to be more than 1,000 years old.
- Home to rare and sensitive species.

Address: Lat: 50.0649° N; Long: -114.6488° W
Tel: (403) 382-4097
Website: albertaparks.ca/beehive
Open: Year-round
Activities:

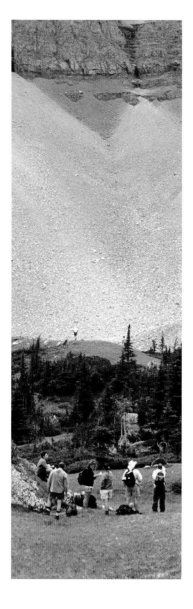

→ **A wide variety of terrain provides excellent hiking opportunities.**

There are only a few places on our planet where you can stand in the middle of a big landscape and grasp a sense of your own smallness. In such moments, you can see beyond the mundane tasks and pressures of everyday life and find your own place in a vast universe.

The mountains and old-growth forests of Beehive Natural Area provide a habitat for rare and sensitive species in a larger-than-life landscape. The spruce-fir forests have been there for about 1,000 years. Individual trees can be as old as 300 years, but the forest is more than just a collection of really old trees. An old-growth forest is a complex system of interconnected species. The protection of old-growth forests is vital to the survival of these species and to the health of our planet. Species like the pileated woodpecker and the northern flying squirrel count on old-growth forests to survive.

At 6,734 hectares, the Beehive Natural Area contains a variety of habitats. In addition to the old-growth forest, there

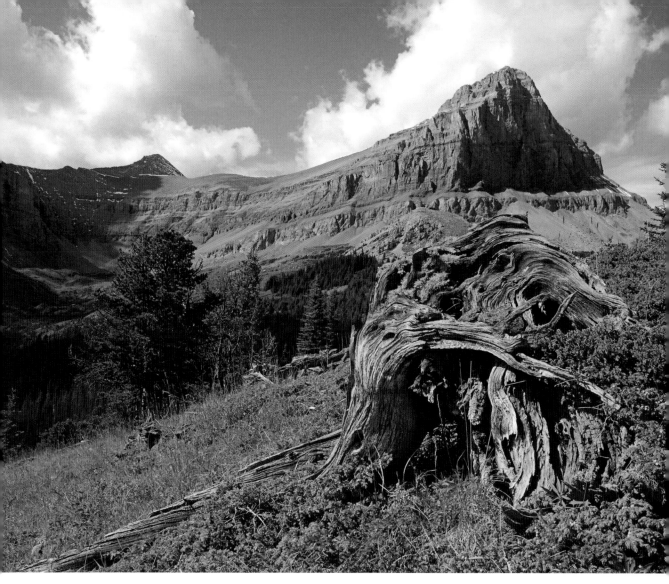

are lodgepole pine forests, grasslands, alpine areas and meadows. Rare plants and animals have been found in a number of areas. Some of the rare and sensitive species that might be seen include the grizzly bear, Canada lynx, peregrine falcon, golden eagle, common nighthawk, pileated woodpecker, yellow angelica, lance-leafed grape fern, Rocky Mountain willowherb, and blunt-fruited sweet cicely.

This natural area is a summer range for elk and contains lambing sites for bighorn sheep. Birding is popular, and wood warblers, rosy finches, Hammond's fly-catchers, Clark's nutcrackers and white-tailed ptarmigans are often spotted. The Great Divide Trail runs through the treeline of the natural area, and crosses the Oldman River at its northern boundary.

↑ Be sure to watch for Canada lynx tracks.

↑↑ Stunning mountain scenery is a feature of this natural area.

Bighorn Backcountry – David Thompson Country

East of Banff and Jasper National Parks are public lands with breathtaking scenery, abundant wildlife and myriad recreational opportunities

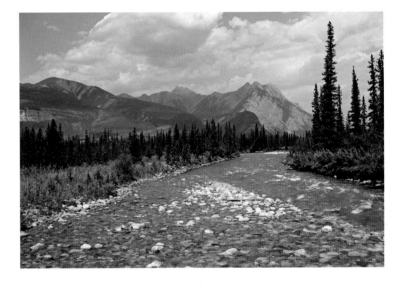

What Makes This Spot Hot?

- Spectacular scenery including mountains, foothills, valleys, sparkling lakes and rushing waterfalls.
- A year-round network of trails opens up the backcountry to visitors.
- Many different recreational options.

Address: Lat: 51.8996° N; Long: –116.3921 (Siffleur Falls Trailhead)
Tel: (403) 845-8349
Website: albertaparks. ca/siffleur or aep.alberta. ca/recreation-public-use/ recreation-on-public-land/ bighorn-backcountry
Open: Year-round
Activities:

The Bighorn Backcountry is a collection of twelve Public Land Use Zones that, when combined, protect more than 5,000 square kilometres of land. Just east of Banff and Jasper National Parks, this region has wonderful mountain scenery and many different areas to enjoy. Each zone has its own rules for usage, but there are distinct places for hikers, snowmobilers, off-highway vehicles and

⭱ **Siffleur Falls is a popular day hike with beautiful mountain views.**

⭲ **The views on the Allstones Lake trail make the climb worthwhile.**

equestrian users.

This part of Alberta is called David Thompson Country because it stretches along the David Thompson Highway. The highway was named in honour of the British-Canadian fur trader,

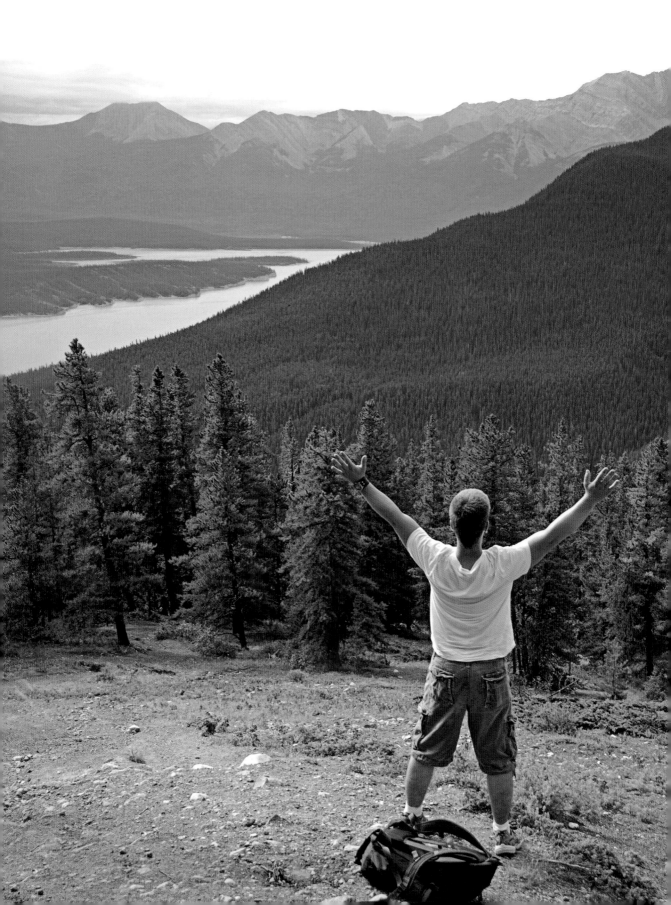

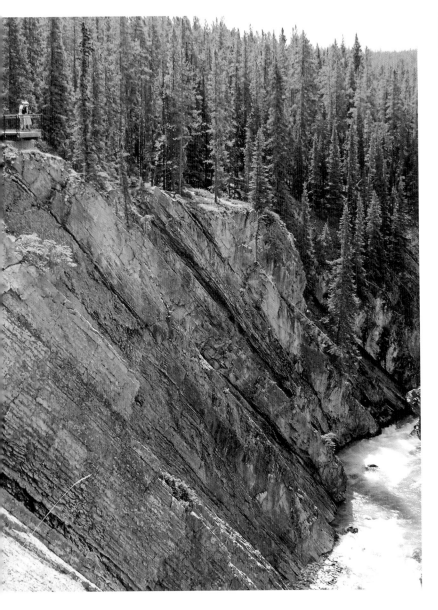

of wilderness (about one-fifth of the continent).

David Thompson's accomplishments went unrecognized in his lifetime. He died in 1857 and was buried in Montreal's Mount Royal Cemetery in an unmarked grave.

This is a truly beautiful area of Alberta that is extremely vast and varied. Near Nordegg, you can tour the Brazeau Collieries, a registered national historic site. There are several wonderful waterfall hikes including Crescent Falls, Ram Falls, Tershishner Falls and Siffleur Falls. There are also lovely lakes like Goldeye Lake, Allstones Lake and Abraham Lake.

This region of Alberta also has unique vegetation and wildlife. The wildflowers can be particularly lovely in July and August. Look for forget-me-nots, paintbrush, alpine poppies, bunchberry, Franklin's lady slipper and round-leaved orchid. There's also a vast array of wildlife including grizzly and black bears, cougars, wolves, coyotes,

↑ **The viewpoint at Siffleur Falls.**

↗ **A chipmunk at Abraham Lake.**

surveyor and explorer who mapped this region of Alberta. David Thompson has been called "the greatest land geographer who ever lived." In his lifetime, he mapped 3.9 million square kilometres

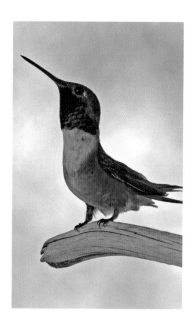

↑ Rufous hummingbird.

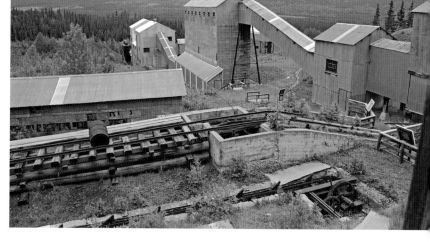

↑↓ Visitors can learn about coal mining in Alberta at Brazeau Colleries National Historic Site.

elk, moose, woodland caribou, mountain goats and bighorn sheep. Birders may find a number of notable species including boreal owl, rufous hummingbird, white-tailed ptarmigan and harlequin duck.

First Nations people have had a long and deep connection with this region and used it as a winter camping area for thousands of years. You may find the remains of sweat lodges and prayer sites in areas of the Bighorn Backcountry. Please be respectful and do not remove or touch artifacts. To the First Nations people, this is a sacred place. Those who hike the trails and explore it come to realize how special it is.

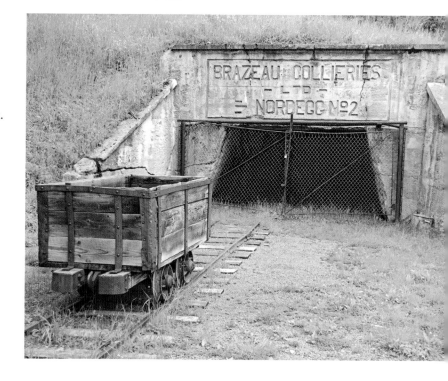

BANFF NATIONAL PARK

Bow Summit and Peyto Lake Lookout

An impossibly blue lake is the highlight of a stop along the highest drivable pass in the national parks of the Canadian Rockies

What Makes This Spot Hot?

- Exquisitely blue Peyto Lake must be seen to be believed.
- Wonderful spot to see wildflowers in July and early August.
- One of the most scenic spots in Banff National Park and prime grizzly bear territory.

Address: 42 kilometres north of Lake Louise on the Icefields Parkway
Tel.: (403) 522-3833
Website: parkscanada.ca/banff
Open: Year-round
Activities:

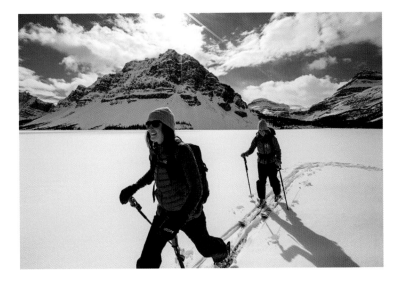

↗ **Skiers crossing Peyto Lake in winter.**

From Peyto Lake Lookout, you can see the turquoise-blue Peyto Lake, Peyto Glacier and the vast Mistaya Valley. Continue following the trail and you'll come to more views of Peyto and the less-visited Bow Lake Lookout with views of the Icefields Parkway, Bow Glacier and Bow Lake. Most tourists never venture beyond the first lookout point; even though the views are great from there, you miss out if you don't travel further down the trail.

Both lakes get their brilliant blue colour from glacial rock flour. Glacial erosion causes silt particles to flow into the lake water and these suspended particles reflect light, giving the lakes their stunning turquoise colour.

Peyto Glacier and Peyto Lake were named for Ebenezer William "Bill" Peyto, a legendary guide and warden in Banff

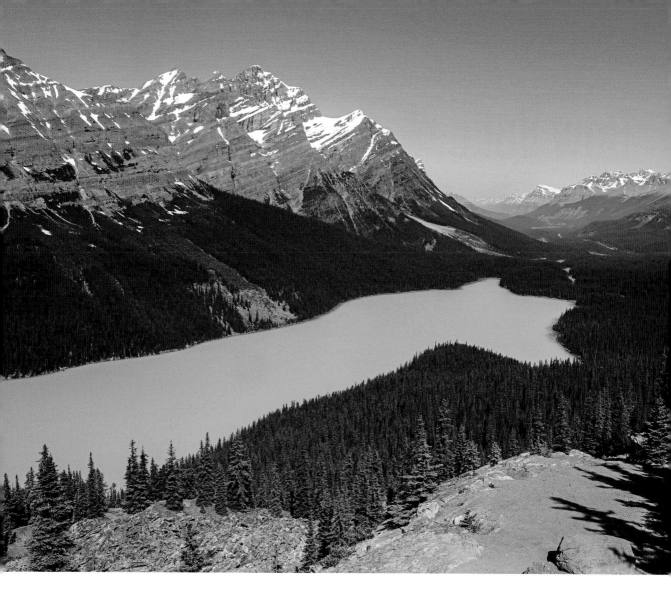

↑ Peyto Lake along the Icefields Parkway.

National Park. He began his guiding career in 1893, and, through extensive reading, became self-educated on topics like geology and paleontology. Walter Wilcox, the famous explorer, mountaineer and writer, was one of his early clients. Mount Wilcox and Wilcox Pass in the Columbia Icefields area of the park were named for Wilcox, who never would have been able to explore so many areas near Lake Louise without Bill Peyto's assistance.

If you continue on the trail, you'll reach Bow Lake Lookout, which is always less crowded and offers great north and south views of Bow Lake and the Icefields Parkway. If you have binoculars, you might get lucky and see a grizzly bear in the meadows below you. Bow Glacier Falls and Bow Lake are at the headwaters of the mighty Bow River, known around the world for its fantastic fly fishing.

DID YOU KNOW?

The name "Bow" refers to the reeds that grew along the river banks. First Nations people used the reeds to make bows. The Peigan name for the Bow River is "Makhabn," which means "[the] river where bow reeds grow."

Bow Valley Provincial Park

Located at the intersection of three ecosystems—grasslands, mountains and the boreal forest

What Makes This Spot Hot?

- Excellent bird watching and wildlife viewing.
- Three unique ecosystems.
- Great hiking, biking and canoeing in the summer.

Address: Bow Valley Campground Lat: 51.0510° N; Long: −115.0727° W
Tel: (403) 678-0760 (Barrier Lake) and (403) 673-3663 (information and administration)
Website: www.albertaparks.ca/bow-valley-pp
Open: Year-round on foot; Bow Valley Campground closed to vehicles Thanksgiving to late April.
Activities:

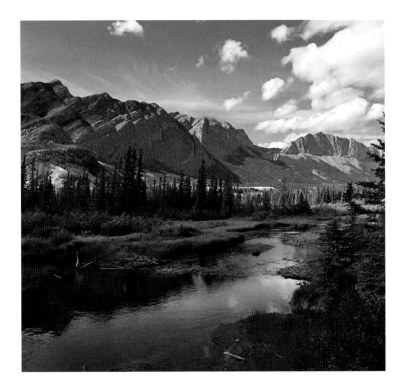

↗ The water reflects the grandeur of the mountains in Bow Valley.

Located less than an hour's drive west of Calgary, Bow Valley Provincial Park is home to a diverse landscape that includes the front range of the Canadian Rockies, grasslands, boreal forest and a section along the glacier-fed Bow River. You'll find lots to do, from canoeing and hiking to biking, horseback riding and nature viewing.

The park is irregularly shaped and divided in the north by the Trans-Canada Highway. There are a couple of kayak launches and picnic areas along Highway 40, but the bulk of the park is explored via two main entry points: off the Trans-Canada Highway at Highway 1X, and at the entrance to the Barrier Dam.

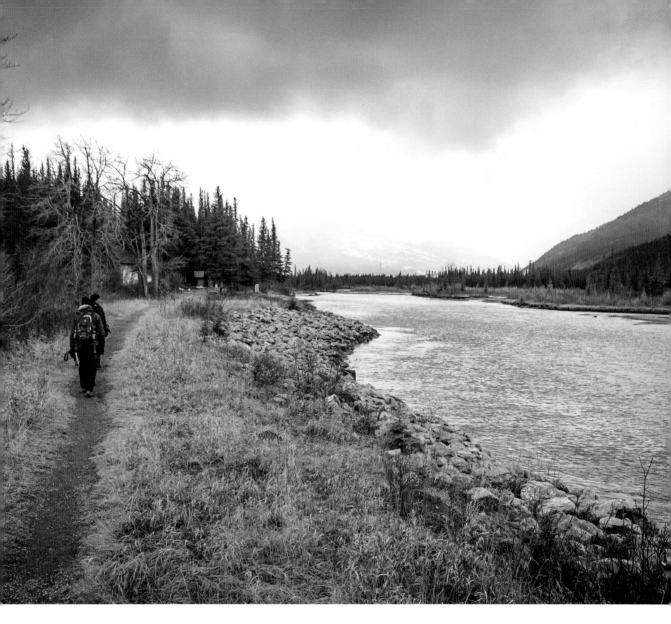

If you have ever driven to Banff, chances are you've passed the northern turnoff to Bow Valley Provincial Park. Next time you pass this way, stop — even if just for an hour or two. This part of the park enjoys a rich ecosystem. It's home to a diverse array of birds, from the diminutive rufous hummingbird to the bald eagle. It's reportedly the only spot in the world where the long-toed salamander (a mountain species) and the tiger salamander (a prairie species) exist together.

There's lots of camping available here, with many fine spots along the beautiful Bow River. If you get one of these sites, you can enjoy the ducks and geese that fly through the area from the front door

⬆ **Pretty hiking beside the Bow River, even in the off-season when the campground is closed.**

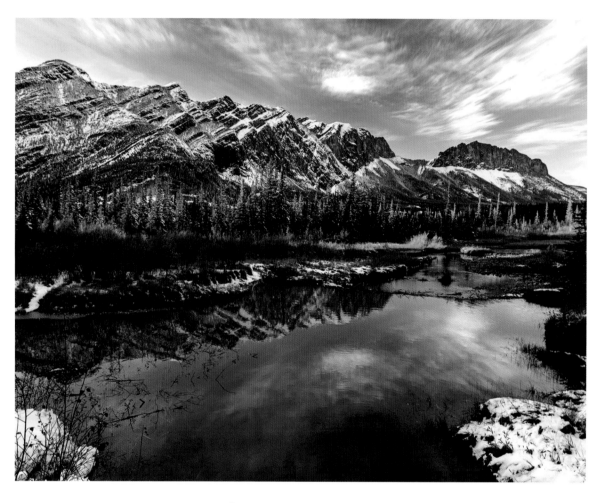

↑ **Looking towards Mount Yamuska from Many Springs in Bow Valley Provincial Park.**

of your tent. Bring a bike and cycle the roads, keeping a close eye out for wildlife like wolves, mule deer, elk, moose and bears.

You can also hike one of the seven trails. All are easy, most offer outstanding mountain views, and despite their short distance they cover many diverse ecosystems. In summer, the most popular trail is the 1.6 kilometre Many Springs Trail that loops through a spring-fed wetland, where the temperature remains constant year-round. Deer and elk are drawn to the minerals in the spring. In June, the trail is dotted with bright yellow lady's slipper. The 1.5 kilometre Montane Trail is also worth an hour. It showcases the challenging transition zone where the foothills meet the mountains.

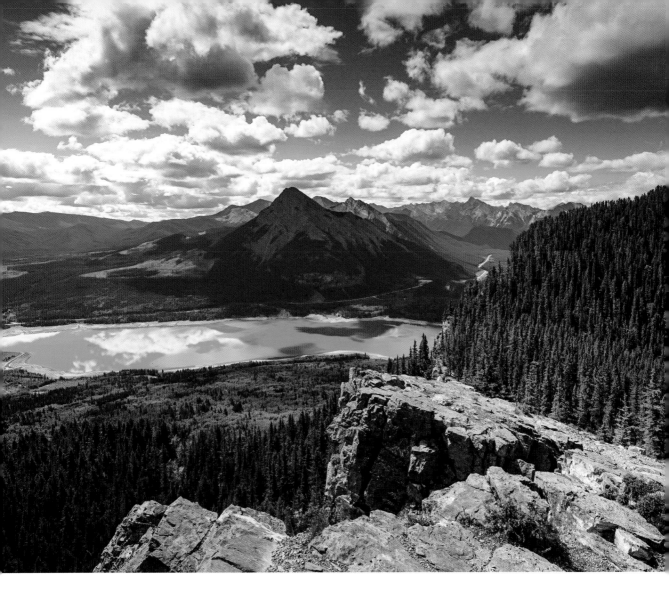

Barrier Dam and Barrier Lake

The turquoise-coloured Barrier Lake is a beautiful place to stop and explore. Birding is good along the lake, the mountain vistas enchant, and there are plenty of early-season wildflowers. You can enjoy the lake from one of several picnic spots along the east shore, but for a more intimate experience go boating or fishing. You can also explore the west side of the lake from a trail starting at the dam. It's accessible to horseback riders, cyclists and hikers.

Bow River Provincial Park is very accessible, and easily visited from Calgary on a summer evening for a few hours.

⬆ This view of turquoise coloured Barrier Lake is the reward for mountain hikers.

⬇ The colourful *Castilleja*, commonly known as paintbrush or prairie-fire.

Castle and Castle Wildland Provincial Parks

These new protected areas encompass just over 1,000 square kilometres of mountains and foothills near Pincher Creek

What Makes This Spot Hot?

- Alberta's second largest montane landscape is home to over 120 provincially rare plant species and 59 species of mammals.
- Stunning scenery and a vast array of recreational opportunities.
- Important territory for grizzly bears and other wide ranging mammals.

Address: Lat: 49.4313° N; Long: −114.3933° W
Tel: 403-627-1165
Website: albertaparks.ca/castle-pp or albertaparks.ca/castle-wpp
Open: Year-round
Activities:

↗ **There's nothing quite like the thrill of skating on a lake with mountain views.**

The southern corner of the province where Alberta, British Columbia and Montana meet is one of the most biologically diverse regions in Canada. This land has long been considered sacred to the Nitsitapii, Piikani (Peigan), Siksika, Kainaiwa (Blood), and Blackfeet First Nations, as well as the Nakoda (Stoney) and K'tunaxa First Nations. Many archeological, historical and traditional Indigenous use sites are found here.

The region is also an important source of clean water for much of Southern Alberta. The headwaters of the Oldman River basin are located within the Castle area contributing one third of all water in the Oldman watershed. These waters are an important spawning area for native bull trout and cutthroat trout.

This area has long been used by recreational enthusiasts but for some the announcement in 2015 to designate the Castle area as protected provincial parkland came as a surprise. The move has limited some usages within the borders of the parks, but it was done to protect habitats, wildlife and clean water. First Nations groups and environmentalists are pleased that the land they treasure is now officially protected.

Visitors to these new provincial parks enjoy beautiful scenery—rugged mountains, rolling hills, grasslands, rivers, forests, lakes and streams. Hiking and equestrian routes are plentiful, but come

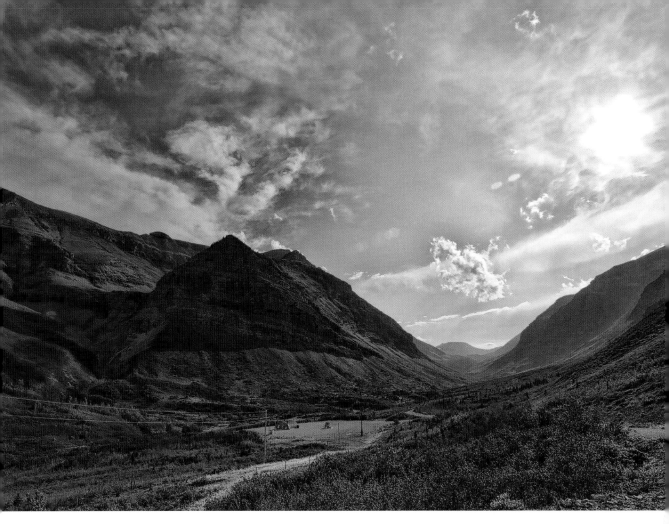

prepared for a wilderness experience with your own topographic maps and back-country gear.

You'll see a wide variety of species here—including more than 120 provincially rare plants. Some plant species to look for include tall huckleberry, thimbleberry, Oregon grape, large flowered fringecup, red and yellow monkeyflower, beargrass, mariposa lily, big sagebrush and mountain hollyhock. Castle's rare plants also attract some extremely rare butterflies.

The Castle area provides important habitat for many animal species including big-horn sheep and grizzly bears, which require large tracts of wilderness. It's estimated that more than 50 grizzly bears reside in Castle and Waterton parks. Other carnivores to look for include wolves, marten, lynx, wolverine, fisher, bobcat and cougar. It's common to see ungulates like elk, moose, mule and white-tailed deer, bighorn sheep and mountain goats in these parks.

↑ Elk are a common sight in the Castle area although not usually with a full moon in the background.

↑↑ Castle Wildland is big, bold and biologically diverse.

JASPER NATIONAL PARK

Columbia Icefield

The Columbia Icefield is both the largest and the most accessible ice field in the Rocky Mountains

What Makes This Spot Hot?

- The Athabasca Glacier, one of eight main glaciers in the Icefield, is easily accessible to visitors.
- An eye-popping landscape filled with glaciers and some of the tallest peaks in the Canadian Rockies.
- World-class hiking with a high probability of seeing wildlife, especially bighorn sheep.

Address: Icefields Parkway (Highway 93N), Jasper National Park
Tel.: (780) 852-6288 (seasonal only)
Website: http://www.pc.gc.ca/eng/pn-np/ab/jasper/activ/explore-interets/glacier-athabasca.aspx
Open: Year-round access to the Columbia Icefield, but the Glacier Discovery Centre is only open from April until October.
Activities:

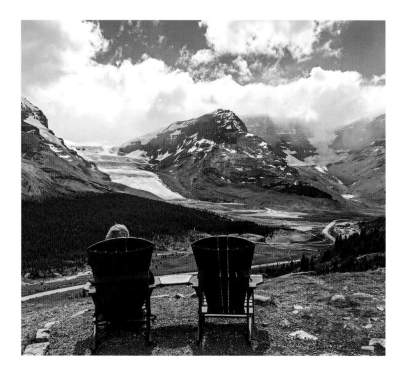

↗ **A comfortable place to view the Columbia Icefields on the Wilcox Pass hike.**

The Columbia Icefield is a massive expanse of ice located high in the Canadian Rockies on the Alberta-British Columbia border. Covering approximately 325 square kilometres, it's made up of about 30 glaciers and ringed by 11 mountains, including Mount Columbia (3,747 metres), the highest in Alberta. The ice is up to 300 metres thick, equivalent to over one-and-a-half times the height of the Calgary Tower. From the Glacier Discovery Centre you can see the Athabasca and Dome Glaciers, along with several mountain peaks, but it's a fraction of the entire Icefield. Also missing from view is Castleguard Cave, Canada's longest cave that passes in part beneath the Icefield.

To reach the Columbia

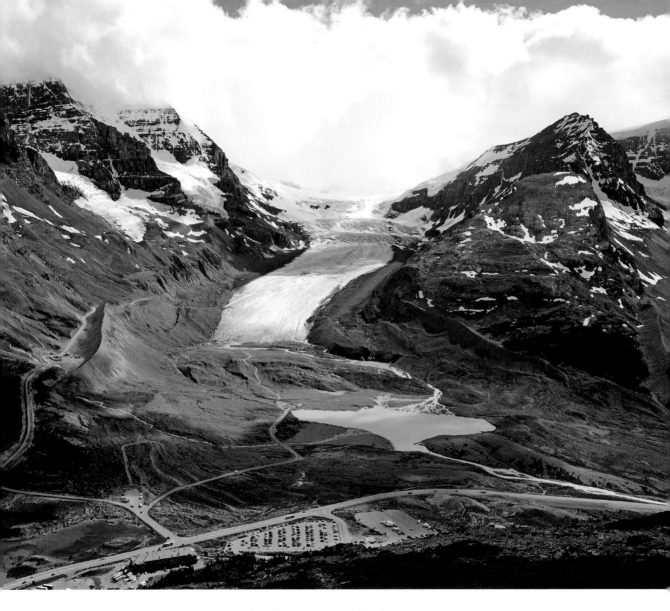

Icefield, visitors must travel either south from Jasper or north from Lake Louise along the Icefields Parkway, a spectacular mountain highway that is considered one of the most scenic drives in the world. Built in part during the Great Depression, it was called "the road through the clouds" by the men who worked on it. The Columbia Icefield is the highlight, and the most visually arresting sight along the parkway.

Each year approximately one million visitors come from around the globe to experience firsthand the beauty of the glaciers that make up the Columbia Icefield. While some people get no further than the parking lot at the Glacier Discovery Centre, others hop on board Brewster's all-terrain Ice Explorer for a one-hour lesson

↑ An expansive view of the Columbia Icefield, though the icefield is much larger than what is visible here.

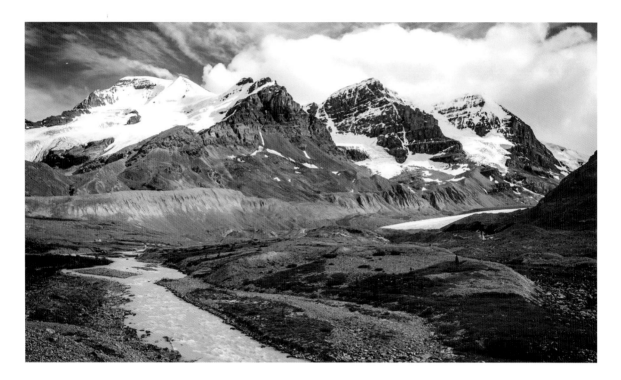

↑ **Stop at the pullover along the highway to take in this magnificent view of the glacier.**

↓ **White-tailed ptarmigan.**

↗ **By early April you can walk partway up the trail towards the Athabasca Glacier.**

→ **This massive ice-explorer bus takes tourists across the Athabasca glacier.**

on glaciology and a chance to safely walk on a glacier. Still others opt for a self-guided hike. There are several to choose from. The easiest hike leaves from the parking lot across from the Glacier Discovery Centre and follows a trail through the moraine left by the retreating Athabasca Glacier. Alternatively, you can hike at least partway up to Wilcox Pass via a trail on the north side of the highway to get a bird's-eye view of the glacier and surrounding mountains. Another highlight on this hike is a virtually guaranteed sighting of bighorn sheep and some excellent birding in the meadows.

Through interpretative

displays, old photos and short films at the Glacial Discovery Centre, visitors gain a sense of the history and importance of the area. The Columbia Icefield, for example, has been called the "Mother of Rivers," as meltwater from the glaciers feeds four major river systems including the Athabasca, Fraser, Columbia and North Saskatchewan. These rivers provide drinking water for millions and ultimately carry the meltwater to three different oceans: the Atlantic via Hudson's Bay, the Pacific and the Arctic.

There is a photo gallery at the visitor centre where you can see that the glacier has retreated over 1.5 kilometres

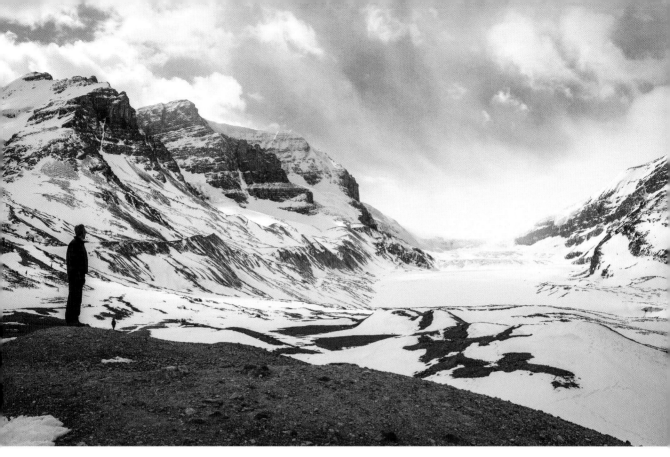

since the mid-1800s. Interestingly, around 5,000 years ago the middle section of the Columbia Icefield wasn't covered with ice, but forest.

Although the Icefields Parkway is open year-round, winter driving can be quite treacherous with limited services and almost no cell coverage. Most visitors come between April and October when the Glacier Discovery Centre is open and tours onto the glacier are offered. It's also easier to find accommodations in spring, when the hotel on the fourth floor of the Discovery Centre and nearby campgrounds are open.

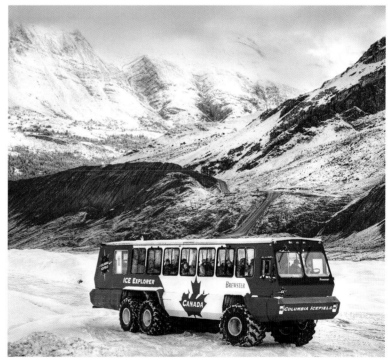

Frank Slide and Turtle Mountain

Explore Canada's second-largest landslide two ways — on the ground, or on the mountain where it all started

What Makes This Spot Hot?

- The site of Canada's second-largest landslide.
- Hike through the landslide beside boulders the size of a truck.
- Excellent onsite interpretive centre.

Address: Box 959, Blairmore, Crowsnest Pass, Alberta, T0K 0E0
Tel.: (403) 562-7388
Website: history.alberta.ca/frankslide
Open: Interpretive centre is open year-round except Christmas Eve, Christmas Day, New Year's Day and Easter Sunday.
Activities:

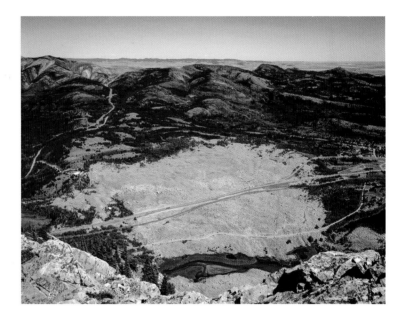

↗ **Scar left from the Frank Slide as seen from the top of Turtle Mountain.**

The Frank Slide occurred on April 29th, 1903 at 4:10 a.m. Eighty-two million tons of rock broke off from Turtle Mountain and buried the eastern part of the town of Frank, 2 kilometres of the CPR railway line and at least 90 people — all in under 100 seconds.

Today, as you drive along scenic Highway 3 in the Crowsnest Pass area (an amalgamation of five communities near the British Columbia border), you are met with an abrupt change in the landscape. Beginning outside the town of Frank, massive boulders line both sides of the highway and continue into the surrounding countryside, covering 3 square kilometres in total. If you stop at the highway pullover, you

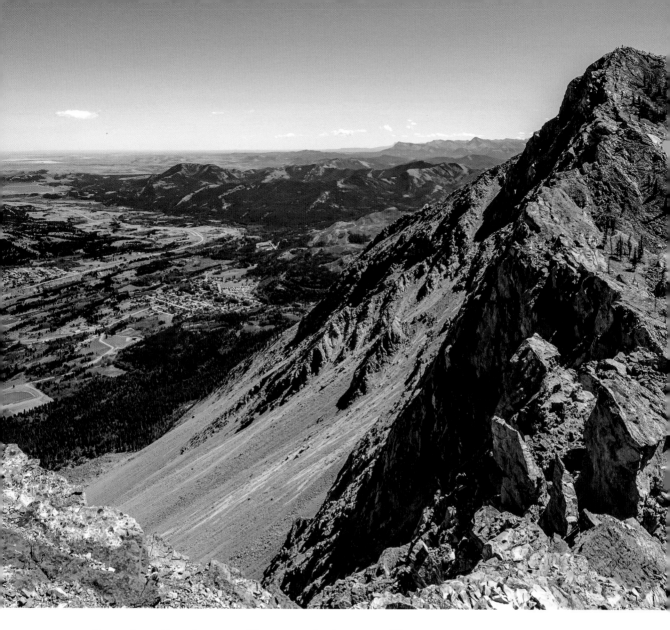

can pretty much see the missing "chunk" of Turtle Mountain, estimated to be about 1 kilometre along the top by about half a kilometre down the slope by about 150 metres deep.

Before a portion of Turtle Mountain collapsed, it was well known that there were fissures along its ridge. In fact, the native Blackfoot and K'tunaxa referred to it as "the mountain that moves." It was coal that resulted in the small mining town of Frank being established below Turtle Mountain—interestingly, in an area where the natives would not camp. Miners, too, had noted some unusual underground movements, but didn't link them to a potential slide.

Late April 1903 had been

⬆ **Looking down Turtle Mountain from the spot where the mountain collapsed.**

quite warm, resulting in a lot of snowmelt. But on April 29 it had turned very cold, so it is conjectured that freezing and the consequent expansion of ice may have been the trigger to set off the slide. It's also been suggested that the coal mining and 2 kilometres of tunneling under the mountain may have contributed to the collapse. Nonetheless, it's clear that the massive slide was going to happen at some point due to the instability of Turtle

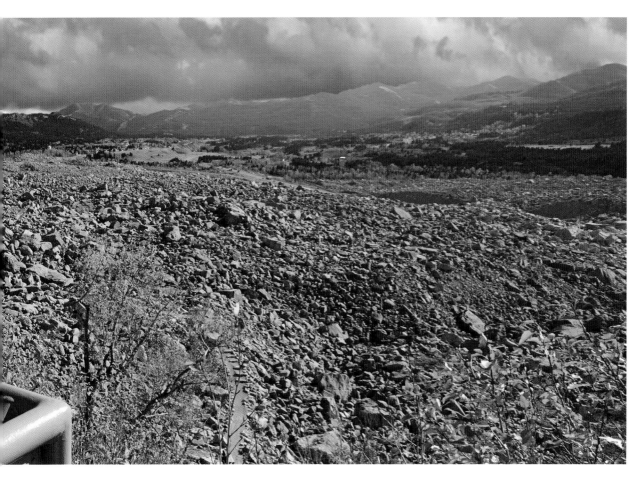

Mountain. The interpretive centre does a fabulous job of showcasing the disaster and the stories surrounding it.

You can spend an hour or two hiking the 1.5 kilometre Frank Slide Trail and marvel at the scale of destruction. Better yet, hike to the top of Turtle Mountain via a steep 3.1 kilometre trail from nearby Blairmore. There's a tension you'll feel as you get close to the summit, knowing that one day the mountain will collapse again. Peer over the edge of the precipice—if you dare—to see the scarring and devastation.

When will Turtle Mountain slide again? That's the big question, and experts seem to think it will be sometime in the distant future. For now, Turtle Mountain is monitored with precise instruments, so there should be plenty of early warning signs. Let's hope so.

↑ **The remains of the Frank Slide disaster as seen from the lookout point.**

← **Turtle Mountain in the distance.**

Grassi Lakes

Southwest of Canmore, this trail is one of the prettiest and most family-friendly hikes in the Canadian Rockies

What Makes This Spot Hot?

- Stunning mountain scenery with a chance to see a waterfall and the blue-green Grassi Lakes.
- A family-friendly hike that has two routes to accommodate all ages and abilities.
- An opportunity to watch rock climbers and explore shallow caves.

Address: Goat Creek Parking Lot: Lat: 51.0870 N; Long: −115.5018 W
Tel: (403) 678-2400
Website: albertaparks.ca/canmore-nordic-centre/information-facilities/day-use/grassi-lakes
Open: Year-round
Activities:

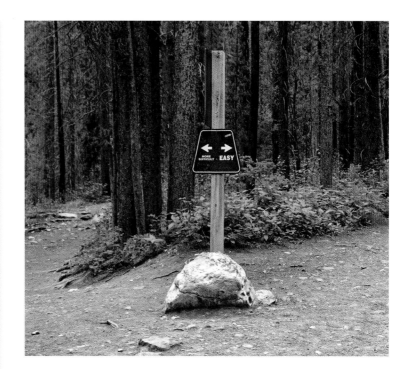

↗ **A marker indicates the degree of difficulty on one of the Grassi Lakes popular hiking trails.**

→ **Rock climbers carefully make their way above Grassi Lakes.**

There's often more than one way to get somewhere; in the case of the Grassi Lakes, there's an easy way and there's a more difficult option. If you take the easy way, you walk up a gravel service road with a gentle grade. If you take the more challenging route, however, you go along a wooded trail to a rocky viewpoint with a great view of the Grassi Lakes Waterfall and the town of Canmore—something you completely miss on the easy route. Whichever path you choose, you'll end up at a pair of beautiful blue-green lakes.

There are some very shallow caves above the lakes that are fun to explore. This area is popular with rock climbers and you can sit on a large rock, enjoy a snack, and watch them inch their way up the cliffs

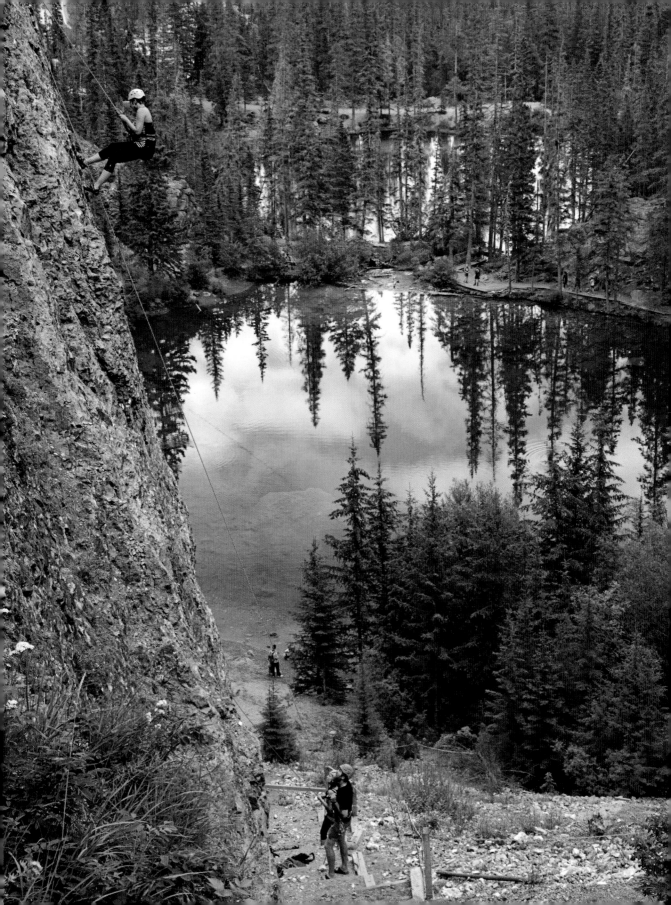

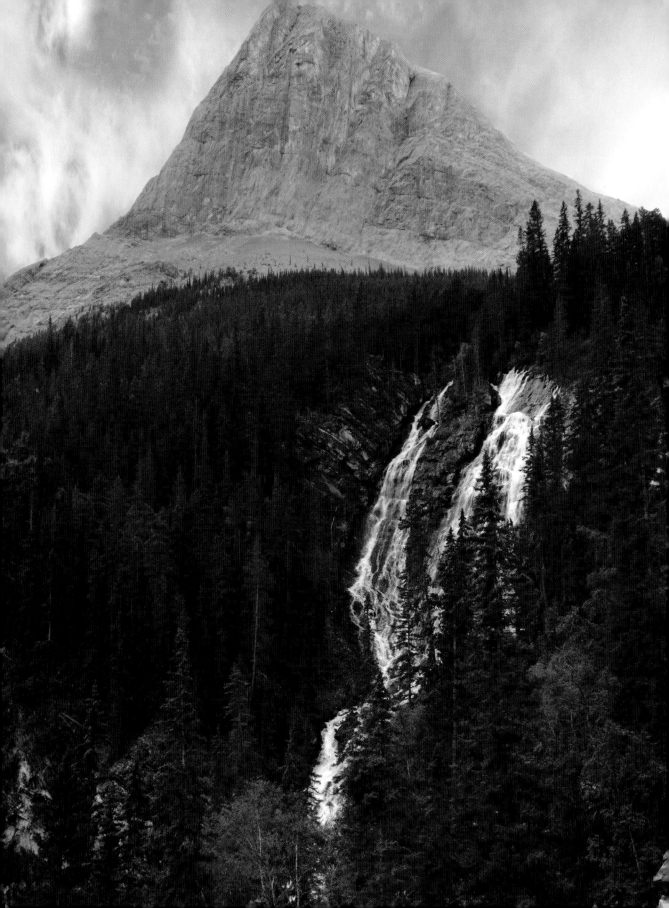

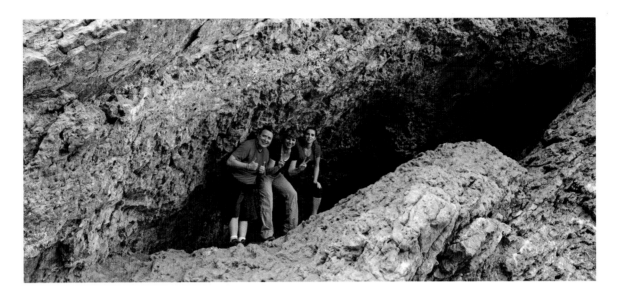

above the two lakes.

The lakes, the mountain and the trail were all named in honour of Lawrence Grassi, an Italian immigrant miner who lived in Canmore and built the original Grassi Lakes Trail, as well as many others in the Canadian Rockies. Grassi worked in the Canmore coal mines, climbing mountains and working as a climbing guide in his spare time. He is remembered as a trailblazer who spent his life building trails so that others could more easily enjoy nature. Today, Grassi Lakes is a popular day use area in Canmore Nordic Centre Provincial Park. Cross-country skiing, snowshoeing, day hiking, mountain biking, roller skiing, orienteering and disc golf can all be enjoyed here.

Golden Eagle Migration

Each spring and fall, thousands of golden eagles migrate between their wintering grounds in the western United States and northern Mexico to breeding grounds in Alaska and the Yukon. They pass over the Rockies in relatively narrow streams, and large numbers can be seen in the skies near Canmore each year. The Rocky Mountain Eagle Research Foundation (eaglewatch.ca) conducts annual bird counts at two sites in Kananaskis Country — Hay Meadows and Mt. Lorette. If you're passing through this region in the spring or fall, it's a good idea to keep your eyes on the skies.

↑ The caves at Grassi Lakes are a favourite with tourists.

← A view of this stunning waterfall is the reward for taking the more difficult trail to the Grassi Lakes.

High Rockies Trail

Alberta's newest long-distance trail offers the opportunity to travel uninterrupted through a huge swath of beautiful Kananaskis Country

What Makes This Spot Hot?

- An 80 kilometre wilderness trail that straddles three provincial parks.
- The trail winds partially through a wildlife corridor.
- Numerous opportunities for spectacular mountain and Spray Valley views.

Address: Goat Creek Trailhead: Lat: 51.0870; Long: –115.5018
Website: thegreattrail.ca
Open: Year-round
Activities:

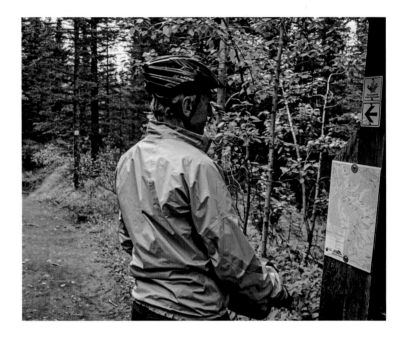

The recently completed 80 kilometre High Rockies Trail, built with mountain bikers and hikers in mind, spans three provincial parks—Bow Valley Wildland, Spray Valley and Peter Lougheed. It runs from Goat Creek, on the border with Banff National Park, to Elk Pass on the Alberta-British Columbia border with a number of access points along the route. It's the westernmost section of the Trans Canada Trail in Alberta.

The trail is a mix of old and new trails with short connectors added, so that existing day use areas along the Smith-Dorrien Spray Trail can be used. The trail is well-built, well-signed and quite diverse. Expect to travel through large swaths of forest. Sometimes you'll be in the valley bottom, with little in the way of views; at other times high above the highway, with exceptional panoramas, especially of the

↗ **Checking the route map at the Goat Creek Trailhead.**

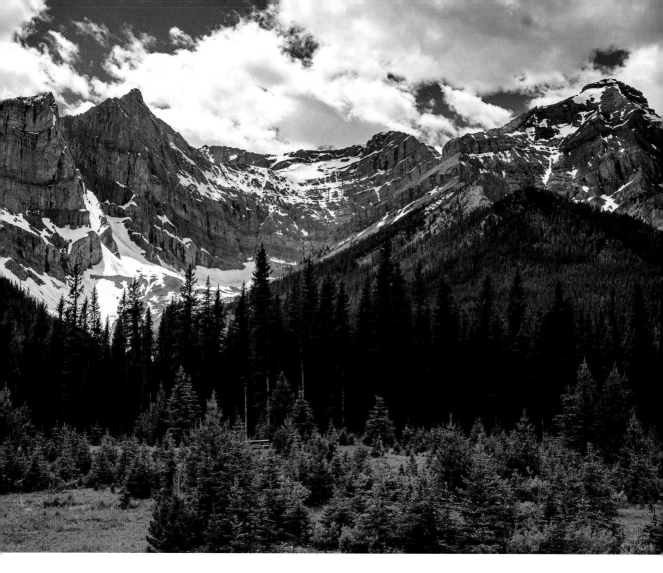

Spray Valley between the Sparrowhawk Day Use Area and Buller Creek. There are pretty sections along Goat Pond and the Spray Lakes Reservoir. As you travel south from the Sawmill Campground to Lower Kananaskis Lake, the mountain views are exceptional.

In this part of Kananaskis Country there's a lot of wildlife. Even if you don't see black and grizzly bears, moose or wolves, you'll probably see their droppings. It's especially important in the forest to make lots of noise to warn the animals of your approach. Small mammals you're likely to see include red squirrels, golden-mantled ground squirrels, Columbian ground squirrels and the least chipmunk. Occasionally you'll catch a glimpse of a pine marten or a weasel.

With up to 130 bird species nesting in Kananakis Country, you're sure to spot gray jays,

↑ **Gorgeous mountain backdrop in the Sawmill Creek area.**

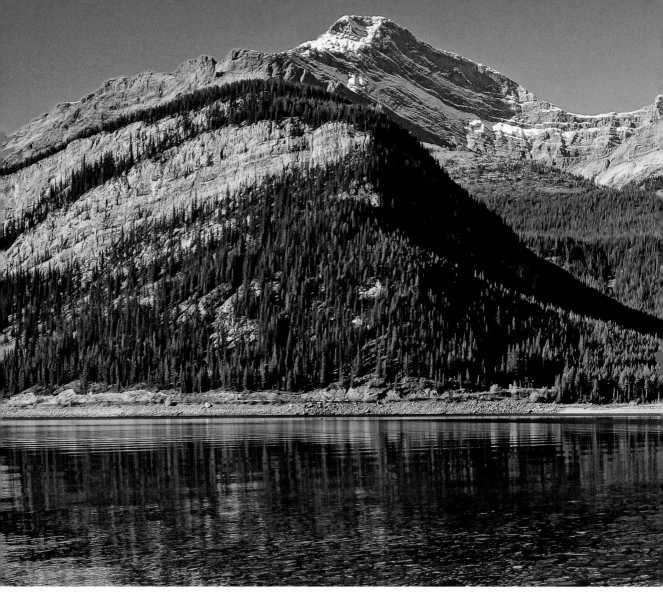

→ **The High Rockies Trail includes a beautiful section along the Spray Lakes Reservoir.**

crows and ravens, especially at picnic stops. Look for the black dipper and spotted sandpipers along the water. Lucky people might catch the dance of the spruce grouse in the forest, while everyone, whether they recognize it or not, will hear the Swainson's thrush and the chipping sparrow singing their hearts out.

Wildflowers are common along parts of the trail. Look for calypso orchids, twinflowers, arnica and bunchberry in the lodgepole pine forests. In wet areas, particularly meadows, you'll find white camas, lousewort and elephanthead. Elsewhere, brown-eyed Susan, buffalo berry, bearberry, asters, alpine lupine, fireweed, milk and purple vetch all grow in abundance.

The trail would be a challenge for any biker, let alone

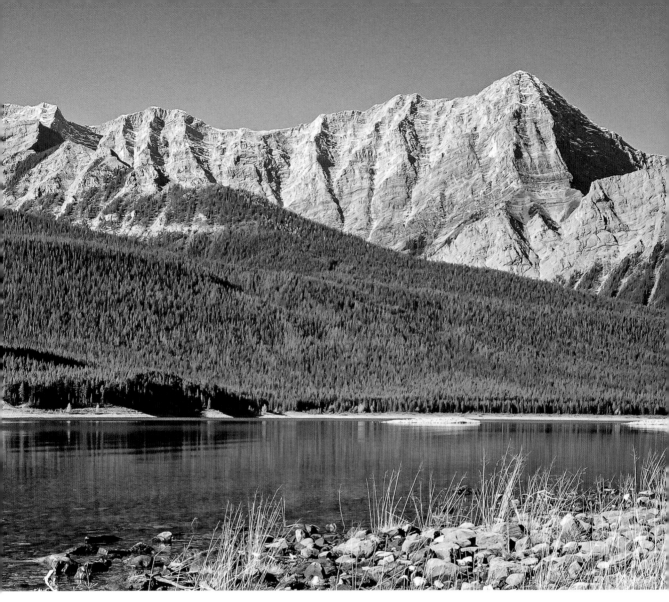

→ Don't forget the bear spray as black bears are a common sight in this part of Kananaskis Country.

a hiker, to complete in a day. There are no services along the trail, so you must take all your food and water with you. Treat water from streams. The trail now shows up on maps, copies of which are available at the Barrier Lake Visitor Centre.

Highwood Pass

At 2,206 metres above sea level, this road through Kananaskis Country is Canada's highest paved pass

What Makes This Spot Hot?

- One of the most spectacular roads in Canada— the site of the 2017 Gran Fondo bike tour.
- Breathtaking mountain scenery with great opportunities for wildlife watching.
- Connects a multitude of campgrounds, trails and recreational areas; superlative hiking options lie just off the top of the pass.

Address: Lat: 50.7175° N; Long: –115.1071° W (King Creek Day Use Area—starting point)
Tel: (403) 678-0760
Website: albertaparks.ca/peter-lougheed/information-facilities/day-use/highwood-meadows
Open: June 15th to Nov 30th.
Activities:

→ A curious North American red squirrel.

You don't usually think of a road as a nature hot spot, but Highwood Pass is no ordinary road. Canada's highest paved public road passes through the front ranges of the Canadian Rockies and provides travellers with some glorious scenery and many opportunities to view wildlife. The Kananaskis Trail runs through this area, and there are many wonderful day use areas and hiking spots along the way. It's such a spectacular strip of pavement that it was chosen as the site for the 2017 ATB Financial Gran Fondo bike race.

Highwood Pass is an exhilarating ride for hardcore cyclists, but sections of it are very doable for the average weekend warrior. The easiest way to cycle this road would be to start at the gate near Longview, cycle 37 kilometres to Highwood Pass and then descend 17 kilometres on the steep road to the King Creek Trailhead. If you go in the other direction from King Creek, part of the road is Category 1—the steepest grade bikers on the Tour de France climb.

For those who are not into cycling, Highwood Pass is also beautiful to drive through. The drive through the pass is punctuated with wonderful day use areas, great mountain views, and an abundance of wildlife. Watch for elk, deer, moose, bighorn sheep and grizzly and black bears as you make your way along the pass.

HOT TIP

⭐ Cyclists and runners who go in early June get the road all to themselves. Highwood Pass isn't open to cars until June 15th. Be bear aware and carry bear spray if you are hiking, running or cycling in this part of the Rockies.

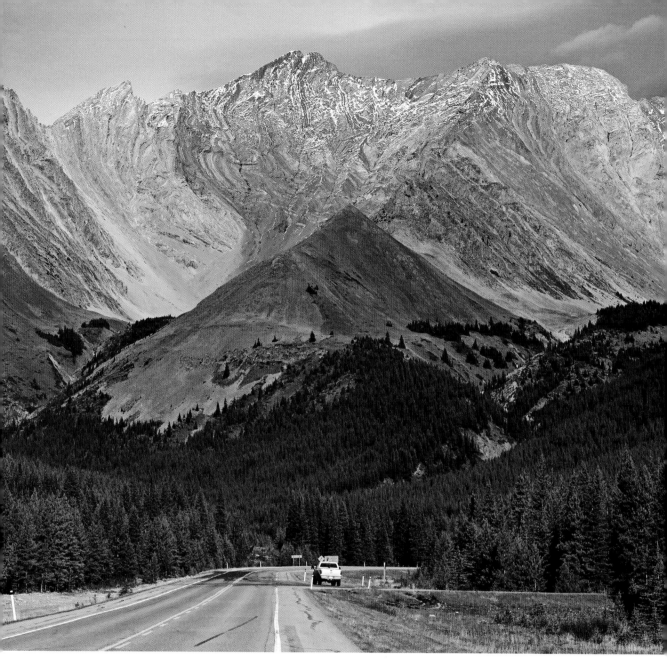

↑ Glorious multi-hued mountain scenery on the drive up from Longview.

← Grey jays are a common sight.

←← Watch for bighorn sheep of all ages on the roads.

BANFF NATIONAL PARK

Johnston Canyon and the Ink Pots

One of the most spectacular canyons in Banff National Park is also one of the park's most popular day hikes

What Makes This Spot Hot?

- The deep canyon is one of the most stunning geological features of Banff National Park.
- A paved hiking trail and metal catwalk make the canyon accessible to visitors.
- See seven sets of waterfalls and the emerald-coloured mineral springs known as the ink pots.

Address: About 17.5 kilometres along the Bow Valley Parkway from Banff's town site
Lat: 51.2538° N;
Long: −115.8381° W
Tel: (403) 762-1550
Website: parkscanada.ca/banff
Open: Year-round
Activities:

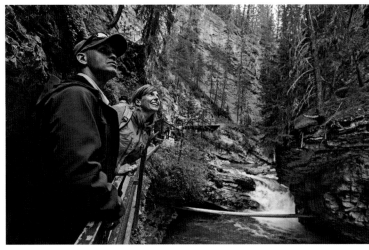

Johnston Canyon is one of the most popular day hikes in Banff National Park, but the adventure begins long before you reach the trailhead. Situated on the Bow Valley Parkway, the drive to Johnson Canyon is often punctuated by wildlife sightings. It's possible to see elk, deer, bighorn sheep, black bears or grizzly bears while driving the parkway. Moose, cougars, and foxes are also found in this area, but are less commonly seen. You should also look for owls, ospreys and eagles.

At the trailhead, you'll discover a scenic trail with a metal catwalk that takes you through the depths of the canyon. Over thousands of years, Johnston Creek has carved its way through the limestone walls of the canyon, creating waterfalls, tunnels and sheer drops. The trail passes seven sets of waterfalls, and is paved much of the way. It's an easy 1.2 kilometre

↗ **Hiking in Johnston Canyon, Bow Valley Parkway.**

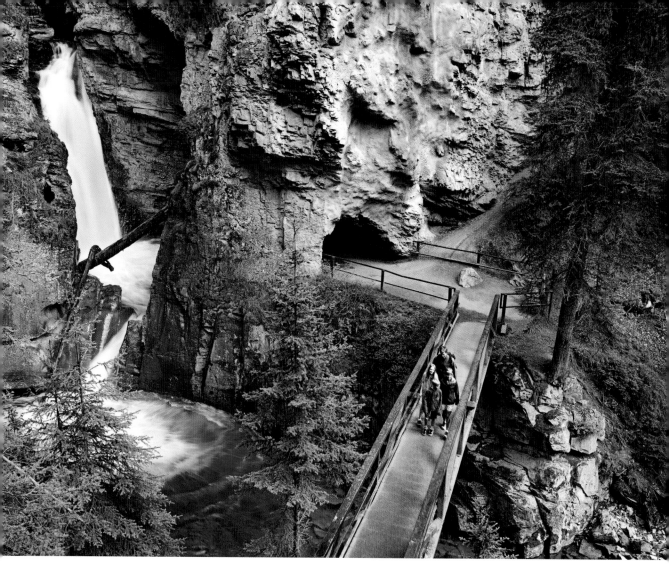

walk to the lower falls, and a moderate 2.4 kilometre climb to the 30-metre-high upper falls. To reach the Ink Pots, continue 3 kilometres on from the Upper Falls. The moderate climb out of the canyon takes about an hour and leads to several pools of emerald-coloured mineral springs that bubble to the surface, at a constant temperature of about 4°C.

Watch for birds as you hike through the canyon. American dippers are often spotted near fast-moving water and you might see black swifts nesting in the canyon walls. Johnston Canyon is one of the few known nesting sites for the black swift, an at-risk bird species in Canada.

Ice viewing walks have become popular in the canyon. Bring your own ice cleats and go for a self-guided stroll along the trail, or join one of the guided tours that are offered during the winter months.

↑ **Well-constructed bridges and trails make Johnston Canyon a pleasurable family hiking destination.**

DID YOU KNOW?

Johnston Canyon is named for the prospector who originally discovered the canyon in the 1880s.

BANFF NATIONAL PARK

Lake Louise and Moraine Lake

Surrounded by rugged peaks, the awe-inspiring beauty of these two sparkling lakes is a highlight of Banff National Park

What Makes This Spot Hot?

- Some of the prettiest views in the Canadian Rockies.
- Excellent hiking trails.
- Home to a vast array of flora and fauna—and prime grizzly bear territory.

Lake Louise Visitor Centre
Address: Samson Mall, 201 Village Rd, Lake Louise, AB T0L 1E0
Tel: (403) 522-3833
Website: parkscanada.ca/banff
Open: tk
Activities:

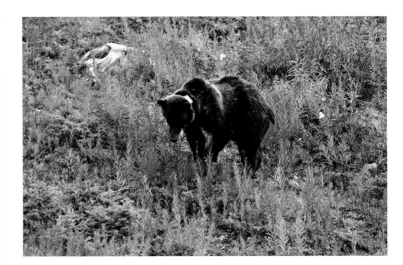

↗ A young grizzly hunting for gophers.

↗↗ The famous tourquoise colour of Lake Louise contrasts with the mountains.

→ Visitors enjoy the Agnes Lake hike, Moraine Lake.

Lake Louise is one of the highlights of Banff National Park: an impossibly blue lake surrounded by rugged mountains and the Victoria Glacier. The lake was named for the fourth daughter of Queen Victoria, Princess Louise Caroline Alberta, who was the wife of John Campbell, the Governor General of Canada from 1878 to 1883. Interestingly, the province of Alberta was also named for the princess in 1905—though she chose to use her fourth name as a way to honour her deceased father.

The tiny hamlet of Lake Louise began as Laggan Station in 1890, the last stop on the Canadian Pacific Railway line into Banff National Park. You'll still see the name "Laggan" on a winter trail and a popular bakery and delicatessen.

Moraine Lake, the other spectacularly beautiful lake, is outside the hamlet. Situated in the Valley of the Ten Peaks, this glacially-fed lake is one of the most photographed sites in the Canadian Rockies. It's sometimes called "the lake with the twenty-dollar view," because an image of Moraine Lake was on the 1969 and 1979

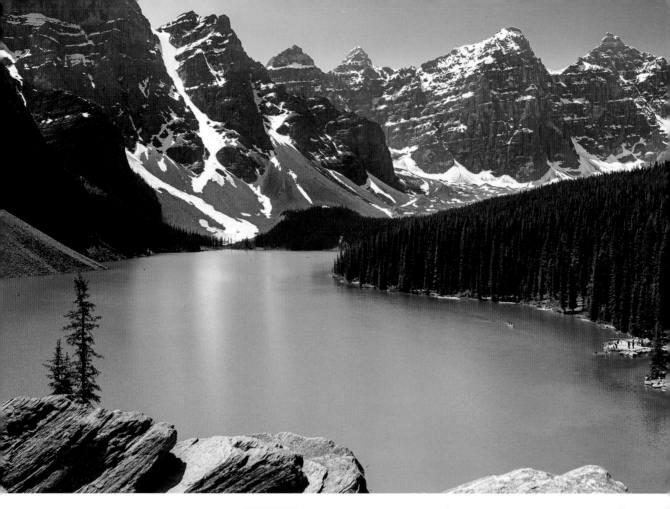

issues of the Canadian $20 bill.

This gorgeous area is at the heart of some of the finest hiking and skiing in the Rockies. Lake Louise Ski Resort is one of the largest ski resorts in North America. In the summer months, the ski gondola becomes a sightseeing gondola, and grizzly bears are often seen in the area.

Lake Louise is the hiking centre of Banff National Park. The two lakes attract famously large crowds, especially during the peak summer months, but a little crowd-dodging is worth it to take in the amazing scenery. Parks Canada

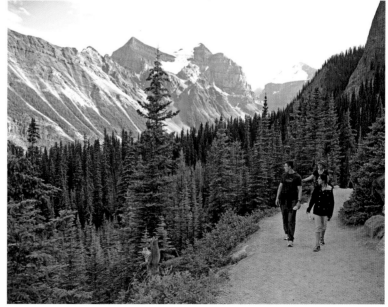

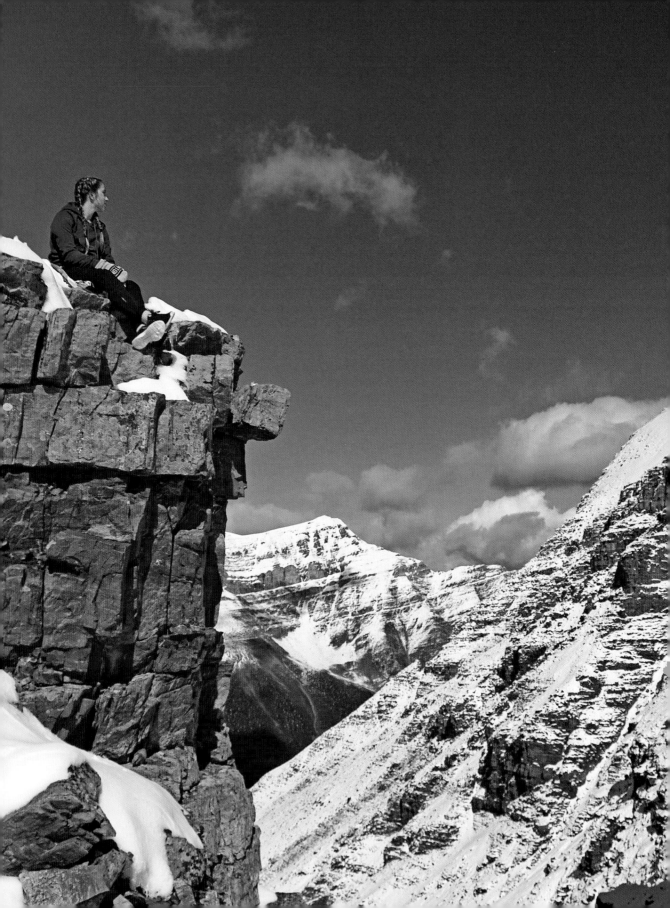

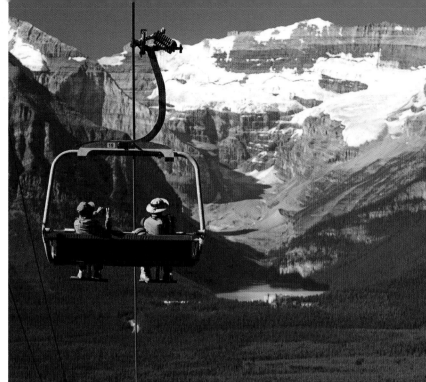

operates free shuttles from the village to Lake Louise during the peak summer months and to Moraine Lake during September, when larch hiking is popular.

You can rent a canoe and enjoy a peaceful paddle on either lake, or hike one of the many area trails. From Lake Louise, you can hike to Lake Agnes Tea House or the Plain of Six Glaciers Tea House. If you hike to both tea houses in a single day, you will have conquered the "Tea House Challenge." The Larch Valley is accessed from Moraine Lake and is a spectacular hike in September, when larch trees turn yellow and their needles begin to drop. There are many trails, and it's possible to find places of solitude even in the most popular spot in Canada's first national park.

⬆ A whiskey jack (also known as grey jay).

⬆⬆ The Lake Louise Gondola ride is an experience not to be missed.

⬅ This spectacular view on the Sentinel Pass hike is accessed from Moraine Lake.

JASPER NATIONAL PARK

Maligne Valley

Carved by ancient glaciers, the Maligne Valley contains some of the most spectacular scenery in the Canadian Rockies and is home to a wide variety of plants and animals

What Makes This Spot Hot?

- Wonderful scenery, including spectacular geological features unique in the world.
- Excellent area for spotting wildlife.
- Maligne Lake is Jasper's largest lake and the largest natural lake in the Canadian Rockies.

Address: Lat: 52.6654° N; Long: −117.5345° W (Maligne Lake)
Tel: (780) 852-6236
Website: parkscanada.ca/jasper
Open: Year-round
Activities:

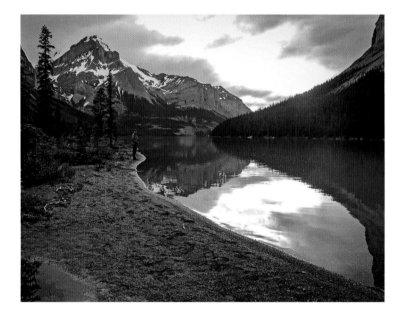

↗ **Maligne Lake reflecting the surrounding mountains in July.**

The Maligne Valley is one of the most geologically fascinating regions of the Canadian Rockies. Shaped by ancient glaciers, the U-shaped valley is more than 58 kilometres long and a little more than 1.6 kilometres wide at its narrowest point, and features two key areas—Maligne Lake Valley and Maligne River Valley. It's also one of the best places in Jasper National Park for viewing wildlife. Watch for moose and bears as you travel along Maligne Lake Road.

Maligne Lake is the largest natural lake in the Canadian Rockies, and it was well known to the area's First Nations. Mary Schäffer was the first non-native explorer to visit the lake and was credited with its discovery in 1907. Female explorers were rare in those days. She first travelled to the area with her husband, and together they worked on a book about the flowers of the Canadian Rockies. After his

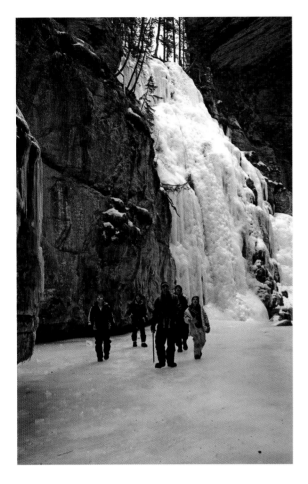

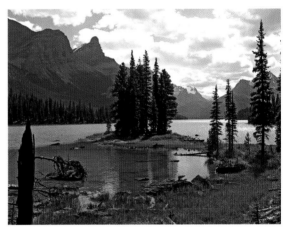

death, she returned to complete the work and discovered the lake; she returned again to survey the area at the request of the Canadian government. It was during that visit that she named the lake and several of the surrounding mountains and peaks. Schäffer named Opal Hills after the vibrant array of wildflowers in that area—look for heart leaved arnica, globe flower and western anemone as you hike the Opal Hills Trail.

You can rent canoes at the lake and enjoy a peaceful paddle or take Brewster Travel Canada's 90-minute boat cruise to Spirit Island, one of the most photographed views in the Rockies. When Kodak introduced colour film they held a photo contest, and a picture of Spirit Island was the winner. The picture was displayed in their ad at New York's Penn Station for many years and became one of the park's iconic images.

↑ **Spirit Island is the most photographed spot in the Maligne Valley.**

↑↑ **Moose feeding in the snow.**

↖ **The Maligne Canyon ice walk.**

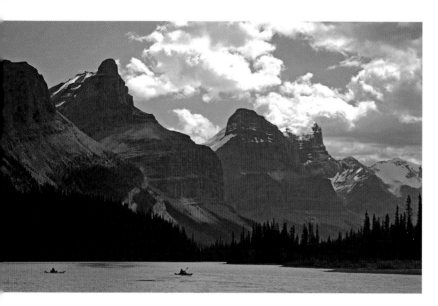

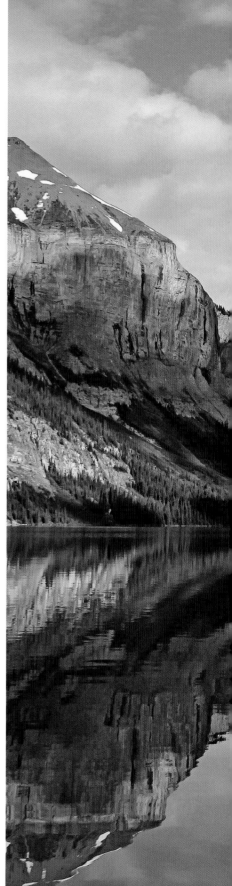

↑ **Kayakers on Maligne Lake.**

→ **A perfect reflection of the mountains on Maligne Lake, the largest natural lake in the Canadian Rockies.**

Maligne Canyon is the highlight of the Maligne River Valley. Hikers can follow a 4.4 kilometre (return) pathway that winds along the canyon edge to spectacular viewpoints and over six bridges. Many hikers stop after the second or third bridge and miss the natural springs that can be found between the fifth and sixth bridges. The canyon is impressive in every season. In the winter, guided ice walks offered by several tour companies provide a unique perspective from the canyon floor.

Medicine Lake is another must-see site. It is also known as the disappearing lake. A unique drainage system causes the water level to fluctuate dramatically from season to season—sometimes disappearing altogether. First Nations people once believed that spirits were responsible for this astounding phenomenon.

There are several wonderful hikes that depart from or traverse the Maligne Valley, including the Opal Hills Loop, the Bald Hills Trail and the iconic Skyline Trail, one of the premiere backpacking trails in the Canadian Rockies. With 25 kilometres of trail at or above the treeline, this trail is well known for its scenic views. Maligne Adventures (maligneadventures.com) offers a hiking shuttle service that provides one-way transportation between the trailheads of the Skyline Trail.

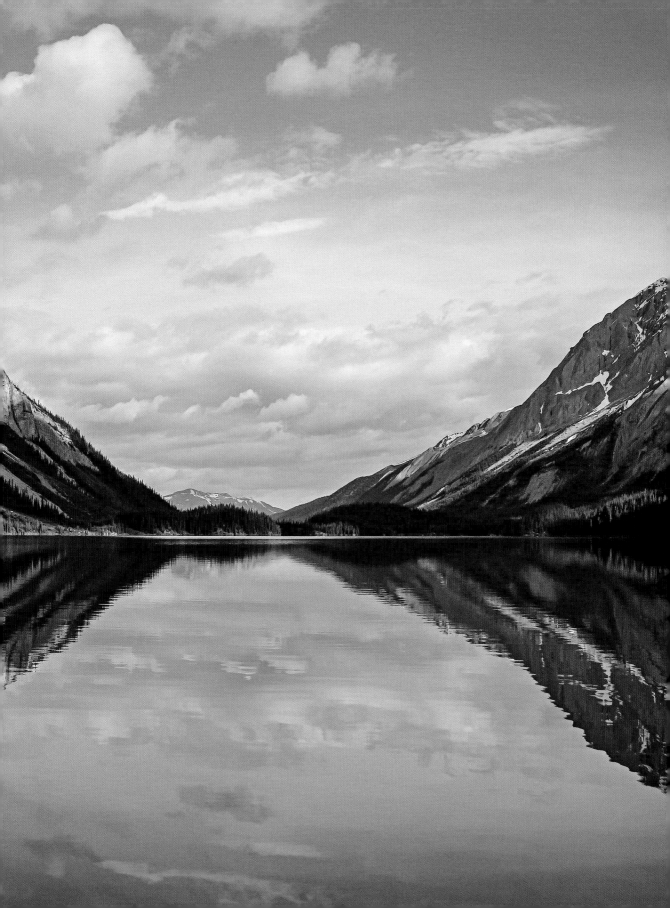

JASPER NATIONAL PARK

Mount Edith Cavell

One of the most recognizable peaks in the Canadian Rockies, Mount Edith Cavell towers above the town of Jasper. Area trails offer views of the Angel Glacier and meadows filled with summer wildflowers

What Makes This Spot Hot?

- The most prominent peak in Jasper National Park.
- A short walk gives you an incredible view of an ancient glacier.
- Wildflowers are abundant in Cavell Meadows in the summer.

Address: Lat: 52.6683° N; Long: –118.0567° W
Tel: (780) 852-6236
Website: parkscanada.ca/jasper
Open: Mid-June to mid-September
Activities:

↗ **Hiking in Mount Edith Cavell, Jasper National Park.**

→ **Mount Edith Cavell Glacier.**

Mount Edith Cavell is a majestic 3,300 metre peak that is an icon in Jasper National Park. The mountain was named in 1916 for a British nurse who was executed during World War I for helping 200 Allied soldiers escape from German-occupied Belgium. During the war, she saved the lives of soldiers on both sides without discrimination. Many monuments have been made in her honour—none more spectacular than the mountain that bears her name.

Climbers have long appreciated the challenge and thrill of climbing this peak that towers above the others in the area. The entire summit is made of Gog quartzite, which is very angular in nature and makes good handholds and footholds. It's such a popular climb that the "North Face Route" is listed as one of the 50 classic climbs of North America.

The Angel Glacier stretches down the north face of the mountain and looks like an angel with its wings spread open. The basin holding the glacier is a classic bowl shape, created from the scouring of glacial ice. Below it is Cavell Pond, which is filled with glacial meltwater. There was a time when visitors could walk right to the end of the pond, but that is not recommended today. Falling rocks and ice can be extremely dangerous. In 2012, a large portion of the Ghost Glacier fell from Mount Edith Cavell and created a massive flood that caused significant damage to the trails and parking lot.

The Path of the Glacier Trail is a short 1.6 kilometre (return) paved trail that goes from the parking area towards the north face of the mountain. The trail ends with a viewpoint overlooking Cavell Pond and the layered ice of Cavell Glacier.

Cavell Meadows Trail is a moderately difficult 7 kilometre return hike that offers wonderful views of the Angel Glacier and alpine meadows. Watch for gray pikas and golden-mantled ground squirrels in the boulder moraine. If you're truly fortunate, you might see

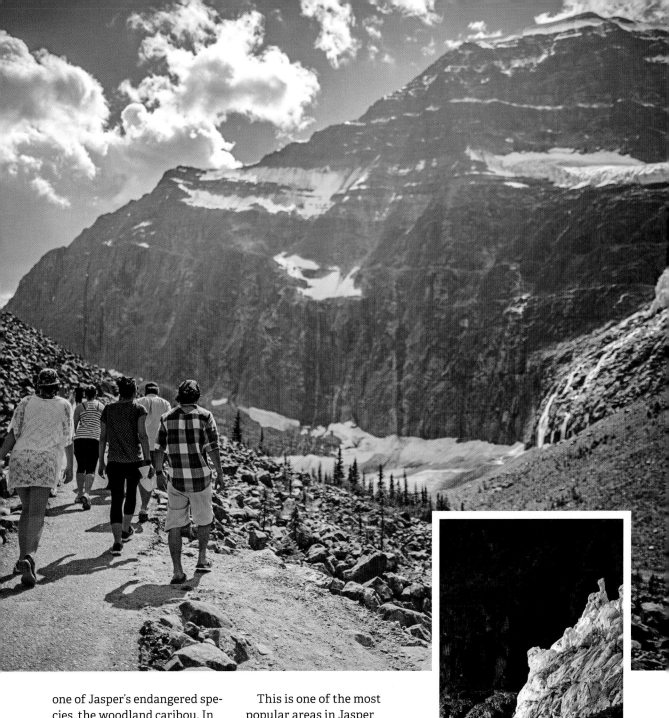

one of Jasper's endangered species, the woodland caribou. In mid-July, the highlight of this hike is the meadows filled with colourful wildflowers. Look for Indian paintbrush, forget-me-nots and cinquefoil—to name just a few.

This is one of the most popular areas in Jasper National Park, and you should go early if you want to avoid the crowds. The 12 kilometre road leading to Mount Edith Cavell is open from mid-June to mid-September.

Peter Lougheed and Spray Valley Provincial Parks

These two parks protect 76,740 hectares of land in the front ranges of the Rockies, a scenic area of high ecological importance

What Makes This Spot Hot?

- Recreational opportunities abound in the Upper Kananaskis, Smith-Dorrien and Spray Valleys.
- Breathtaking scenery that is home to a wide array of plant and animal species.
- Year-round, barrier-free wilderness lodging and trails for persons with disabilities.

Address: Lat: 50.6841° N; Long: -115.1847° W (PLPP); Lat: 50.8891° N, Long: -115.2951° W (SVPP)
Tel: (403) 678-0760
Website: albertaparks. ca/peter-lougheed or albertaparks.ca/spray-valley
Open: Year-round
Activities:

These two parks are both part of Kananaskis Country, an area of park land about 90 kilometres west of Calgary in the front ranges of the Rocky Mountains. There are 10 provincial parks in all, and one ecological reserve in Kananaskis Country. The area gets its name from the river that passes through it. In 1858 John Palliser, an Irish-born geographer and explorer, named the Kananaskis River after a Cree acquaintance. He probably never anticipated that the entire region would someday be known by that name.

The parks in Kananaskis Country are incredibly popular with locals and visitors alike. Peter Lougheed and Spray Valley Provincial Parks are located near the Great Divide in the front ranges of the Rocky Mountains, and the scenery is glorious.

A wide array of wildlife species can be found here.

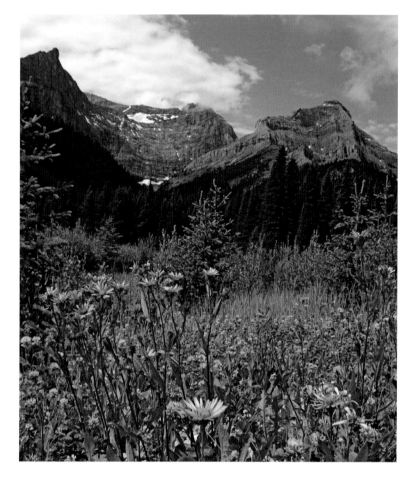

You might see mule deer, white-tailed deer, elk, moose, bighorn sheep, mountain goats, grizzly and black bears, cougars, wolves, wolverines, lynx, and coyotes, as well as smaller mammals typical of alpine and sub-alpine habitats. There's also a wide array of flora to be discovered in the montane, alpine and sub-alpine terrain of these parks. The forests of Peter Lougheed Provincial Park are mostly lodgepole pine, while the forests in Spray Valley Provincial Park are dominated by spruce and fir trees. The differences in forest composition are attributed to the frequency of wildfires.

Too often wilderness areas are inaccessible to people with disabilities, but that is not the case here. The William Watson Lodge in Peter Lougheed Provincial Park provides year-round accessible wilderness lodging for seniors and people with disabilities, by reservation only. The facility allows people of all abilities and ages to enjoy the recreational opportunities. There are more than 20 kilometres of accessible trails near the lodge as well as cabins, RV sites and picnic areas.

These parks can be very busy, thanks to all the wonderful trails, scenery and recreational opportunities they provide. Visitors should make reservations at campgrounds or lodges in advance, especially for the summer months.

↑ **Wildflowers in Spray Valley Provincial Park.**

← **Sunlight through the dense trees provides its own beauty and drama.**

Pierre Grey's Lakes

Beautiful lakes offer an all-season recreational paradise in a peaceful, little-visited part of the province

What Makes This Spot Hot?

- Three stunning lakes offer excellent fishing.
- Easy, family-friendly hiking.
- The chance to see woodland caribou.

Address: Lat: 53.9043° N; Long: –118.5917° W
Tel: (780) 827-7393
Website: www.albertaparks.ca/pierre-greys-lakes
Open: May 17 – October 10 for camping, but road access year-round.
Activities:

↗ **Looking out over Moberly Lake, the site of an historic trading post.**

If you're after a weekend of fishing, boating, hiking and tranquility, then this is a great park to visit. It's a little off the beaten path, as it's a solid 4 hour, 400 kilometre drive northwest of Edmonton. But that helps keep numbers down, so campsites are relatively easy to find, and you can reserve online. Most are quite lovely and private, with lake views and plenty of space. It's also a stopover for many RVers, as it's on the scenic route to Alaska.

A large number of people who visit the park come for the excellent fishing. Three of the five lakes in the park, Moberly Lake, Desjarlais Lake and McDonald Lake, have boat launches. These three lakes are stocked with both rainbow and brook trout. Kayaking and SUP paddle boarding are popular on the lakes as well.

Hikers love the park. There are 24 kilometres of easy trails, including loop trails around Desjarlais and McDonald Lakes. One of the prettiest parts of the park is found on the hike out to the end of the spit in Desjarlais Lake. When you reach the end, look up high in the tree for a massive osprey nest. In early summer,

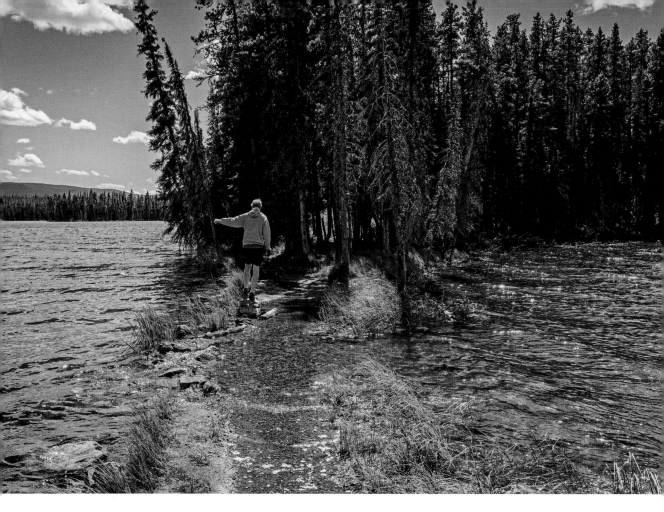

you might hear the osprey chicks. Occasionally there are bald eagle sightings, and you will most certainly hear the cry of the loon.

The hike to the remains of the historical trading post on the shores of Moberly Lake is also worthwhile.

This park is named for Pierre Gris, a Métis trapper who ran the trading post between 1886 and 1894. Reportedly, on one trip to Lac Ste. Anne, he had more than 100 pack horses loaded with pelts. He and his wife were known for raising a number of homeless children. They were casualties of the 1918 flu epidemic.

Lucky visitors, especially in the spring and fall, might see a few of the woodland caribou who live in the area. Other animals you might encounter include black and grizzly bears, white-tailed deer, elk and moose.

The park is popular in the winter for ice-fishing. Thanks to the grooming efforts of a local volunteer group, you can cross-country ski 15 kilometres on rollercoaster-style runs through kame and kettle topography.

⬆ **Hiking to the spit on Desjariais Lake.**

JASPER NATIONAL PARK

Pyramid and Patricia Lakes

At the foot of Pyramid Mountain, Pyramid Lake and nearby Patricia Lake are two of the prettiest recreational areas in Jasper National Park and great locales for wildlife watching

What Makes This Spot Hot?

- Breathtaking scenery—both lakes are surrounded by snowcapped Rocky Mountain peaks.
- One of the premier birding locations in Jasper National Park and an excellent area for wildlife watching.
- Abundant recreational opportunities.

Address: Lat: 52.9235° N; Long: –118.0989° W
Tel: (780) 852-6236
Website: parkscanada.ca/jasper
Open: Year-round
Activities:

↗ **Don't miss the walk out to and around Pyramid Island.**

Pyramid Lake and Patricia Lake are amongst the most popular spots in Jasper National Park because of the fabulous scenery, the abundance of wildlife and the wide array of recreational opportunities available. In summer, you can rent canoes, kayaks, rowboats, paddleboats, mountain bikes and electric cruisers at Pyramid Lake Lodge. In winter, they offer skate, snowshoe and fat bike rentals as well as horse-drawn sleigh rides. An area of the lake is kept clear for skating in winter and, if you bring cross-country skis, you can ski on the frozen lake or the groomed trails just off Pyramid Road.

As you drive or hike this area, watch for elk and deer as well as the occasional moose, black bear and grizzly. This area is one of the best birding locations in the park. There's a wide variety of waterfowl, including Barrow's goldeneye and pied-billed grebe. You should also keep your eyes open for barred owls.

Be sure to take a walk out to Pyramid Island. It's a short jaunt from the roadway. It has a lovely picnic area and public area with bench seating for

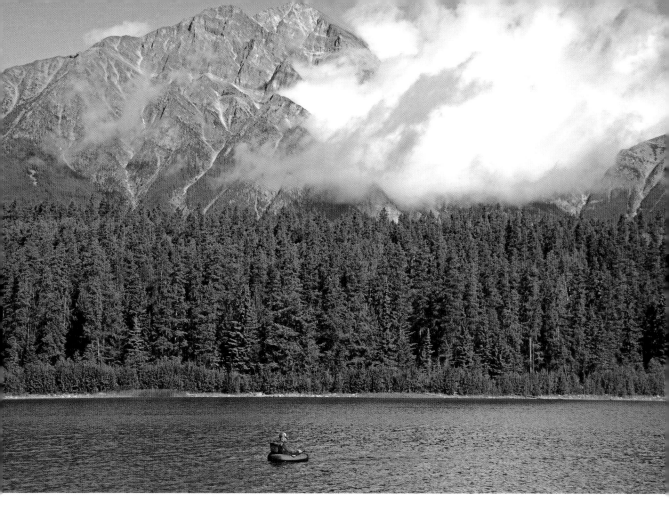

up to 50 that can be rented for inexpensive outdoor weddings with million-dollar views.

Patricia Lake is the quieter of the two lakes, but, as they say, still waters run deep. Below the water's surface lies Project Habbakuk, a top-secret World War II prototype vessel made from a composite mixture of ice and sawdust called Pykrete. Construction of the prototype vessel took place in January 1943 on Patricia Lake. The idea was that a ship made of ice could easily be repaired if it were damaged by a bomb or torpedo. Though reports say the ship did float,

it was expensive to make and costly to keep frozen during the summer months. As the war was coming to a close, the refrigeration was turned off and the ship was allowed to sink to the lake bottom. It was rediscovered in 1985 by a diving expedition. Only the west wall of the structure remains intact, and other pieces are strewn around the wreck site. Today, visitors with dive experience can go on a guided dive tour with Jasper Dive Adventures (jasperdiveadventures.com) and see the underwater plaque that notes the site and its role in history.

↑ **Fishing on Patricia Lake.**

BANFF NATIONAL PARK

Sunshine Meadows

Enjoy one of the best wildflower displays in Canada with a gorgeous mountain backdrop and accessible hiking trails

What Makes This Spot Hot?

- Phenomenal wildflower display in season.
- Spectacular high alpine setting.
- Easy hiking trails above tree line offering incredible mountain views.

Address: The meadows cover approximately 15 kilometres along the Continental Divide
Tel: (403) 760-4403
Website: sunshinemeadowsbanff.com or skibanff.com/summer
Open: Approximately June 30 – September 24th but will vary slightly depending on the year
Activities:

One of the premier day hikes in Banff National Park (called the number one day hike in Canada by *Lonely Planet*) takes you high above the tree line into Sunshine Meadows. Here you're treated to both spectacular views of the snow-capped Rocky Mountains and meadows that are literally carpeted in wildflowers. It's especially beautiful if you catch peak wildflower season which runs from mid-July until late August.

For most people the hike to Sunshine Meadows starts with a bus or gondola ride from the parking lot of Sunshine Village as it knocks off 4.5 very steep kilometres of hiking. There are several options to access the meadows once you reach the Sunshine Village ski area. Either start the hike on the Rock Isle Trail or hop on the Standish chairlift and get whisked to an elevation of over 2,400 metres and enjoy 360° views. Because the meadows are located on the continental divide, you'll spend time in both Alberta and British Columbia.

Before you make your way to Sunshine Meadows make a short stop to visit the interpretive centre. You'll find information on the alpine flowers, wildlife and the mountains. Wild strawberry flowers are one of the first to bloom in late June. In July look for the prolific yellow alpine avens; the lovely diminutive, alpine blue forget-me-nots; yellow glacier lily and the abundant heart-leaved arnica that can grow up to 0.8 metres tall. In August the bright red and pink fireweed is the star attraction.

The hike to Rock Isle Lake

↗ **Alpine forget-Me-Not.**

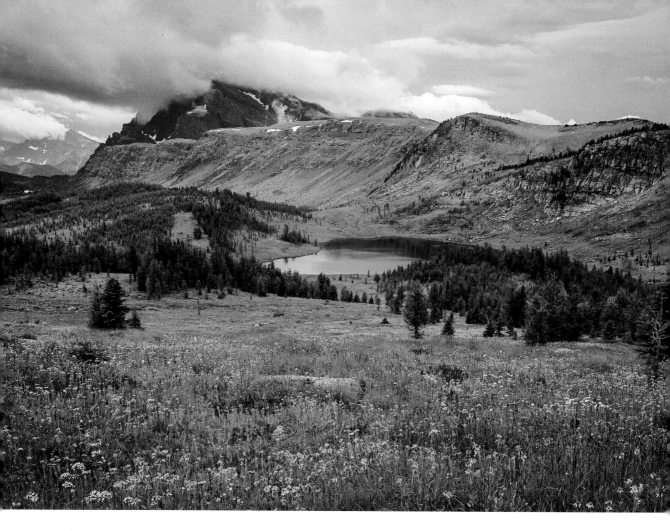

with its jaw-dropping scenery is good, even awesome but the better wildflowers are found nearby between Grizzly and Larix Lakes. If you want more time in the mountains include a hike on portions of the Great Divide and Simpson Pass Trail before returning to the ski area.

If you want to avoid the summer crowds, consider the 9.2 kilometre hike (one way) up the Healey Creek Trail to Healey Pass where the wildflowers are simply breathtaking and even better than the ones around the lakes. It's a harder hike than anything starting at the ski area with more than double the elevation gain but it's free and starts right from the Sunshine Village parking lot.

It's not just wildflowers and mountains you'll see on the hike into Sunshine Meadows. Almost certainly you'll hear the piercing call of a marmot before you see it. Keep an eye out for bighorn sheep, mountain goats and even grizzly bears. And with luck you'll observe the rosy finch, American pipit and other alpine bird species on your visit to the meadows.

⬆ **Mind-blowing wildflower displays above Sunshine Meadows at Healey Pass.**

JASPER NATIONAL PARK

Tonquin Valley

This scenic backcountry wilderness retreat is one of Canada's premier alpine regions

What Makes This Spot Hot?

- Wonderful scenery, including the lovely Amethyst Lake at the base of the Rampart Mountains.
- Excellent area for spotting wildlife—especially the rare woodland caribou.
- Great place to see endangered whitebark pine.

Address: Lat: 52.4687° N; Long: -118.0458° W (Portal Creek parking lot—near trailhead)
Tel: (780) 852-6236
Website: parkscanada.ca/jasper
Open: Closed Nov 1 – Feb 15 to protect the woodland caribou.
Activities:

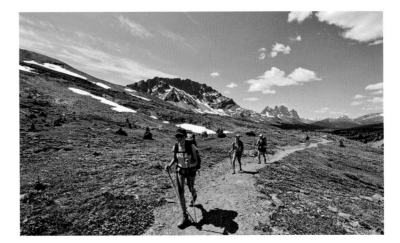

↗ **Hikers at Maccarib Pass in the Tonquin Valley.**

Situated at the continental divide, the Tonquin Valley is one of the most scenic spots in the backcountry of Jasper National Park. In 1939, Fred Brewster built the first permanent camp on the shores of Amethyst Lake. His original log building, Brewster Chalet, is one of the oldest lodges in the park.

The scenery is spectacular in the Tonquin Valley. Those who venture in on foot, horseback or cross-country skis enjoy views of towering mountain peaks, pristine lakes and starry skies. The view of Amethyst Lake at the base of the Rampart Mountains is 23 kilometres from the nearest road.

Wildlife is abundant in this area of the park, and hikers and campers need to take precautions. You might see wolves, black bears and grizzly bears in this area. The valley is also home to a small herd of woodland caribou, a species at risk in Jasper National Park.

It can sometimes be difficult to see a woodland caribou, but you can always see an endangered species if you hike the Astoria Trail. Whitebark pine is prevalent along the first few kilometres of the trail, and this species is listed as endangered. This five-needled pine

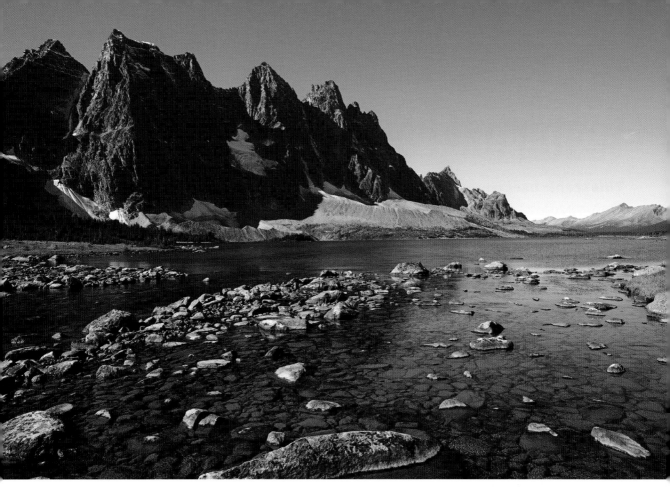

only grows at high elevations and can survive harsh conditions that other trees can't tolerate. It plays an important role in protecting snowpack, regulating flows of mountain creeks and rivers and in aiding the establishment of high-elevation forests after a fire. Its seeds are an important food source for many birds and animals, and the tree relies totally on one bird species to reproduce. The Clark's nutcracker pecks seeds out of cones and caches them in the ground where they germinate. These trees are long-lived and have been known to survive for more than 1,000 years.

Disease, climate change, a reduced number of fires and its limited method of reproduction have led to the severe decline in this species.

Late summer and early fall are the best times to hike the Tonquin Valley. The area is closed in early winter, but in late winter you can ski in. There are two outfitters lodges in the area: Tonquin Valley Backcountry Lodge and Tonquin Valley Adventures Lodge. The Alpine Club of Canada maintains a hut on the north shore of Outpost Lake that can also be rented. There are also several backcountry campgrounds available.

↑ Caribou in a meadow.

↑↑ The Ramparts in scenic Tonquin Valley.

Waterton Lakes National Park

Where the prairies meet the mountains, this small Rocky Mountain park in the southwest corner of Alberta is big on scenery, wildlife and recreation

What Makes This Spot Hot?

- Fantastic mountain scenery and a wide array of year-round recreational opportunities.
- Excellent conditions for spotting wildlife; the prairies run up the sides of the mountains, making for easy viewing from roadways.
- The Waterton-Glacier International Peace Park was the first park of its kind in the world.
- A boat cruise can take you from Waterton into Glacier National Park in Montana, USA.

Address: Lat: 49.0603° N; Long: –113.9085° W (Parks Canada Visitor Information Centre)
Tel: (403) 859-5133
Website: parkscanada.ca/waterton
Open: Year-round
Activities:

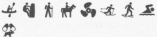

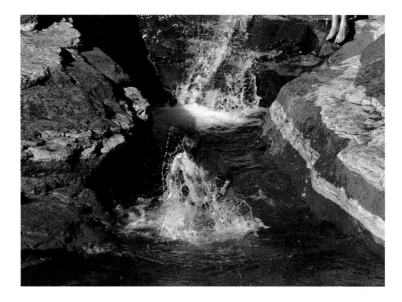

↗ **A cooling plunge in the waters of Red Rock Canyon.**

The old saying "good things come in small packages" holds true when you look at Waterton Lakes National Park. At 505 square kilometres, Waterton is the smallest of the Canadian Rocky Mountain National Parks, but it's also one of the most diverse parks in the national parks system.

Located in a region known as the Crown of the Continent, this park contains beautiful scenery and a vast array of flora and fauna. Over half of Alberta's plant species can be found inside the park and there are more than 175 provincially rare plants here, such as mountain lady's slipper, pygmy poppy and mountain hollyhock. An annual spring wildflower festival celebrates the diversity of plant life in the park.

There is also an incredible array of wildlife to be found. More than 60 species of mammals, 250 species of birds, 24 species of fish and 10 species of reptiles and amphibians can be found in the park. Large predators include grizzly bears,

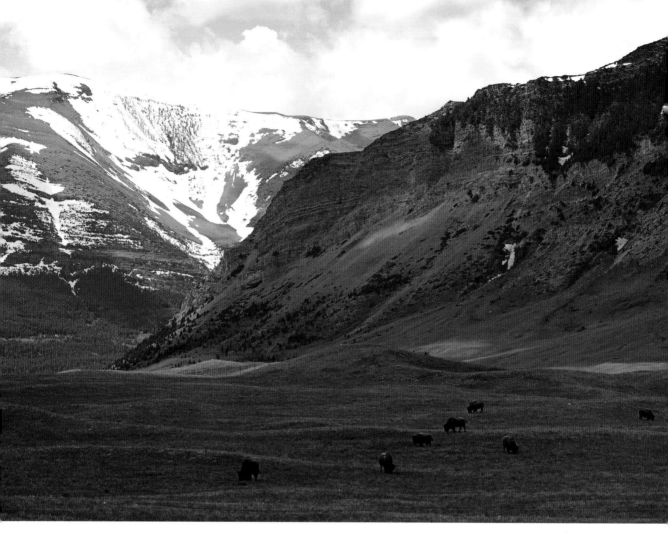

↑ Bison Paddock, Waterton Lakes.

← The *Miss Waterton* tour boat offers some of the best views of the park.

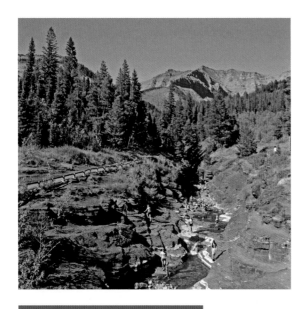

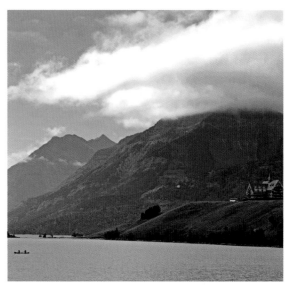

black bears, wolves, coyotes and cougars. Visit the bison paddock just inside the park boundary to see bison grazing in their natural habitat. Wildlife is celebrated at an annual autumn festival.

In 1932, Waterton became part of the Waterton-Glacier International Peace Park, a symbol of peace and goodwill between Canada and the United States. You can take a two-hour cruise (watertoncruise.com) from the Canadian side of Upper Waterton Lake to the American side of the lake. If you want to hike on the American side, you will have to bring a passport and clear United States Customs at the Goat Haunt port of entry. It's common to see moose on the 4 kilometre Kootenai Lakes hike that departs from Goat Haunt.

↑ **Prince of Wales Hotel, Waterton Lakes National Park.**

↖ **Swimmers enjoy the day.**

There are many wonderful hikes in Waterton, including Bear's Hump, Crandell Lake, Rowe Lakes, the Carthew-Alderson Trail and the famous Crypt Lake Trail. In 2014, *National Geographic* rated the Crypt Lake Trail one of the "World's 20 Most Thrilling Trails." This unique hike features a 15-minute boat ride across Upper Waterton Lake to the trailhead at Crypt Landing. You'll pass four waterfalls, climb a steel ladder, crawl through an 18 metre tunnel and maneuver around a cliff using a steel cable before you arrive at beautiful Crypt Lake.

→ **The hike to Crypt Lake has been called one of the world's 20 most thrilling trails.**

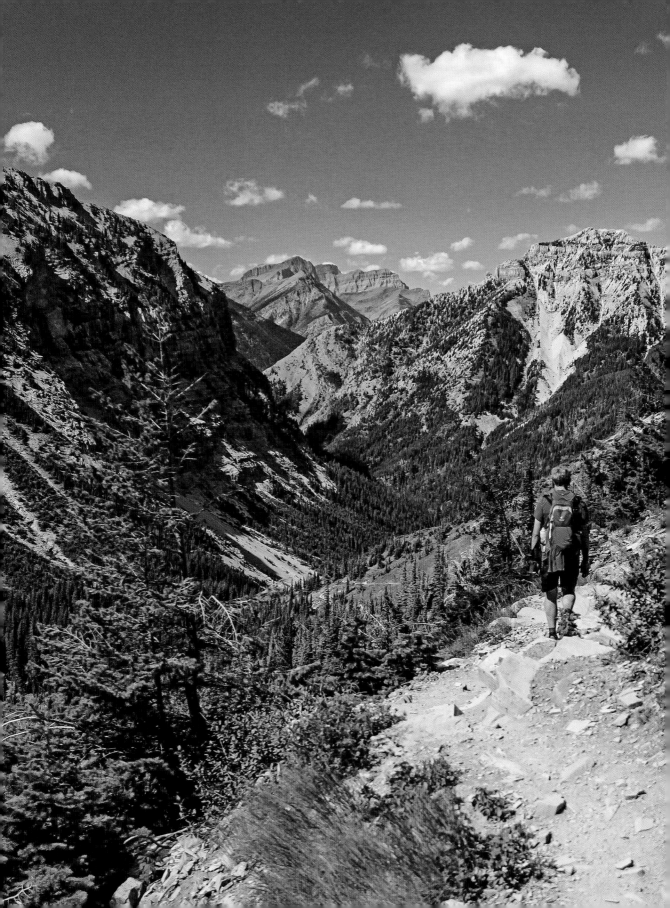

Whitehorse Wildland Provincial Park

A little known park that's wild, beautiful and rich in plant species and wildlife. Adventurous souls will love the empty spaces

What Makes This Spot Hot?

- One of the few places in Alberta where you can drive to an alpine meadow.
- Cadomin Cave provides important habitat for bats; it's one of only four spots in Alberta where bats can overwinter.
- Over 277 plant species including many that are rare.

Address: Cardinal Divide:
Lat: 52.9068 N; Long: −117.2116 W
Tel: (780) 865-8395
Camping reservations:
(780) 865-2154
Website:
albertaparks.ca/whitehorse
Open: Cardinal Divide—
approximately mid-June until the Thanksgiving weekend but weather and snow dependent; Open year round from the Whitehorse Creek Provincial recreation Area. You should be very familiar with winter safety in the backcountry before venturing in.
Activities:

If you love truly wild places, head for Whitehorse Wildland Provincial Park located about an hour's drive south of Hinton. The park shares its western border with Jasper National Park. On the drive up to the park, especially if you go to the divide, you'll feel like you're heading off on a remote adventure.

Visitors can explore the park via a backcountry trail that begins at the Whitehorse Creek Provincial Recreation Area, not far from Cadomin or on foot from the Cardinal Divide Viewpoint Parking Lot. The trail to the Cadomin Bat Caves (Alberta's largest bat hibernation cave) is temporarily closed to reduce the risk of White-Nose Syndrome, a fungal disease that kills cave roosting bats.

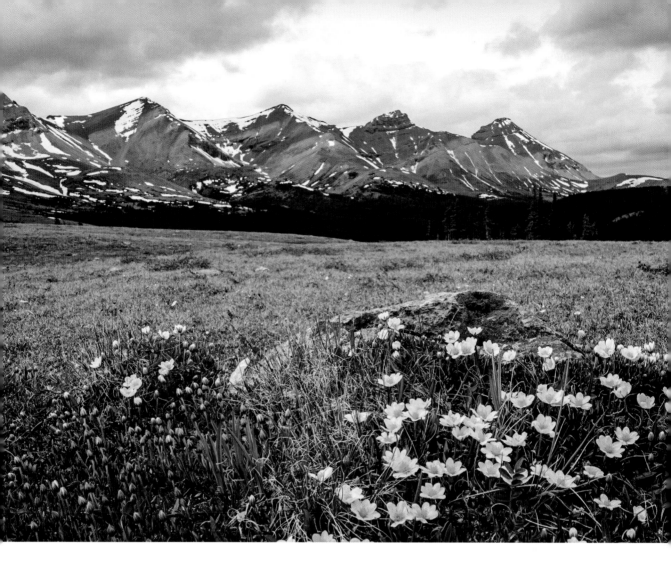

The Cardinal Divide

If you head for the Cardinal Divide, a high clearance vehicle is recommended in case there are issues with the road. The drive up the dirt road passes an active coal mine with massive trucks at work on their own dedicated road. Once you get past the mine, you'll be struck by the beauty of the wilderness, prime habitat for a variety of animals including elk, moose, mule deer, bighorn sheep, black bears, wolves, cougars, marmots and pika. The Cardinal Divide sits at an elevation of 1,981 metres on the division of two major river systems. The McLeod River drains into the Athabasca River which flows north to empty into the Arctic Ocean. To the south the Cardinal River flows into the Brazeau River and then into the North Saskatchewan River

↑ You can drive right to this high alpine meadow.

← *Silene acaulis*, also known as moss campiom, is a common wildflower in the high alpine.

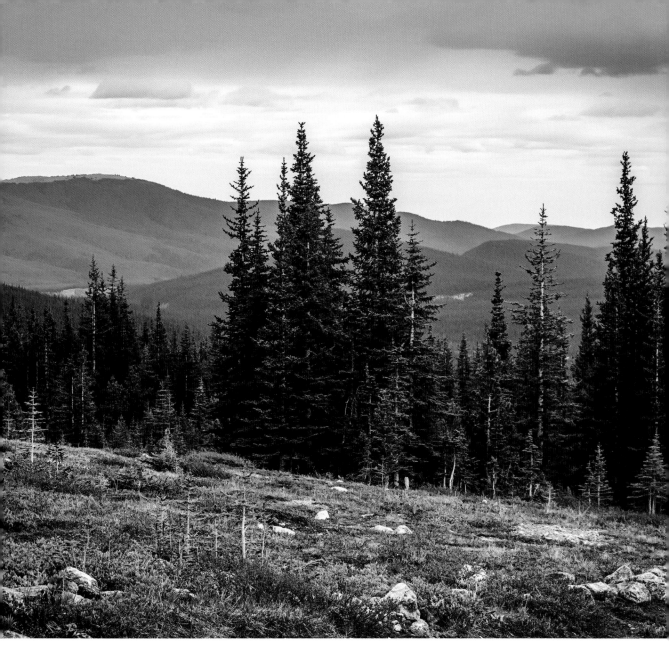

↑ **Repeating hills in the distance.**

which flows east across the prairies to drain into Hudson's Bay.

The area around Cardinal Divide can only be explored on foot and camping is not permitted. Extensive alpine meadows, renowned for their summer wildflowers and sub-alpine slopes will beckon the hiker. Stay on the unmarked trails to protect the very fragile soil and plants. Some people attempt to scramble up the closest mountain you can reach on foot. Another hiking option is to follow the dirt track from the parking lot east up the ridge for gorgeous views of the upper foothills.

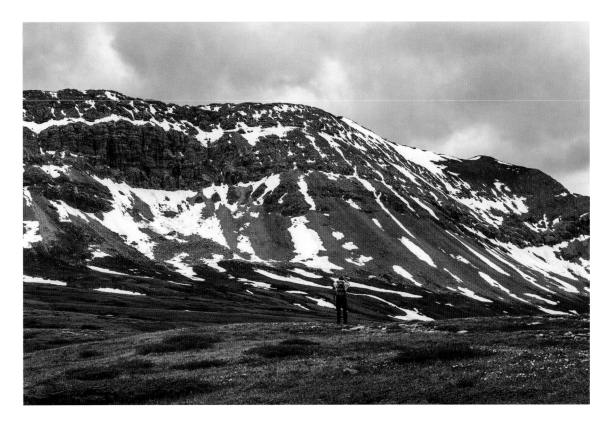

Whitehorse Creek Staging Area

↑ **The size and grandeur of the mountains dwarfs the visitor.**

It's also possible to hike, backpack or horseback ride into the park from the Whitehorse Creek Provincial Recreation Area. To find it, look for a turn-off marked "camping" on the road up to the Cardinal Divide not far from Cadomin. There are a number of campsites by the trailhead that can also accommodate horses.

The Lower Whitehorse Trail takes you through prime grizzly country so be bear aware. You can actually do several multi-day trips; one over Fiddle Pass and into Jasper National Park or visit the Wildhorse Creek Falls. There are several backcountry campsites along the trail. As you hike or ride look for some of the 277 different plant species that live in the park, including 37 that are rare. One, a moss, *Bryum porsildii*, is found only at a few other locations in the world. At the lower elevations you may also spot harlequin ducks and some of the 128 bird species that visit the park.

Willmore Wilderness Park and Sulphur Gates

Explore a vast wilderness park known for its spectacular mountain scenery and plentiful wildlife in an area that's a virtual unknown

What Makes This Spot Hot?

- Superlative views of the Sulphur River Canyon where it meets the Smoky River.
- Largest wilderness area in Alberta.
- High density of wildlife in Willmore Wilderness Park.

Address: Willmore:
Lat: 53.6855° N;
Long: −119.0745° W
Sulphur Gates: 53.8712° N;
Long: −119.1875° W
Tel: (780) 827-7393 and
(780) 865-8395.
Website: albertaparks.ca/
sulphur-gates and
albertaparks.ca/parks/
central/willmore
Open: Year-round in theory
though in winter roads
are not a high priority and
you must expect to add
extra mileage on skis or
snowshoes to gain access.
Activities:

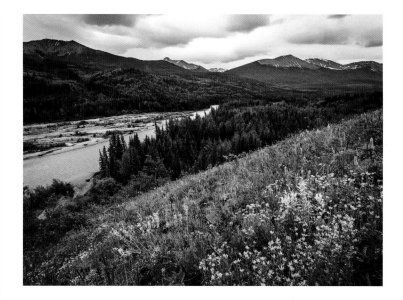

↑ **This expansive view is but one small part of Willmore Wilderness Park.**

The Willmore Wilderness Area and the Sulphur Gates Provincial Recreation Area meet just west of Grande Cache. While Sulphur Gates can easily be visited and enjoyed over an hour or two, Willmore Wilderness, the largest wilderness area in Alberta, needs more of your time to fully appreciate it.

The Sulphur Gates area offers limited recreational opportunities. People visit to be wowed by the spectacular views of the confluence of the Sulphur and Smoky Rivers and the Sulphur River Canyon. You can enjoy the views via a short trail from the parking lot.

The Sulphur Gates are one of three access points to Willmore Wilderness Park and

↑ **Wild rose.**

→ **Looking up the Sulphur River.**

act as a staging area for both backpackers and equestrians. Horse-friendly campsites are located by the parking lot. Day hikers can enjoy a 3 kilometre trail to Eaton Falls in the Willmore Wilderness. The falls themselves are quite lovely and along the way there's a marvelous viewpoint.

The Willmore Wilderness Park, despite its size — 4,597 square kilometres — is virtually unknown. But if you're well-equipped for backcountry adventures, either on foot or on a horse, you can explore the 750 kilometres of trails that run through the park.

The Willmore area is known for broad, grass covered valleys, green sub-alpine and alpine ridges, alpine meadows, mountain peaks and glaciers on some of the high mountains. Six rivers crisscross the park, with all but the Smoky River originating in the park. The scenery

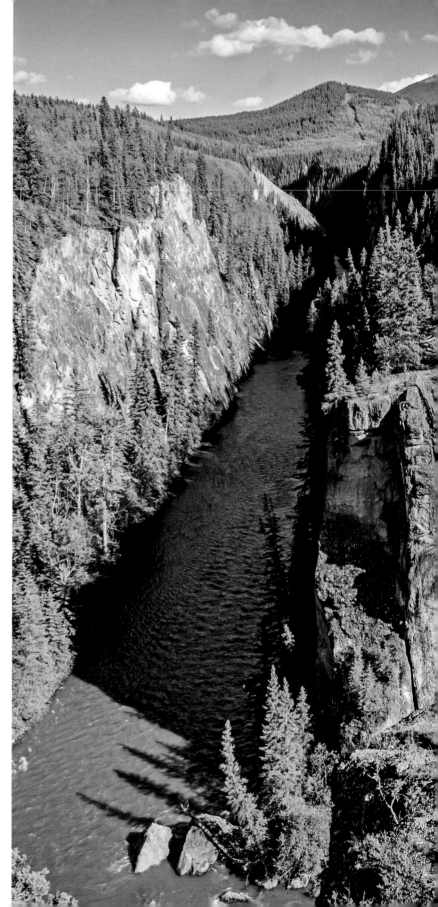

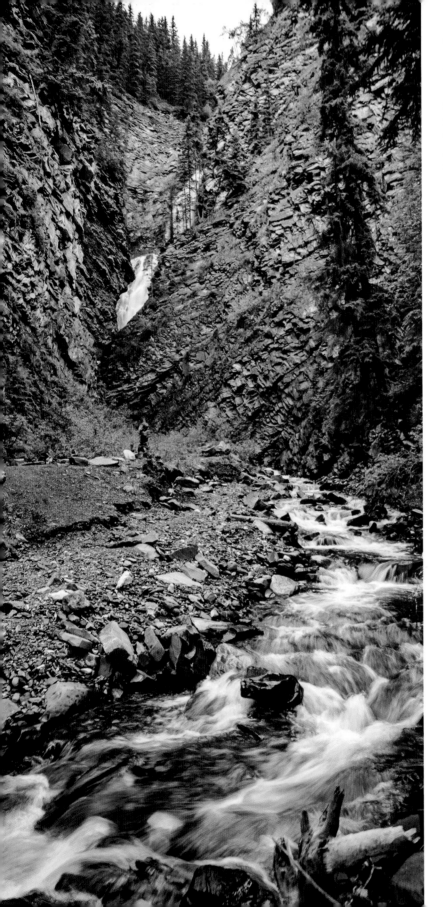

is spectacular—rugged mountains, lots of wildflowers, waterfalls, rapids and a sense of space in a huge expanse of wilderness.

Wildlife in the park includes mountain caribou, grizzly and black bears, cougar and wolves, moose, and elk, mountain goats and bighorn sheep. Birds include boreal and mountain species along with harlequin ducks in wetland areas.

Rock Lake Provincial Park, is the access point that's most used to visit the park. It's a 90 minute drive from Hinton via Highway 40 and a 30 kilometre drive on a dirt road. The third option is via Big Berland Recreation Area off of Highway 40.

A large number of visitors visit the park on horseback via original pack trails that have been described as deep ruts and gouges, not exactly what a hiker wants to hear. It's recommended that hikers allow a minimum of four days to experience the park and the best way to do it is to set up a base camp. Then do day hikes up to the ridge tops to enjoy the views the park is famous for. By sticking to the main valley trails, hikers will miss much of the park's beauty.

Adventurous types eager to explore a little visited part of the province will find plenty to love on a trip to Willmore Wilderness Park.

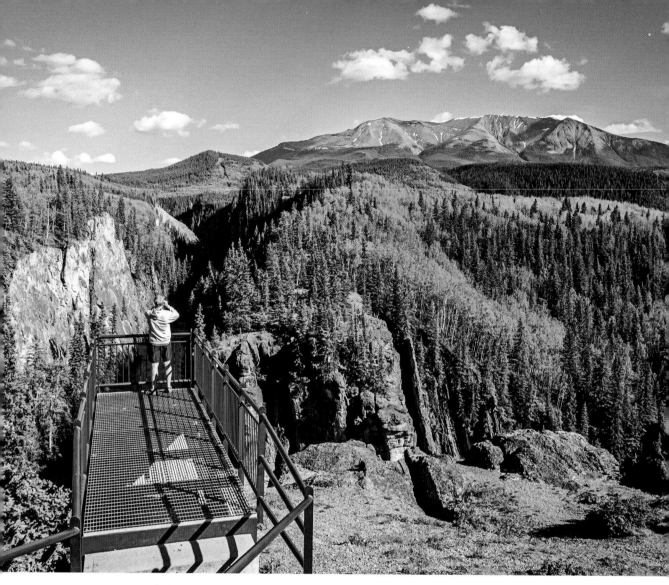

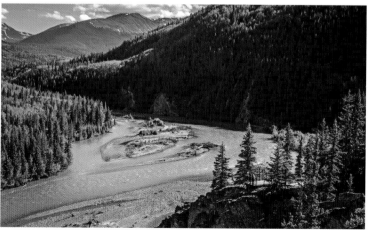

↑ Looking into the vast Wilmore
 Wilderness Area.

← It's an easy hike to Eaton Falls from
 Sulphur Gates.

←← The Smoky River is a tributary
 of the Peace River.

Ya Ha Tinda Ranch

This historic ranch has abundant wildlife, spectacular mountain views and great trails that can be enjoyed on foot or on horseback

What Makes This Spot Hot?

- The only federally-operated working horse ranch in Canada.
- 3,945 hectares of land with spectacular mountain views and 27 kilometres of riverfront.
- An abundance of wildlife—this site is a major wintering area for elk.

Address: Lat: 51.7362° N; Long: –115.5401° W
Tel: (403) 621-1128
Website: pc.gc.ca/en/pn-np/ab/banff/activ/cheval-horse/YaHaTinda
Open: Year-round
Activities:

↗ **Poplar Ridge in the distance.**

Although there are thousands of kilometres of trails inside the national parks, some places in the backcountry of the Rockies are particularly difficult to access. Since the establishment of Canada's first national park in 1885, park wardens have patrolled the backcountry of specific mountain parks on horseback. Even today, there is no better way to see the country than from the back of a horse.

Ya Ha Tinda Ranch is the place where Parks Canada patrol horses spend the winter months and receive their training. The ranch was originally established by the Brewster Brothers Transfer Company in the early 1900s. They used the ranch to raise and break horses for their outfitting business. At that time, the ranch was inside what was then called the Rocky Mountains National Park, but the boundaries of the park changed over the years and the ranch is now west of the

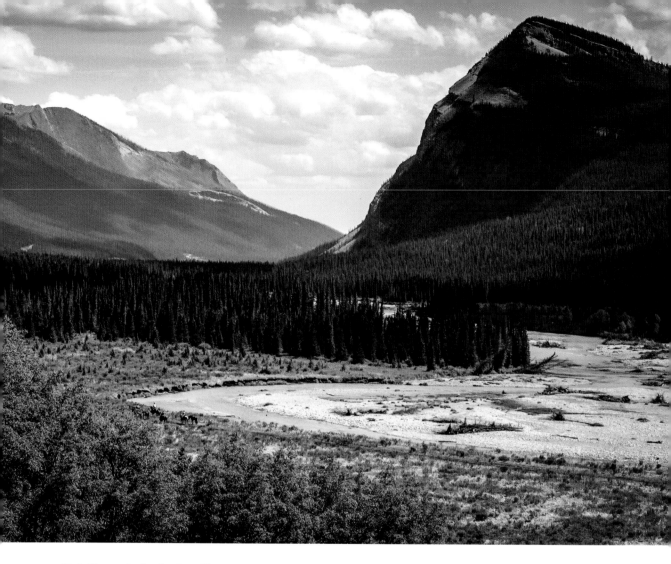

official boundaries for Banff National Park.

In 1917, Parks Canada took over the ranch to use as a winter range, breeding and training facility for park horses. In 2003, the breeding program was discontinued. The ranch now purchases weanlings each year, raising them and training them over the next four years before assigning them to the various mountain parks. The horses return to the ranch each winter.

Ya Ha Tinda provides the perfect conditions for training park horses—plenty of varied terrain and an abundance of wildlife. Grizzly bears, wolves, cougars, moose, deer, elk and bighorn sheep can be found here. You may also see domestic bison at the ranch. Bison were brought in to train the horses prior to the reintroduction of wild bison to Banff National Park in 2017.

Though it is not inside the borders of the national park, Ya Ha Tinda is private deeded

↑ **Stay at the Bighorn Campground and you'll get views like this.**

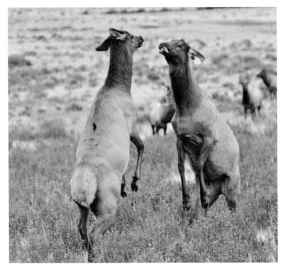

↑ **Grizzly bear in meadow.**

← **Elk sparring.**

↓ **Riding trails, Ya Ha Tinda.**

land, owned by the Federal Government and managed by Parks Canada. Hikers and horse owners are welcome to use and enjoy the incredible scenery. The onsite Bighorn Campground is equipped with tie stalls and high lines. The campground is maintained by the Friends of the Eastern Slopes Association and funded by donations and voluntary memberships. There are rules for its usage and for riding inside the ranch. The most important of these is to stay on designated trails and not to travel within fenced pastures.

There are 10 trail routes through the site that can be enjoyed on foot or on horseback. Tours of the ranch buildings area are available, with schedules posted at the campground.

 Elk herd crossing a river.

DID YOU KNOW?

The name "Ya Ha Tinda" means "Mountain Prairie" in Stoney. Archaeological evidence indicates that the area has been used by First Nations people for over 9,000 years.

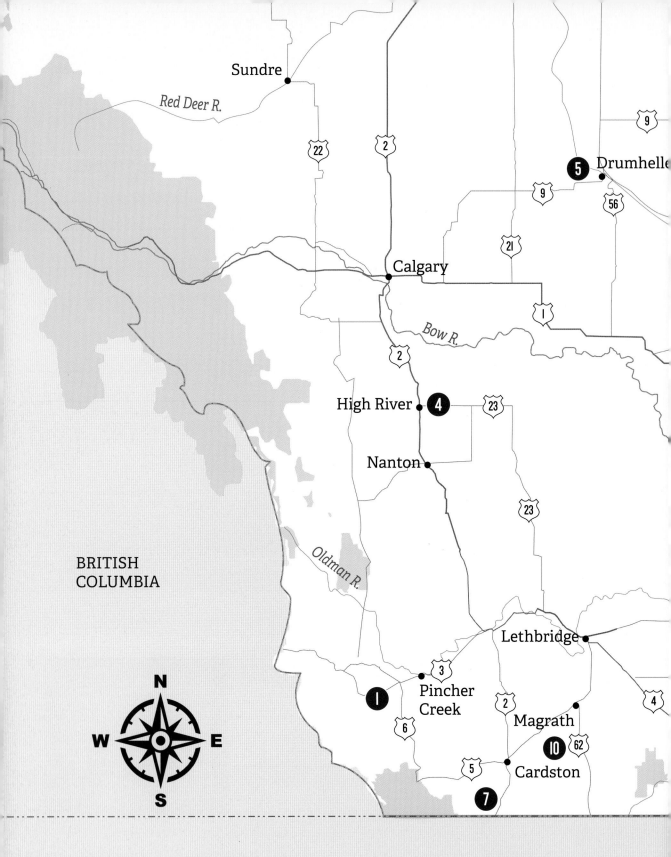

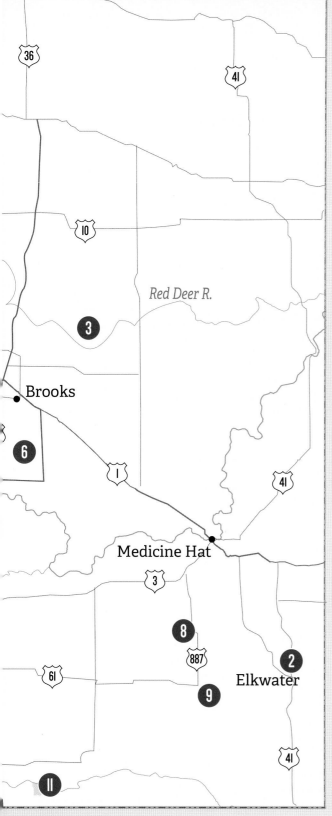

Southern Alberta

Beauvais Lake Provincial Park

Situated in the picturesque foothills region near Pincher Creek, this provincial park is an all-season natural paradise and recreational area

What Makes This Spot Hot?

- Diverse montane grasslands, wetlands and woodlands that provide habitats for a wide variety of species, including some threatened ones like the northern leopard frog.
- Rare plants, including nine different species of wild orchids.
- Lies within the Pacific Flyway; over 180 species of birds have been recorded inside the park.

Address: Lat: 49.4091° N; Long: -114.1160° W
Tel: (403) 627-1165
Website: albertaparks.ca/beauvais-lake
Open: Year-round
Activities:

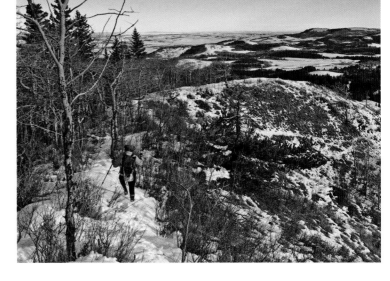

↗ **Walking trail in winter.**

If you want to see uncommon birds, plants and animals, this is the spot. The diverse montane grasslands, wetlands and woodlands surrounding Beauvais Lake provide a wide range of habitats for birds, plants and animals, and you can see a number of uncommon species in this area.

The lake lies within the Pacific Flyway, a major north-south flyway for migratory birds in America. Bird watching is very popular — especially in the spring or fall. You can see a wide variety of birds, including the McGillivray's warbler, western tanager, Clark's nutcracker, ruby-crowned kinglet, osprey, bald eagle and great blue heron, to name a few. Pairs of sandhill cranes, which are classified as a sensitive species in SW Alberta, have been observed nesting in the area.

In 2009, the Government of Alberta released 11,000 northern leopard frogs at Beauvais Lake Provincial Park in an effort to rebuild the population of this threatened species. Populations of these

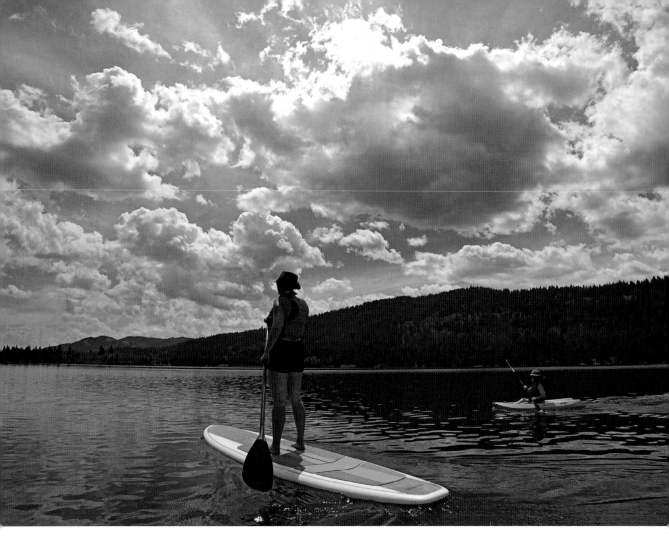

frogs declined sharply across many parts of Western Canada in the 1970s, and scientists are not completely certain why. The reintroduced frogs are doing well. There are a total of eight species of reptiles and amphibians in the park.

The lake itself has been stocked with rainbow trout and brown trout, and is very popular with anglers in both summer and winter. In summer, the lake is great for canoeing, kayaking and powerboating (12 kilometres/hr maximum speed). There's a beautiful lakeside campground in a treed area with a small playground for children and boat launch nearby.

There are more than 18 kilometres of hiking trails in summer and almost 28 kilometres of cross-country ski trails in winter. The park is also a popular spot for snowshoeing in winter. Walk to Scott's Point to see the gravesite of James Whitford, an early settler who claimed to have been one of General Custer's scouts at the famous 1876 battle of Little Bighorn.

↑ **Watersports are popular on Beauvais Lake in summer.**

↓ **Northern leopard frog.**

Cypress Hills Interprovincial Park

A year-round park to visit for nature and outdoors lovers

What Makes This Spot Hot?

- Excellent year-round recreational opportunities.
- Over 220 bird species and a large population of cougars.
- Highest point between the Rocky Mountains and Labrador.

Address: 40 Lakeview Drive, Elkwater, Alberta, T0J 1CO
Tel: (403) 893-3833
Website: albertaparks.ca/cypress-hills
Open: Year-round
Activities:

↗ **Kids love flying down the luge at the Learning Centre.**

Anyone living near Medicine Hat knows how lucky they are to live in close proximity to Cypress Hills Interprovincial Park. Sharing a border with Saskatchewan and situated within sight of Montana's Sweet Grass Hills, this park is a first-class year-round destination for both recreation and nature lovers.

The park is loaded with unusual features. For starters, the hills are the highest between the Rocky Mountains and Mount Caubvick in the Torngat Mountains of Labrador. Rising 600 metres above the surrounding prairie, they are responsible for affecting the climate and providing a diverse array of ecosystems. You can find everything from prairie and wetlands through to grasslands and lodgepole pine forests. Orchids are prevalent. So too are a dizzying

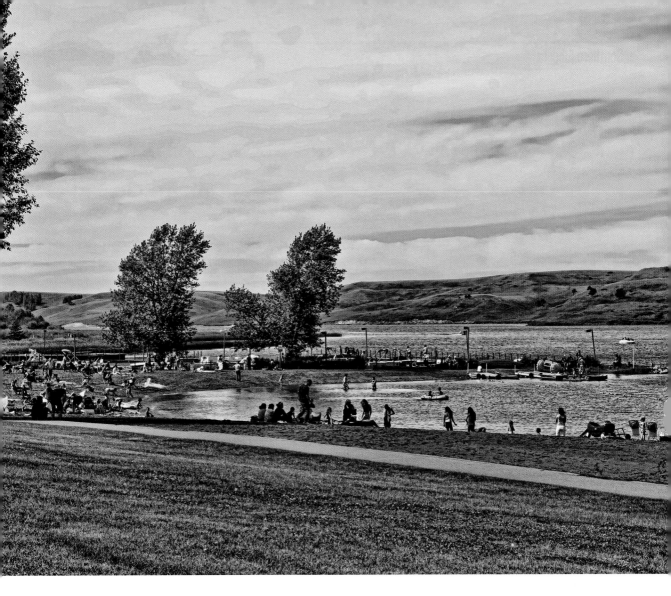

number of birds, with upwards of 220 species sighted, including the loggerhead shrike, a bird that impales its victims on the thorns of the park's hawthorn trees. There's a lot of wildlife, especially cougars and deer—but what you won't find are any bears.

Geologically, the park is of great interest. In the last ice age, the uppermost 100 metres of the park were never covered by glacial ice. It was essentially an island, or nunatak, with the top of the hills peaking above the surrounding ice. The rocks, too, have something to say. The area has been likened to a layer cake, with the bottom layer dating back 70 million years when it was covered by the Bearpaw Sea. In between the highest and lowest points are lots of layers, including one made of thick volcanic ash and others laden with fossils from camels and sabre-toothed

⬆ **The beach is a popular spot in the summer; you can rent canoes, kayaks and paddleboards here.**

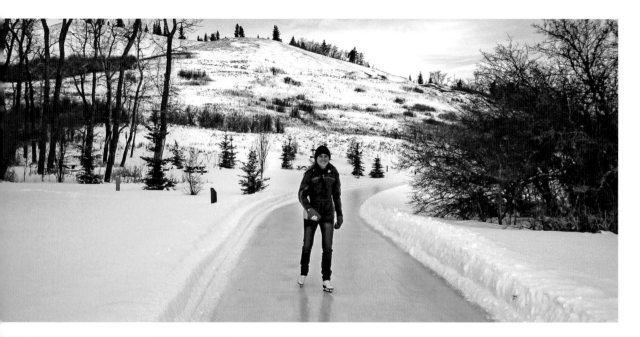

↑ This conglomerate provides a lesson in the geology of the region.

↑↑ It's great fun skating on a trail through Beaver Creek Campground.

→ Enjoy easy kayaking on Elkwater Lake.

tigers. A tough gravel deposit derived from the Sweet Grass Hills is now a conglomerate. It protects the underlying rocks from erosion and is a big reason the Cypress Hills stand tall today.

Come summer, people flock to Cypress Hills to go boating, canoeing, kayaking, paddleboarding and swimming and to bike and hike on the 50 kilometres of mixed-use trails that crisscross the park. In winter, you can downhill or cross-country ski, snowshoe and skate on a trail through the woods.

In summer, sign up for a guided nature tour. Over a couple of hours, you will experience the full range of ecosystems in the park. You can see the Survival Tree, a lone lodgepole pine at the top of the plateau that has been growing for more than 150 years. Check out the unassuming headwaters of Battle Creek and observe this water as it begins its journey to the Gulf of Mexico. Then, just a kilometre away, watch the water as it flows to Hudson's Bay. Visit either the Head of the Mountain Viewpoint or the Horseshoe Canyon Viewpoint at sunset. Both are magnificent.

Cypress Hill Provincial Park is a 50-minute drive south of Medicine Hat via Highway 1 (Trans-Canada) and Highway 3. The Visitor Centre, which is open year-round, is located at the west end of town. You can stay overnight in the park year-round.

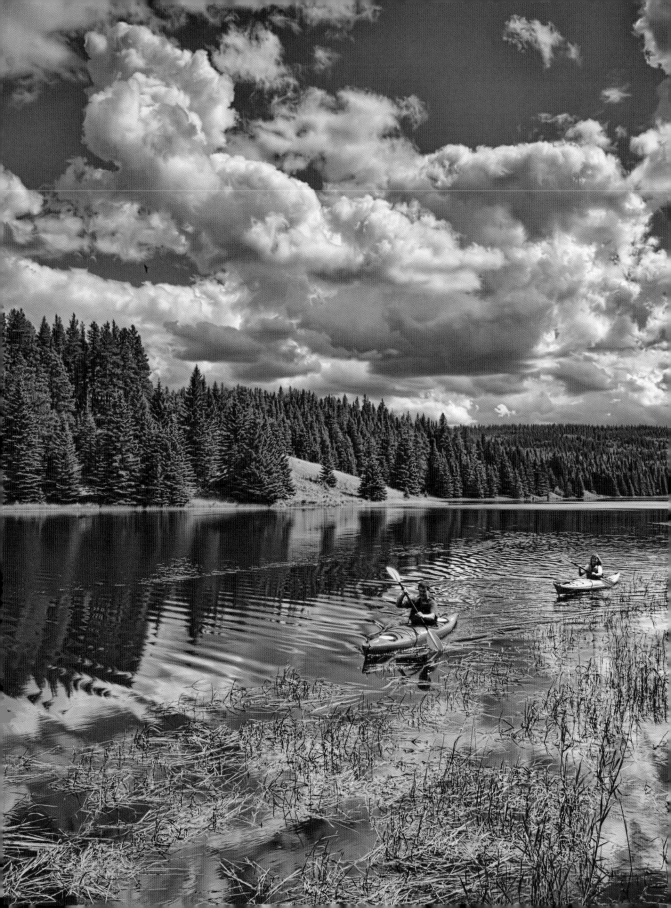

Dinosaur Provincial Park

Dinosaurs once roamed the lunar-like landscape of Dinosaur Provincial Park, a UNESCO World Heritage Site that is unlike anywhere else on earth

What Makes This Spot Hot?

- UNESCO World Heritage Site that contains the highest concentration of late Cretaceous Period fossils in the world.
- Activities include dinosaur digs, bus tours, fossil prospecting, guided hikes, and interpretive theatre programs.
- Stunning badlands scenery provides a variety of recreational opportunities.

Address: Lat: 50.7594° N; Long: –111.5190° W
Tel: (403) 378-4342, extension 235
Website: albertaparks.ca/dinosaur
Open: Year-round
Activities:

↗ **Young visitor finds a fossil in Dinosaur Provincial Park.**

→ **Badlands and hoodoos form a dramatic landscape.**

The landscape of the Canadian Badlands takes you by surprise. One moment you're driving through the flat prairie fields of grass and wheat typical of southeastern Alberta. The next, the scenery changes to a starkly beautiful landscape of semi-arid steppes, gorges, buttes and oddly misshapen hoodoos. It's an area of exceptional beauty, and the landscape played a part in the decision to make Dinosaur Provincial Park a UNESCO World Heritage Site.

When you're in the middle of the lunar-like landscape, it's hard to imagine this place as a subtropical paradise—but millions of years ago, this park was filled with palm trees and ferns. Dinosaurs roamed here on the edge of a great inland sea. There were so many dinosaurs that this spot contains the highest concentration of late Cretaceous Period fossils in the world.

The outstanding number and variety of high-quality fossil specimens inside the park was the second major consideration for awarding it

a UNESCO designation. Every known group of Cretaceous dinosaurs is found here. More than 300 specimens have been extracted from the Oldman Formation in the park, including more than 150 complete skeletons which now reside in more than 30 major museums. Many fossils still lie waiting to be uncovered, and the opportunities for paleontological discovery at this site are great.

This park has incredible presentations that teach visitors about dinosaurs, show them how to identify fossils and even provide opportunities to excavate fossils under

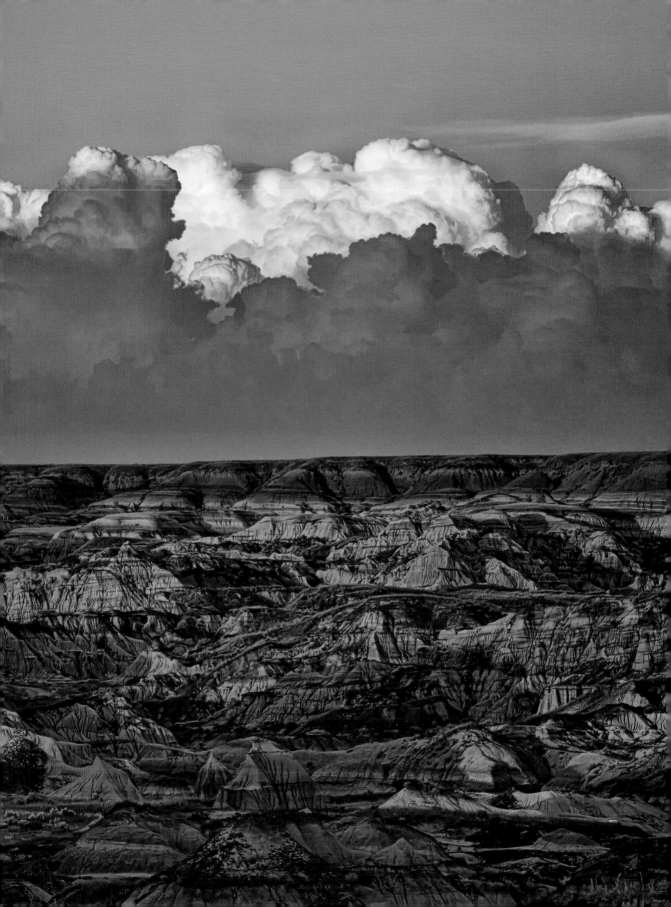

↑ Prickly pear cactus blooms for up to a week from late May to early July.

↑↑ The greater short-horned lizard is often mistakenly called a horned toad, but it's not a toad at all.

the watchful eye of scientists. There are also guided badlands hikes and interpretive theatre programs.

The final reason for the park's UNESCO designation is that it protects 26 kilometres of riparian habitat along the banks of the Red Deer River.

Hike the Cottonwood Flats Trail and enjoy a leisurely walk along the riverside under a canopy of cottonwood trees. Cottonwood trees require natural flooding in order to reproduce. Since the water level in many rivers is controlled by dams, this type of habitat has become rare in Alberta.

Located near the town of Brooks, and just about an hour-and-a-half drive southeast of the Royal Tyrell Museum of Palaeontology in Drumheller, the park stretches along the Red Deer River and provides a varied habitat for a wide variety of animals, reptiles, amphibians and birds. You might see pronghorn antelope, mule deer, bobolinks, lark buntings, Brewer's sparrow or yellow-breasted chats, depending where you are in the park. Over 165 species of birds have been recorded in the park, with 64 species nesting here regularly. There is a significant

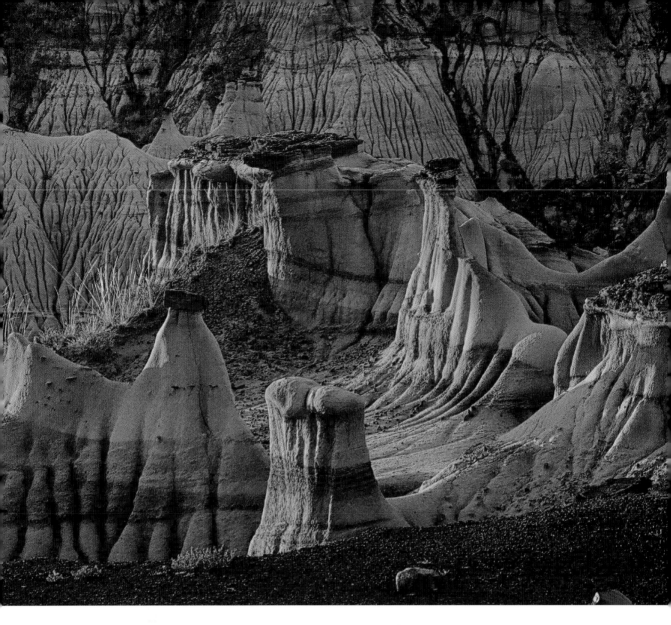

number of breeding birds of prey, including golden eagles, ferruginous hawks, prairie falcons, merlin, marsh hawks and kestrels.

You may see snakes in the particularly arid parts of the park, but most are harmless. The only venomous snake found in this area is the prairie rattlesnake, and it is very rarely seen.

It's common to see pincushion and prickly pear cacti in arid areas as well.

There are wonderful trails and excellent campground facilities for tents and RVs. The park also offers semi-permanent canvas-walled tents with wood floors, real beds and handmade furnishings.

↑ **Eroded landscape in Dinosaur Provincial Park.**

Frank Lake

The best birding close to Calgary

What Makes This Spot Hot?

- Southwest Alberta's most important wetland for waterfowl.
- One of the 597 Important Bird Areas in Canada.
- 190 plant species have been documented.

Address: Lat: 50.563° N; Long: −113.716° W (for the road near the blind)
Tel: None
Website: None
Open: The gate to the blind is open in April or May depending on road conditions and is locked at the end of August before the start of hunting season. The blind can be accessed on foot during the fall and winter months.
Activities:

↗ **In summer, the male ruddy duck has a bright blue bill.**

Keen birders from the Calgary area sing the praises of Frank Lake. Located just 50 kilometres south of the city, and only 6 kilometres east of High River, the shallow lake is part of a restored wetland that has had an uncertain existence. Over the past century the lake has dried up a couple of times but with the help of Ducks Unlimited, industry and government, a long term solution to create sustainable water levels is finally in place.

You might be a little surprised when you drive up to the lake for the first time. Hydro poles and wires dot the landscape. It's not a promising first impression. But drive to the end of a dirt road and walk the short distance to a strategically placed bird blind via a walkway over a cattail filled marshy area and the magic begins to unfold. Depending on the time of day and the season, you may see a huge number of the 194 bird species sighted at Frank Lake. There's a little bit of luck required too as frequent birders say the birding can change substantially from hour to hour.

Frank Lake is a haven for a significant number of waterfowl and shorebirds, particularly during the spring and fall migration. From the bird blind in spring you may see rafts built of plants by the eared grebes as a place to lay their eggs. Look for California gulls, ring-billed gulls, common terns and the black-crowned

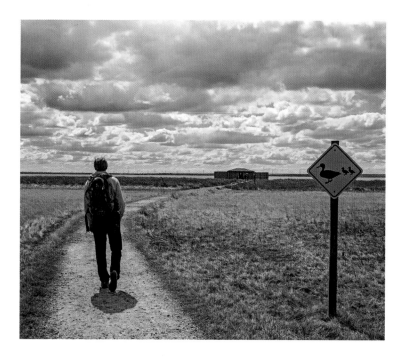

night heron, all of which breed here. Others speak of Northern harrier sightings, rafts of trumpeter swans in spring and sightings of sora and the white-faced ibis. There is no shortage of Canada geese,

On an early spring visit we were treated to ruddy ducks, American coots, cinnamon teals, blue-winged teals, Northern shovelers, lesser scaups, mallards and large numbers of avocet that flew so close overhead we could hear their wings beating. Muskrats swam by the blind, a killdeer did her best to move us away from her nest and the yellow headed blackbirds sang their hearts out. The bat box built adjacent to the blind for the little brown bat was quiet but come summer bats can be seen

flying overhead catching and eating seven to eight insects a minute.

You can head out into the fields and low-lying meadows or walk to another section of the basin for a different vantage point.

The Frank Lake area is composed of three basins with 4,800 acres of dry and flooded habitat. There are several roads that offer access to other basins but most are passable only in dry conditions.

If you truly love birds you could easily spend a full day in the area. Take a lunch and bring warm clothing as the wind can howl through here. At the blind, talk to the local birders. You'll learn a lot.

↑ The American coot nests on a floating platform made of the stems of marsh plants.

↑↑ Photographers at the blind.

↖ Walking to the bird blind at Frank Lake.

Horseshoe Canyon Drumheller

This glacier carved landscape is a dramatic introduction to the badlands near Drumheller.

What Makes This Spot Hot?

- Stunning badlands landscape featuring rock layers dating back 70 million years.
- Three unique ecosystems—badlands, prairie and wooded coulee slopes.
- Wonderful day hiking destination.

Address: Lat: 51.4515° N; Long: –112.888° W
Tel: (403) 443-5541
Website: kneehillcounty.com/2272/Horseshoe-Canyon or natureconservancy.ca
Open: Year round
Activities:

These badlands near Drumheller provide many visitors their first view of the other-worldly landscape of the Canadian Badlands.

Horseshoe Canyon has a way of sneaking up on you. You don't expect to stumble across a magnificent canyon with exposed rock layers dating back millions of years when you are in the middle of the prairies. For many, this isolated pocket about 17 kilometres outside Drumheller is their first view of the Canadian badlands.

This region was once the nomadic territory of the Blackfoot Nation and it was First Nations people who discovered the first fossils in the badlands. They believed the large bones belonged to giant ancestors of the bison and saw the badlands as a graveyard for these ancient creatures.

It was French Canadian explorers Francois and Louis Joseph de la Verendrye who first described the landscape as "mauvaise terre," or "bad earth." Since the area had little agricultural value for early settlers, the name "badlands" stuck.

Today the area is valued for its fascinating geology and the abundance of dinosaur fossils. It's been estimated that the exposed layers of canyon

wall date back to the Creta-
ceous period 70 million years
ago. There are three unique
ecosystems in the canyon:
badlands, prairie and wooded
coulee slopes. Each ecosystem
has its own distinct plants
and animals. Here you can still
see the wild prairie grasses
that once fed the plains bison.
You'll also see white spruce,
Saskatoon berry bushes and
wild roses as well as several
species of cactus and wild sage.
Watch for mule and white-
tailed deer, coyotes and rabbits.
Keep an eye on the sky for
golden eagles, prairie falcons

↑ **An aerial view of Horseshoe Canyon.**

→ **Hiking is the best way to see the
eerie landscapes in Horseshoe
Canyon.**

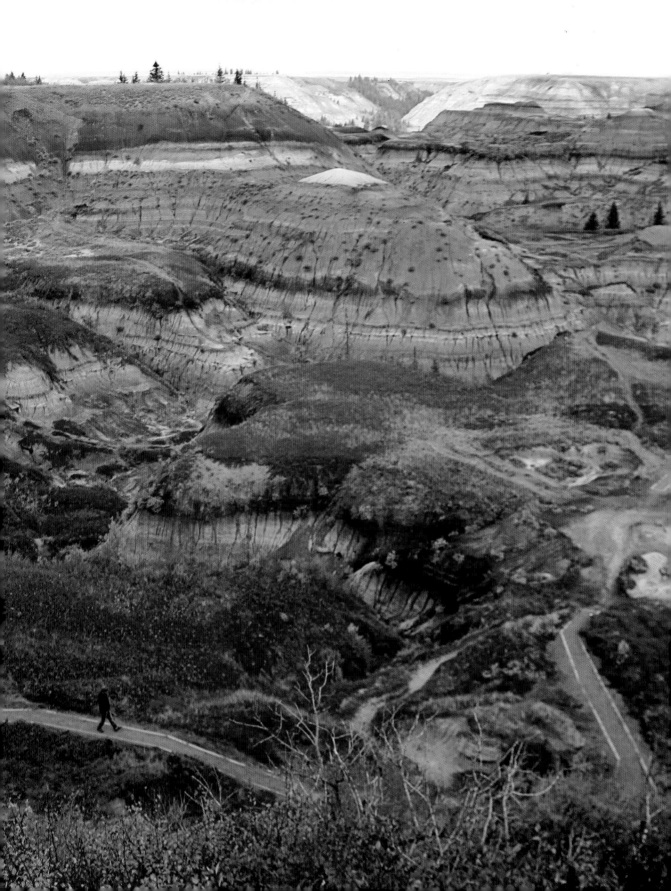

and mountain bluebirds.

A portion of the western side of Horseshoe Canyon is owned by the Nature Conservancy of Canada. It purchased 130 hectares of land from the Nodwell family in honour of Leila Nodwell who worked as an interpreter in the canyon. In 2016, Kneehill County purchased the land containing the canyon and agreed to continue the long-term preservation of the canyon. Since the purchase, the county has worked to make the canyon safer for visitors by improving the observation decks, building new lookouts and improving parking. A private campground is being built on the south side of Horseshoe Canyon.

↑ **Close proximity to Drumheller makes this canyon a great spot for a family hike.**

← **There are fossils hidden in the exposed layers of rocks.**

Kinbrook Island Provincial Park

Play in the lake or enjoy watching birds from a nature trail that goes into a 200 hectare marsh.

What Makes This Spot Hot?

- Lake Newell is one of the largest lakes in southern Alberta.
- Excellent birdwatching opportunities—white pelicans and other waterfowl, predator birds and song birds.
- Abundant recreational opportunities in all seasons.

Address: Lat: 50.4371° N; Long: −111.9105° W
Tel: (877) 537-2757 (camping reservations)
Website: albertaparks.ca/kinbrook-island
Open: Year round
Activities:

↑ **American white pelican, Kinbrook Island.**

Alberta may be a landlocked province, but that doesn't mean there aren't beautiful beaches to enjoy when the weather gets warm. On a hot summer day, it's common to find families playing on the wide sandy shores of Lake Newell, swimmers in the water, boaters waterskiing and anglers fishing for northern pike and walleye.

At more than 66 square kilometres, Lake Newell is one of the largest and warmest man-made reservoirs in Alberta. The reservoir was created in 1914 as a result of the construction of the Bassano Dam, a major irrigation project. The provincial park sits on the eastern edge of the reservoir

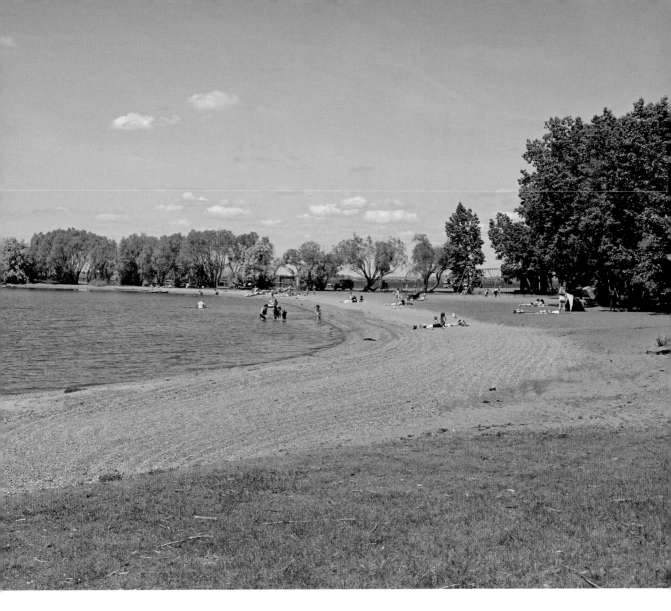

near two man-made marsh areas and features shady campgrounds, playgrounds, picnic areas and walking trails.

The park is popular with birders. The islands in Lake Newell provide undisturbed nesting sites for double-crested cormorants and American white pelicans. A nature trail leads to man-made marsh areas that provide habitat for ducks, coots, rails, bitterns and geese. Other species common in this area include ring-billed gull, California gull, Caspian tern, eared grebe, great blue heron and common tern.

This park is about 12 kilometres south of the city of Brooks in the County of Newell and makes a good base for exploring the badlands. Dinosaur Provincial Park is just a 45 minute drive to the northeast.

↑ **Kinbrook Island Beach is a popular swimming spot in summer.**

Police Outpost Provincial Park and Outpost Wetlands Natural Area

Police Outpost Lake is stocked with rainbow trout and has beautiful views of Chief Moutain

What Makes This Spot Hot?

- Loons, trumpeter swans, sandhill cranes and other species can be observed.
- Diverse ungrazed foothills parkland and rolling grassland habitat with extensive wetlands.
- Excellent trout fishing lake that allows non-motorized and motorized fishing boats (up to 12 kilometres/hr).

Address: Lat: 49.0045° N; Long: –113.4649° W
Tel: (403) 653-2522 (Police Outpost Provincial Park) (403) 382-4097 (Outpost Wetlands Natural Area)
Website: albertaparks.ca/police-outpost; albertaparks.ca/outpost-wetlands
Open: May 1 – October 15
Activities:

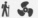
↗ **White pelican landing.**

Tucked away in the southern corner of the province near the American border, Police Outpost Lake is known for its rainbow trout. It's the perfect spot to enjoy a day of fishing and paddling or to simply sit back and observe the many moods of the iconic Chief Mountain across the border in Montana's Glacier National Park.

The park gets its name from the fact that the North-West Mounted Police established a post here in 1891. The area was a favoured route for whiskey runners and the North-West Mounted Police were brought in to establish law and order on the frontier. Four men were originally posted to a small building that once stood in the grassy clearing on the southwest side of the lake. Unfortunately, the remote location made it difficult to get recruits to continue to serve there. The post was closed in 1899 and then reopened in 1902

with a single officer posted there until 1909 when it was permanently closed.

The park is home to more than 50 species of birds and 240 species of vascular plants. Extremely rare William's miterwort flowers can be found in this park as well as the rare western blue flag iris. Both are considered species at risk. It's been estimated that there are less than 10,000 western blue flag plants in all of Canada. If you visit in June, you'll see an abundance of blue camis flowers. *Camassia* is a genus of plants in the asparagus family and the bulbs were once an important food staple for First Nations people.

Outpost Wetlands Natural Area is located just west of the provincial park. The Nature Conservancy of Canada provided funding for the acquisition of this important natural area. There is an abundance of birds in the wetlands, the lake and the two ponds on the southern edge of the lake. Species include the trumpeter swan, sandhill crane, mountain bluebird, common loon, eastern kingbird, American goldfinch and common snipe. You can also see other species like red-necked grebes, ducks, bitterns and pileated woodpeckers in this area.

→ **Chief Mountain dominates the horizon.**

Red Rock Coulee Natural Area

The naturally formed red rock sandstone concretions are some of the largest in the world

What Makes This Spot Hot?

- Otherworldly landscape and a photographer's dream.
- Red Rock coulee badlands.
- Red sandstone concretions litter the landscape.

Address: Lat: 49.6541° N; Long: –110.8705° W
Tel: (403) 893-3777 or (403) 528-5228
Website: albertaparks.ca/red-rock-coulee
Open: Year-round access
Activities:

→ **Some of the largest red sandstone concretions in the world are found here.**

Located off a dusty, dirt road in what feels like the middle of nowhere, but is in fact eastern Alberta, sits the otherworldly Red Rock Coulee Natural Area. From the highpoint at the parking lot you can sometimes see Montana's Sweet Grass Hills, about 100 kilometres away. Though just 324 hectares in size, Red Rock Coulee has got a big reputation, especially among geologists and photographers. It's also a special place for hikers who love to explore; you won't find any marked trails here.

Red Rock Coulee is the home of red spherical rocks up to 2.5 metres in diameter lying on the surface in an enchanting landscape of big prairie skies and open spaces. These large round rocks are iron-rich concretions that formed in place in the 75 million year old Bearpaw Formation. They resist erosion more than the surrounding rock and so end up as large spheroids partly

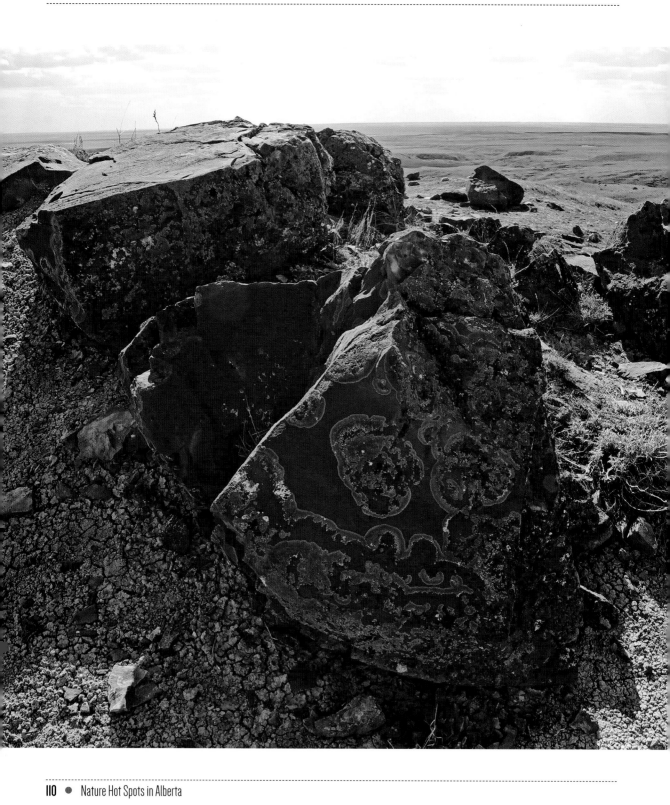

← **Visit Red Rock Coulee at sunrise or sunset, when the light provides for the best photographs.**

exposed or sitting on the surface. The concretions are some of the largest on the planet and photograph best in the magic light of sunrise and sunset.

Concretions start with a natural occurring nucleus like a bone or shell, akin to pearls but much bigger and not as pretty. They are thought to grow by the concentric deposition of minerals both in and around the sand grains and the nucleus before it's solidified as rock. In some concretions in the coulee you can actually see the concentric rings. And the landscape here is literally peppered with concretions left behind as the softer surrounding rock eroded away. Most of the concretions are now covered in beautiful but tough-as-nails lichens called *Xanthoria* that can withstand extremes of temperatures from –46°C to 42°C.

The biggest reason to go to Red Rock Coulee is to see the concretions, but the area is also home to grasslands, badland scenery, hoodoos, lots of wildlife and an array of vegetation including some hardy wildflowers. You'll encounter juniper and sagebrush along with prickly pear cactus, prairie crocus, broomweed and gumbo primrose.

Wildlife is plentiful especially mule deer, pronghorn antelope, coyotes, Richardson's ground squirrel and white-tailed jack rabbits. Birding is also good. Look for grasshopper sparrows, lark bunting, horned larks, western meadowlark and the common nightjar. On the way to Red Rock Coulee, check out the ponds along the highway for ducks, avocets and horned grebes. If you venture out hiking, be very aware of where you put your hands and feet, for this is rattlesnake country. You might see a bull snake or a short-horned lizard but only rarely a scorpion.

To reach Red Rock Coulee drive 60 kilometres south from Medicine Hat via Highways 3 and 887. The closest hamlet is Seven Persons, a clue perhaps to the fact there are no services, food or washrooms in the area. The entrance, though low-key, is marked.

Silver Sage Conservation Site

Pronghorn antelope roam free on the shortgrass prairie

What Makes This Spot Hot?

- Conservation efforts are focused on restoring native prairie grasses to this site.
- Important habitat for prairie birds like greater sage grouse and Sprague's pipit.
- Possibility of seeing a variety of grassland species such as ferruginous hawk, sharp-tailed grouse, swift fox and pronghorn antelope.

Address: AB-501, Onefour, AB T0K 1R0
Tel: (877) 969-9091
Website: albertadiscoverguide.com/site.cfm?grid=F4&number=16
Open: Year-round
Activities:

There was a time when southern Alberta was a fenceless prairie covered with native grasses and sagebrush. Plains bison roamed free and the land teemed with deer, elk, antelope and prairie birds. Hundreds of male sage grouse gathered each spring in leks, or display grounds, to perform a unique courtship display for attentive females.

When European settlers came and the land was divided, fenced and tilled for crops, native prairie grassland began shrinking and along with it the habitat for many species of plants, birds and animals.

The greater sage grouse became one of Canada's most endangered species. In 1996, Canada's sage grouse population was estimated to be 777, but by 2014 that estimate had dropped to 100.

For some time now, environmental groups, individuals and government organizations have been working together to restore the dwindling native grasslands that provide important habitat for prairie birds and animals. The Silver Sage Conservation Site is

the result of those efforts. Situated in the heart of the greater sage grouse range, this 2,371 acre site was purchased through collaboration between governments and individuals.

Ongoing efforts are being made to restore cropland back to native grassland to benefit populations of greater sage-grouse and other grassland species and those efforts seem to be paying off. Spring bird counts have been improving.

Visitors who explore the area on foot may see mule deer, white-tailed deer, pronghorn antelope and grassland birds like greater sage grouse, Sprague's pipit, ferruginous hawk, and sharp-tailed grouse.

↗ **A male greater sage grouse with full mating display.**

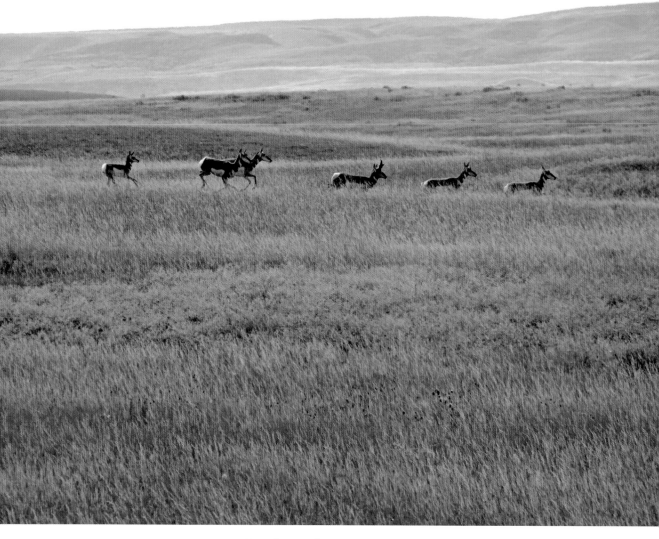

Other grassland species to watch for include badger, swift fox and prairie rattlesnake. On the wetland area it's common to see northern pintails, mallard and a variety of songbirds.

The decrease in habitat for prairie species is a man-made problem. Silver Sage Conservation Site is a man-made solution and proof that conservation efforts really can make a difference.

↑ Pronghorn antelope.

→ Ferruginous hawk searching for food.

Wild Rose Conservation Site

The rolling terrain is a haven for plants and animals of the foothills fescue grasslands.

What Makes This Spot Hot?

- Provides habitat for at least 44 different kinds of animals including several at-risk species.
- Beautiful wildflowers in June.
- Great place to go for a nature walk.

Address: Quarter Sections: NW/NE-25-003-23-W4M, NW/NE/SW/SE-36-003-23-W4M
Tel: (877) 969-9091
Website: albertadiscoverguide.com/site.cfm?grid=F3&number=19
Open: Year-round
Activities:

↑ **Northstar checkered white butterfly.**

↑ **Rare white prickly wild rose.**

The 960 acres of rolling natural fescue grassland at this site is beautiful at any time, but particularly in June when lupines and other wildflowers bloom. It's a wonderful place for a day hike or nature walk.

This spot on the Milk River Ridge outside Magrath provides habitat for a wide variety of flora and fauna including several at-risk species of grassland birds. Some of the at-risk species include the ferruginous hawk, burrowing owl, Sprague's pipit and loggerhead shrike. It's common to see mule deer, white-tailed deer, coyote and sharp-tailed grouse here.

There was a time when native grasslands covered nearly 2.6 million kilometres of North America, but much of the native grassland has been converted to cropland. This is part of the reason that many grassland species are now at-risk.

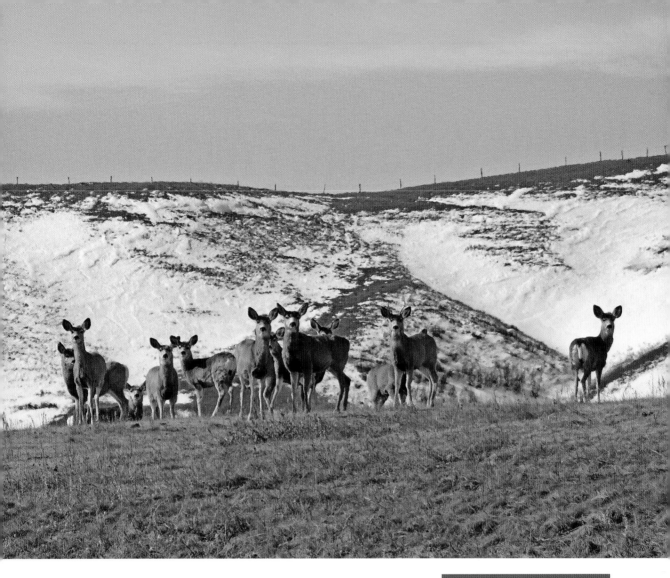

↑ **Mule deer.**

Most people know that forests and trees are important for reducing carbon in the environment, but native grasslands also help the environment by sequestering carbon in the soil. Scientists have only recently realized the importance of native grasslands on a global scale. Grassland is purported to store more carbon on a per area basis than any other ecosystem on earth. Preserving native grassland sites like this one is critical on many levels. Wild Rose Conservation Site provides essential habitat for grassland plants, animals and birds, but it's also globally significant in the effort to reduce the greenhouse effect caused by excess carbon dioxide in the atmosphere. It's also important as a place for nature lovers to get out and experience the beauty of the natural world.

Writing-on-Stone Provincial Park – Áísínai'pi National Historic Site

Surrounded by prairie grassland, this spectacular valley along the Milk River has long been sacred to First Nations and contains many ancient petroglyphs and pictographs

What Makes This Spot Hot?

- National Historic Site containing the largest concentration of First Nation petroglyphs (rock carvings) and pictographs (rock paintings) on the great plains of North America.
- Interpretive programs include storytelling, traditional games, guided tours and wildlife presentations.
- Spectacular sandstone rock formations and unique flora and fauna.

Address: Lat: 49.0851° N; Long: –111.6159° W
Tel: (403) 647-2364
Website: albertaparks.ca/writing-on-stone
Open: Year-round
Activities:

A mysterious energy is concealed in the fascinating landscape of Writing-on-Stone Provincial Park. You feel it when you walk among the sandstone hoodoos and gaze at the Sweetgrass Hills that hug the horizon. It's intangible and yet it's not. The Blackfoot believe that all things within the world—even rocks—are charged with supernatural power. To them this land is sacred and the hoodoos are home to powerful spirits. In the past it was a place that young warriors came to fast and pray on vision quests - some recording their spirit dreams as pictographs and petroglyphs. Many of these living traditions continue to be practised at Writing-on-Stone / Áísínai'pi.

Tucked away in the southeast corner of Alberta, near the Montana border, this special spot contains the largest collection of rock art on the North American Plains dating back thousands of years. Historians believe First Nations people created rock art to depict hunts, battles and important events like vision quests. But according to Blackfoot legend, the rock art at Writing-on-Stone comes from the spirit world. It is a place they still return to for spiritual guidance.

Rock art is the big attraction here. Even though access to most sites is restricted, park interpreters can take you to places where you can view

→ **Ancient Petroglyphs on sandstone.**

↑ **Kayakers exploring the river.**

→ **The eroded landscape at Writing-on-Stone Provincial Park.**

examples for yourself.

The unusual terrain of the park supports many rare species of plants and animals. Pronghorns roam the grasslands, and raccoons and beaver can sometimes be seen on the river or in ponds. Bobcats, mule and white-tailed deer can be found in the coulees. It's not uncommon to see bull snakes and prairie rattlesnakes in the park and it's important to stay on trails and watch where you are walking and sitting.

Visitors can enjoy a wide variety of recreational activities. Paddling or floating the Milk River in a canoe or tube is a marvelous experience and there is a small sandy beach area along the river's edge that is lovely on a warm summer day. The campground is equipped with RV and tent sites.

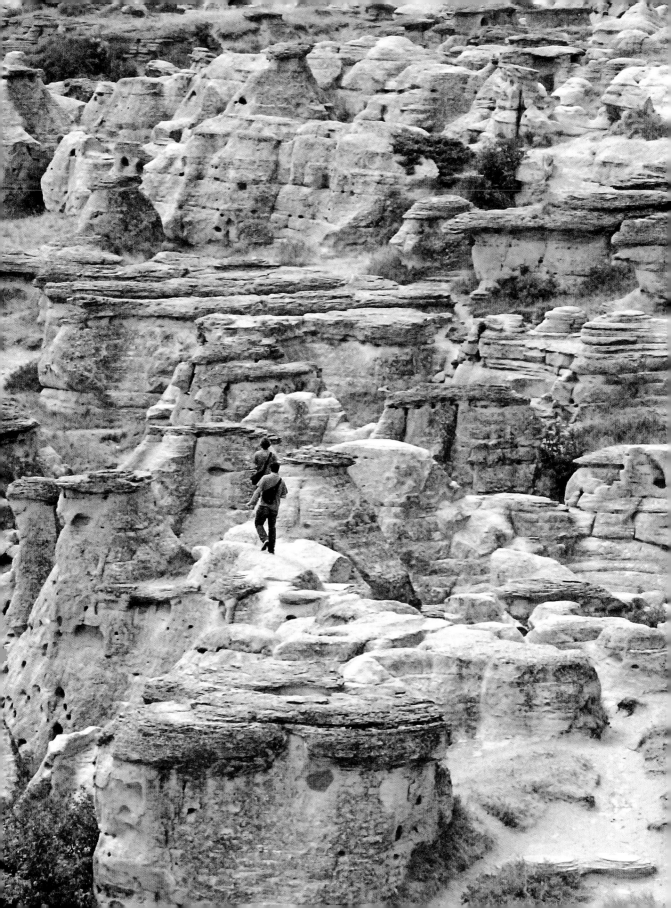

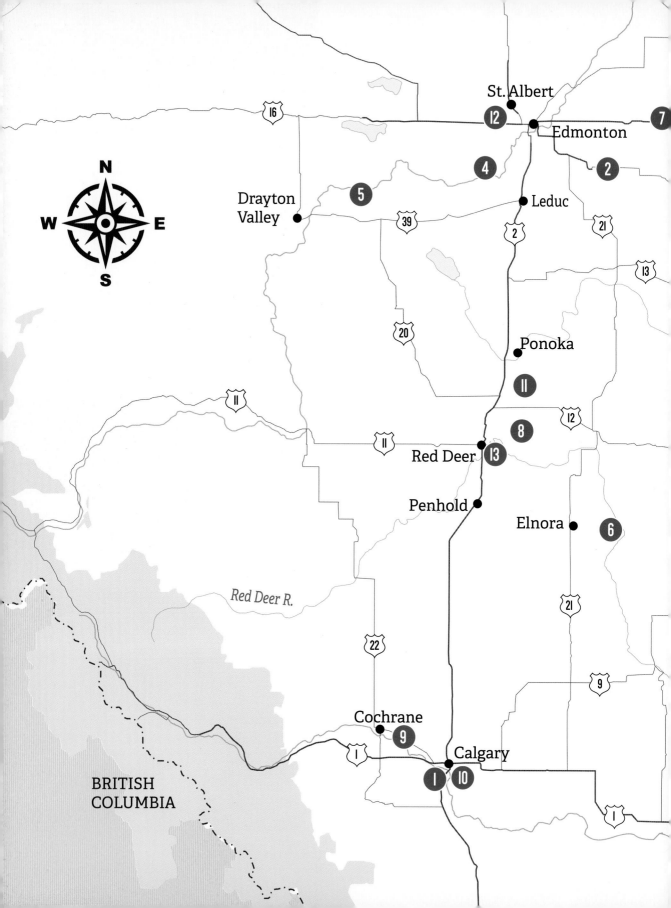

Calgary and Edmonton

Ann and Sandy Cross Conservation Area

Beautiful hiking close to Calgary with lots of opportunities to see wildlife

What Makes This Spot Hot?

- Large tracts of native prairie.
- Diverse wildlife and lots of it, especially big mammals.
- Wonderful hiking with mountain, prairie and city views.

Address: #20, 194001 160th Street West, Foothills, Alberta T1S 4K9
Tel: (403) 931-1042
Website: www.crossconservation.org
Open: 4 AM – 11 PM seven days a week.
Activities:

↗ *Thermopsis rhombifolia*, also called buffalo bean, flowers between April and June.

The Ann and Sandy Cross Conservation Area protects 4,800 acres of rolling foothills just south of Calgary. Sandy Cross, the son of A.E. Cross, one of the four founders of the Calgary Stampede, along with his wife, Ann donated the land in two parcels. The first in 1987, of almost 2,000 acres, was the largest land donation ever made in Canada at the time. The second donation in 1996 added an additional 2,800 acres for the protection of wildlife habitat and conservation education.

The land is truly beautiful. While some of the property was farmed and ranched there are large swaths of native fescue grassland, primarily on the untouched rolling hills. Stands of aspen cover almost 50 percent of the property. Most of the rest of the land is pasture covered with Brome grasses from the days it was farmed. Over 400 types of plants have been recorded here.

Approximately 20 kilometres of trails weave through the conservation area. Most of the hikes are family-friendly loops. The 4.8 kilometre Fescue Trail is a good first choice as it offers a bit of everything including excellent views of the front range of the Rockies, the skyline of downtown Calgary, and rolling hills dotted with wildflowers in spring and early summer. There are regular sightings of elk, especially in winter, and a blaze of colour when aspens put on their fall display.

Other hiking choices include the new 8.6 kilometre Paradise Trail, sections of which were formerly part of the Pine Creek Trail which is now

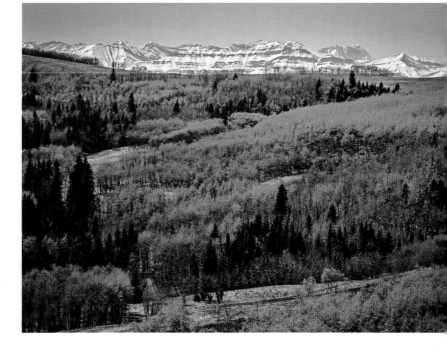

permanently closed so wildlife aren't pushed to the fringes of their habitat. The 2.2 kilometre Mountain Lookout Trail, the 3.5 kilometre Aspen Loop Trail and the 3.6 kilometre Rancher's Trail are other good choices. For all hikes bring water as none is available on the trails.

Animals are frequently sighted in the conservation area. Large mammals include black bear, elk, white-tailed and mule door, moose and even cougar. Almost everyone will see the Richardson's ground squirrel but some of the smaller rodents like the thirteen-lined ground squirrel and red-backed vole are less visible. Birdlife is

also excellent especially for raptors like red-tailed hawks that live at the edges of the woodland. It's also one of the best places near Calgary to see the mountain bluebird.

The Ann and Sandy Cross Conservation Area receives approximately 10,000 visitors a year along with 5,000 school children who are hosted as part of the Open Minds Program. To reduce the impact on the land visitors are asked to leave their pets at home. In winter, snowshoeing is allowed but cross-country skiing is not. Join their mailing list if you want to be informed of special events like Mother's Day yoga and stargazing nights.

↑ The landscape becomes a study in shades of green in the spring.

↖ Prairie crocus, one of the first signs of spring.

↓ Visitor on the lookout for mountain bluebirds.

Beaver Hills Biosphere

This UNESCO designated biosphere reserve encompasses 1,572 square kilometres of predominantly natural landscape east of Sherwood Park.

What Makes This Spot Hot?

- There are 35 lakes and almost 700 campsites within the biosphere.
- The Beaver Hills Biosphere is a distinct geomorphological feature.
- Supports both boreal forest species and parkland species including up to 48 mammals, 152 birds and 8 amphibians and reptiles.

Address: Lat: 53.322° N; Long: -113.009° W (Ministik Lake Game Bird Sanctuary)
Tel: (780) 464-8117
Website: beaverhills.ca
Open: Year-round
Activities:

↗ **Rent a Discovery Pack at the Miquelon Park Centre and go on a family adventure.**

In 2016, UNESCO designated the Beaver Hills as an international biosphere reserve. Canadian biosphere reserves encourage conservation and sustainable development through the promotion of sustainable tourism, research and education, the support of ecosystem services and the implementation of responsible land management. From start to finish, it takes about a decade to receive the designation as a biosphere reserve and it is reviewed every 10 years to ensure program criteria are still being met.

The Beaver Hills Biosphere is a distinct geomorphological region that encompasses 1,572 square kilometres of land east of Sherwood Park. The biosphere reserve comprises an "island" of dry mixedwood boreal forest that overlies what is described by naturalists as the hummocky "knob and kettle" terrain of the moraine—basically a patchwork of wetlands, small lakes and streams. There are several federal and provincial protected areas located entirely within the Beaver Hills. Key ones include Elk Island National Park, the Ministik Bird Sanctuary, Cooking

Lake—Blackfoot Provincial Recreational Area, Miquelon Lake Provincial Park, Golden Ranches, Hicks, Strathcona Wilderness Area and North Cooking Lake Natural Area.

The Beaver Hills Dark Sky Preserve is also within this biosphere. The 300 square kilometre dark sky preserve encompasses Elk Island National Park, Miquelon Lake Provincial Park and Cooking Lake-Blackfoot Provincial Recreation Area.

↑ **Snow kiting on Miquelon Lake.**

Ministik Lake Game Bird Sanctuary

When it was established in 1911, the Ministik Lake Game Bird Sanctuary was Alberta's first provincial bird sanctuary. The 7,349 hectare site contains a variety of informal trails plus one marked trail that is a great place for a nature walk. Look for white pelicans, blue herons, bald eagles, horned grebe, ducks, and a wide variety of waterfowl and songbirds. You might also see moose, deer, small mammals, coyotes and wolves. (ealt.ca/ministik)

↑ **Young visitors enjoy Miquelon Lake.**

Blackfoot Provincial Recreational Area

This 97 square kilometre recreation area contains a wide variety of terrain that supports an equally wide variety of recreational pursuits. There are more than 170 kilometres of trails that can be used in all seasons. This area is the site of the annual Canadian Birkebeiner Ski Festival, the largest classic-style cross-country ski festival in Canada. It's also a great destination for hiking, mountain biking, horseback riding, snowshoeing and dogsledding. In summer, look for nesting pairs of trumpeter swans and other waterfowl. You might also see coyote, deer, elk, fox, moose and lynx. (albertaparks.ca/cooking-lake-blackfoot)

↑ **The pine grosbeak is a large boreal finch.**

↖ **Great blue heron at Miquelon Lake Provincial Park.**

Miquelon Lake Provincial Park

Explore this park on one of the many mountain biking trails or enjoy the paved shoreline path that is suitable for strollers, wheelchairs, bicycles and rollerblades. At the Miquelon Adventure Centre, you can rent a family discovery pack for a small fee and learn about the plants and animals in the park. Miquelon Lake plays host to some of the events at the annual Beaver Hills Dark Sky preserve Star Party. (albertaparks.ca/miquelon-lake)

Golden Ranches Conservation Site

Located on the east shore of Cooking Lake, this 1,350 acre conservation area provides a home for many bird species and serves as a staging area for migratory birds. Look for birds as you walk along the 8 kilometres of shoreline. The upland habitat is a mixture of aspen forest and open grassland that provides habitat for a variety of wildlife including white-tailed and mule deer, moose, grouse, porcupine and a variety of small mammals and songbirds. (ealt.ca/properties/golden-ranches)

Big Knife Provincial Park

Located in the Battle River Valley, this park has a variety of landscapes including some badlands

What Makes This Spot Hot?

- One of the few remaining relatively undisturbed remnants of the Battle River Valley.
- Contains a variety of landscapes, plants and animals.
- Steep exposures of Cretaceous sedimentary bedrock create local badlands topography.

Address: Lat: 52.4893° N; Long: −112.2196° W
Tel: (403) 742-7516
Website: albertaparks.ca/big-knife
Open: Year-round
Activities:

Venturing off the beaten path has its rewards in this gem of a park in east central Alberta halfway between Camrose and Coronation. At almost 300 hectares in size, the park protects valuable riparian areas along the Battle River and the lower reach of Big Knife Creek. Within its borders are a wide variety of landscapes including a small area of local badlands.

This region of the Battle River Valley was originally Blackfoot territory. Big Knife Creek, which lies within the park, gets its name from a legendary fight to the death that occurred near the creek. The fight was between a member of the Cree tribe named "Big Man" and "Knife," a member of the Blackfoot tribe.

Anthony Henday was the first European to explore the Battle River valley. He crossed the river near the mouth of Big Knife Creek while searching for bison in 1754. Henday was instrumental in establishing the fur trade in this part of Alberta. The Palliser expedition also passed through this area in 1858 and camped along

Big Knife Creek. In his journal, Palliser noted the badland formations and coal seam exposures.

Today, visitors can enjoy hiking through the park's varied landscapes. There's a Highland Trail (6 kilometres return) that, as the name suggests, has steep inclines but offers panoramic views of the Battle River Valley. The Lowland Trail (4.5 kilometres return) has views of the river and the hoodoos.

Birdwatchers can see a

↗ **Northwestern fritillary butterfly.**

↑ **The Big Knife badlands.**

variety of species including some less common ones like the American white pelican, ferruginous hawk, short-eared owl and the threatened loggerhead shrike.

The park provides important habitat for several amphibians including the threatened northern leopard frog. You might also see white-tailed deer, mule deer, moose, coyote, red fox, American badger, beaver, muskrat and a variety of other mammals.

DID YOU KNOW?

In the 1920s and 30s, a local character named Jack Nelson operated a secret commercial still from a homestead on the eastern end of the park. The provincial park was established in 1962 and the still remained hidden until 1965, when a park ranger discovered it.

Clifford E. Lee Nature Sanctuary

This nature sanctuary protects 348 acres of marshland, aspen parkland and pine forest southwest of Edmonton

What Makes This Spot Hot?

- More than 100 bird species can be seen in the sanctuary.
- You may see a wide variety of wildlife, including North America's smallest mammal, the pygmy shrew, and one of its largest—the moose.
- Peaceful retreat with a lovely boardwalk and walking trails.

Address: 51274 Range Road 264
—Parkland County
(Lat: 53.4131° N;
Long: -113.7874° W)
Email: info@cliffordelee.com
Website: cliffordelee.com
Open: Year-round
Activities:

→ **American coot and babies. Coots are closely related to the sandhill crane.**

→ **The viewing platform provides a close-up look at nature.**

About 33 kilometres southwest of Edmonton is a lovely little spot to escape into nature. The Clifford E. Lee Nature Sanctuary protects 348 acres of marshland, open meadow, aspen parkland and pine forest. It's a popular spot for birdwatchers, and more than 100 species of birds can be found in the park at different times of the year. Notable species include the red-necked grebe, American coot, tundra swan, bald eagle, red-tailed hawk, great horned owl and many species of ducks.

The varied terrain provides a habitat for many different species of plants and animals. A few of the mammal species visitors might see include muskrat, pygmy shrew, snowshoe hare, coyote, red fox, moose, deer and porcupine. In the spring, you can look along the trails for wildflowers beside the trails like bog violet, evening primrose, paintbrush, western wood lily and wintergreen, to name a few.

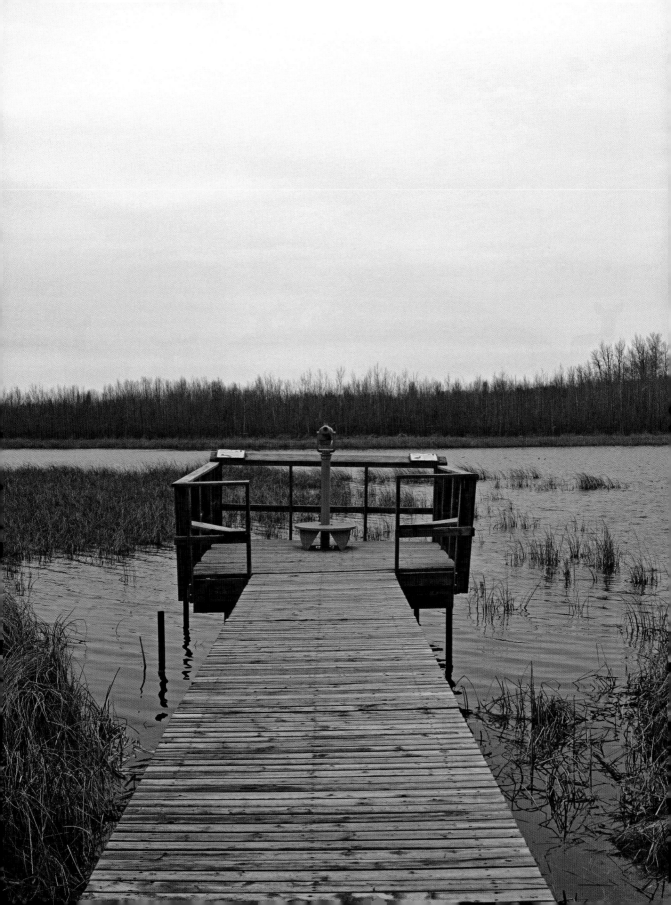

↑ **Red-winged blackbird.**

↑↑ **The entrance to the nature sanctuary.**

→ **Well-kept trails and wide boardwalks make the sanctuary a perfect spot for a family nature walk.**

There are four main trails through the sanctuary. The Boardwalk Loop features a raised boardwalk along the edge of a marsh with several large viewing platforms. It passes through cattails and willows, and includes interpretive signage to help visitors identify the birds they may see along the way. The boardwalk is wide, but it does not have railings so parents need to be careful that children do not fall off. The three other trails in the sanctuary lead through an aspen forest, a jack pine forest and a mixed forest of poplars, paper birch and white spruce. Look for wildflowers and wildlife in the forest clearings and along the trails.

There's a picnic area, some benches and a pit toilet. Water, toilet paper, hand sanitizer, bug spray and binoculars are good items to have in your day pack. If you bring some bird seed, you may get the chickadees to eat right out of your hand.

Coyote Lake

This hidden gem of a natural area about 100 kilometres southwest of Edmonton is in one of the richest biological areas of Alberta

What Makes This Spot Hot?

- Biologically diverse area that provides habitat for 22 mammal species, 154 bird species and 362 documented plant species.
- Important bird breeding habitat that provides exceptional birdwatching.
- Contains features of the boreal forest, central parkland and Rocky Mountain natural regions.

Address: Lat: 53.2542° N; Long: -114.5366° W
Tel: (403) 748-3939
Website: albertaparks.ca/coyote-lake
Open: Year-round
Activities:

In the early 1970s, Doris and Eric Hopkins purchased land in the Coyote Lake area through a Canadian Pacific Railway auction. They intended to use the property as a retirement getaway, but it didn't take long for them to realize the value of the land as a natural area. The couple was impressed with the natural beauty of the property and the wide array of birds, animals and plants found there. When a study found no effects of industrial or agricultural pollution on the property, they knew it had to be preserved. In 1996, they donated their land to the Nature Conservancy of Canada (NCC) to assist with the creation of the Coyote Lake Conservation Area. Their donation combined with donations from neighbouring landowners, lands purchased by the NCC as well as lands designated as protected natural area by the provincial government resulted in more than 850 hectares of land being conserved in this area.

Coyote Lake is a beautiful place to get out into nature without running into crowds of other people doing the same thing. This hidden gem of a park provides important breeding habitat for a wide variety of birds and is an excellent spot for birdwatching. Look for trumpeter swans, pelicans, great blue heron, red-necked grebe, common loon and ring-necked duck on and near the lake.

In the forested areas you

↗ **A walking trail through a treed area near the lake.**

can see a wide variety of songbirds including white-throated sparrows, eastern kingbirds, least flycatchers, pine siskins, Tennessee warblers and more. At the site you'll find about 7 kilometres of basic trails leading to meadows, ponds and overlooks. Mammal species that might be encountered include deer, elk, moose, coyote, black bear and beaver.

The flora is also very diverse and includes several rare and uncommon orchids among other species. The Columbian watermeal is an aquatic species that was first recorded in Alberta at this site. Lakeshore sedge is another rare plant that has been seen along the shoreline. Coyote Lake is the only known Alberta location for ducksmeal, a floating plant of the duckweed family.

↑ **Coyote Lake is a great spot to enjoy nature while avoiding crowds.**

Dry Island Buffalo Jump

Escape the crowds and hike or paddle your way through the fascinating landscapes of this hidden-gem provincial park that was once an important hunting ground for the Plains Cree

What Makes This Spot Hot?

- Stunning badlands scenery that includes a buffalo jump used by Plains Cree over the past 3,000 years.
- More than 150 species of birds, including several species of raptors.
- Fossil-rich area—one of the world's most important Albertosaurus bone beds is inside the park.

Address: Lat: 51.09757° N; Long: -112.9581 W
Tel: (403) 823-1749
Website: albertaparks.ca/dry-island-buffalo-jump
Open: May 1–Oct 15
Activities:

The badlands landscape is ablaze with colours during the autumn.

Finding solitude and having a piece of wilderness all to yourself is one of the best reasons to visit this park. It bears a strong resemblance to Dinosaur Provincial Park; there are hoodoos and badlands, a river and aspen-rich woods. The only thing missing is the crowds.

The park itself is a day-use area with several picnic areas and no formal trails. Its interesting name actually has two parts. The buffalo jump was used by the Plains Cree many times over the last 3,000 years. Hunters herded the buffalo and drove them off the cliff as a way of hunting them. This cliff is unique because it

is higher than other buffalo jumps discovered in Alberta. The dry island is the other interesting feature of this park. Thousands of years of erosion from rain and streams has created what looks like a flat-topped plateau covered in prairie grasses. In the midst of the otherworldly landscape of the badlands, it looks like an island. Visitors to the park often make it a goal to get to the top of the island.

What makes this park special is the wide variety of terrain. There's a little bit of everything here—short grass prairie, semi-desert badlands, boreal/mountain forest and aspen forest. You can find

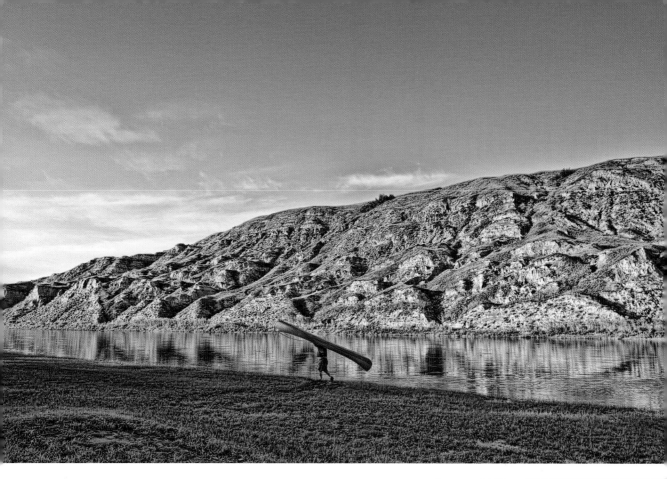

prickly pear cactus growing next to white spruce. This makes for fascinating plant and animal communities.

About 150 species of birds have been spotted in the park, and it's common to see migrating birds of prey along valley cliffs. The badlands provide an ideal habitat for raptor species like ferruginous hawk, golden eagle and prairie falcon. Marsh areas provide a habitat for waterfowl, and many more birds can be found in the deciduous woods.

The park has a launch site that is a good spot to begin a raft, canoe or kayak journey along the Red Deer River. Fur traders and early explorers used the Red Deer River as an important trade and exploration route.

It's not uncommon to see fossils in the park and along the banks of the river. Be warned, however, that fossils and rocks, as well as all plants and animals, are protected in provincial parks. It is illegal to move or remove them. If you spot something interesting, mark the spot and report it to the staff at the Royal Tyrell Museum of Palaeontology. One of the world's most important *Albertosaurus* bone beds is inside the park, and excavations have taken place there in the past.

↑ Wood lilies are a perennial species native to North America.

↑↑ You can canoe on the Red Deer River through the badlands scenery of Dry Island Buffalo Jump.

Elk Island National Park

Just one hour's drive west of Alberta's capital city, this park is an important refuge for bison, elk and more than 250 bird species

What Makes This Spot Hot?

- Great place to see a variety of wildlife, including bison, deer, elk and moose, roaming freely.
- 250 different species of birds have been sighted in the park, from ducks, geese and pelicans to great crested flycatchers and broad-winged hawks.
- As part of the Beaver Hills Dark Sky Preserve and the newly designated UNESCO Beaver Hills Biosphere Reserve, Elk Island National Park is an ideal spot to view the wonders of the night sky.

Address: Lat: 53.5830° N; Long: –112.8365° W
(1 – 54401 Range Road 203 Fort Saskatchewan, AB T8L 0V3)
Tel: (780) 922-5790
Website: pc.gc.ca/elkisland
Open: Year-round
Activities:

↗ **A boardwalk bridge on Lakeview Trail.**

For centuries, bison were at the core of the culture and economy of the indigenous people of the Great Plains. Until the late 1800s, North America's prairies teemed with millions of Plains bison. As a result of western immigration and settlement, industrialization, indiscriminate slaughter and agricultural activities, Plains bison numbers declined catastrophically and the species was nearly lost forever.

Attempts were made to preserve the species, and one of the most successful bison conservation efforts took place in Alberta. In 1907, the Canadian government purchased 410 Plains bison, had them shipped to Alberta from Montana and placed in what was then known as Elk Park. As the herd grew, bison were transported to other national parks. Most of today's surviving Plains bison are descended from this original herd.

Elk Park became Elk Island National Park in 1913. It is Canada's only entirely fenced national park and one of its smallest at 194 square kilometres. It's also one of the few places where you can see Plains and wood bison roaming freely, and learn about the conservation efforts that brought these species back from near extinction.

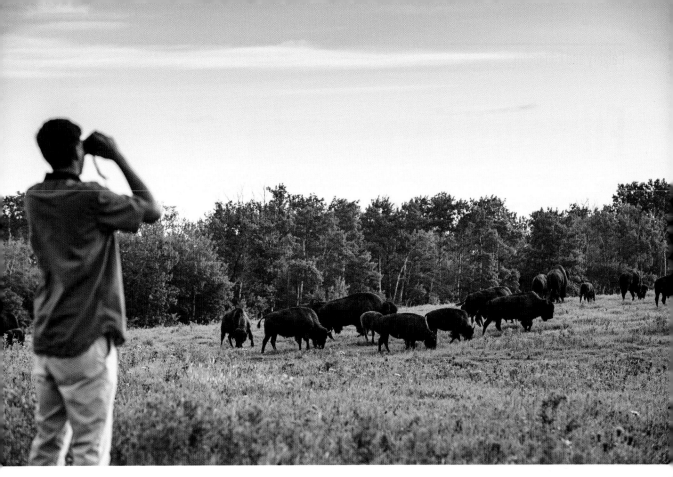

The park is home to the densest population of hoofed mammals in Canada. Plains bison, wood bison, elk, moose, mule deer and white-tailed deer are commonly spotted in the park. Other mammals like the tiny pygmy shrew, porcupine, beaver, coyote and the occasional black bear, timber wolf or lynx may also be seen.

More than 250 bird species can be found in the park throughout the year. In 1987 trumpeter swans were introduced, and the population is healthy and growing. Other notable bird species include the red-necked grebe, double-crested cormorant, red-tailed hawk, American bittern, American white pelican and great blue heron.

Elk Island has more than 80 kilometres of trails that you can hike in summer or use snowshoes and skis to get around on in winter.

The park is also part of the Beaver Hills Dark Sky Preserve. Elk Island hosts an annual star party in early September, where you can learn more about the planets and solar system.

An annual Bison Festival in mid-August features live entertainment, bison products, aboriginal dancing, demonstrations, educational programing, kids' activities and Voyageur Canoe rides.

↑ The sorting pens at the Plains Bison Handling Facility.

↑↑ A visitor observes buffalo at the Bison Loop.

Ellis Bird Farm

Ellis Bird Farm is dedicated to the conservation of mountain bluebirds, tree swallows and other native cavity-nesting birds

What Makes This Spot Hot?

- One of the best spots to see purple martins and other backyard bird species and learn about them.
- Established demonstration NatureScape, providing ideas and inspiration about how to increase biodiversity in yards and gardens.
- Cutting-edge research program tracking purple martin and mountain bluebird migration.

Address: 39502 Range Rd 260, Lacombe, AB
Tel: (403) 885-4477
Website: ellisbirdfarm.ca
Open: Victoria Day (May) to Labour Day (Sept.); Tuesday to Sunday and holiday Mondays 11:00 AM to 5:00 PM; closed Mondays (except for holidays).
Activities:

Hands-on educational programs make learning fun.

Ellis Bird Farm is a one-of-a-kind working farm, non-profit organization, conservation site and birding attraction in the countryside north of Red Deer and east of Lacombe. The site focusses its conservation efforts on purple martins, mountain bluebirds, tree swallows and other native cavity-nesting birds and is an excellent place to see and learn about the backyard birds of Central Alberta.

Ellis Bird Farm was established in 1982 to carry on the legacy of Lacombe-area conservationists, Charlie and Winnie Ellis. The brother and sister pair turned their farm into a haven for wildlife. They rimmed their fields with 300 nest boxes for mountain bluebirds and tree swallows, built and erected houses for black-capped chickadees, purple martins and flickers, established a program for feeding over-wintering bird species and planted extensive

↑ **A purple martin feeds its young.**

orchards and gardens. Charlie became widely known as Mr. Bluebird—a title originally bestowed by Kerry Wood, a well-known Red Deer naturalist.

By the time their farm was purchased by Union Carbide, Charlie and Winnie operated one of the largest bluebird trails in Canada and maintained a huge bird feeding program. They stipulated two conditions for the sale of their land—that "their" birds be looked after, and that the buyer support Ellis Bird Farm, a non-profit organization dedicated to their legacy. Today, a petrochemical complex sits on one corner of the original Ellis homestead. The rest of the farm continues to raise cattle, crops and bluebirds.

Depending on the season and the weather, visitors can expect to see a wide variety of backyard birds, including purple martin, mountain bluebird, ruby-throated

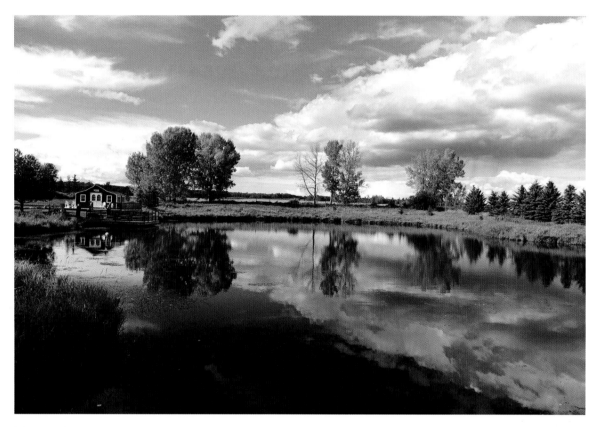

↑ **The great horned owl is the most common owl of the Americas.**

↑↑ **A pond at Ellis Bird Farm.**

hummingbird, pine siskin, American goldfinch, black-capped chickadee, tree and barn swallow, least flycatcher, yellow warbler, cedar waxwing, red-winged blackbird, great blue heron, as well as several species of native sparrows and waterfowl. You might also see great horned owls, North American beavers, short-tailed weasels, snowshoe hares and other wildlife.

The world-class gardens at Ellis Bird Farm have been designed to attract birds and to support native pollinators. There are water gardens, a xeriscape garden, a hummingbird garden and butterfly gardens. Winnie's old orchard, an arboretum of wildlife-attracting trees and shrubs as well as several water features are all linked together with a network of wheelchair accessible trails.

In the visitor centre, you can learn about the history of Ellis Bird Farm, about backyard birds and about the important research going on at the farm. Live webcams allow visitors to watch what's happening inside select nestboxes and with some of the other wildlife.

↑↗→ **Ellis Bird Farm** is home to the
world's largest outdoor collection
of bluebird nest boxes.

↗ **Mountain bluebird.**

Interactive games keep
children engaged and the café
makes a wonderful lunch or
tea stop at the end of a visit.

If you want to see bluebirds,
June is the best time to visit.
The gardens are at their peak
in July and August, and you
should visit before mid-August
if you want to see purple
martins.

Glenbow Ranch

One of Alberta's newest provincial parks, this former cattle ranch near Cochrane protects rare species and endangered ecosystems

What Makes This Spot Hot?

- More than 1,300 hectares of rolling hills with mountain views on the banks of the Bow River.
- 30 kilometres of trails. A paved pathway and special golf cart tours make the park accessible to bicycles, skateboards, rollerblades and people with mobility challenges.
- Preserves rare fescue grasslands as well as many species of plants and animals, including endangered and rare species.

Address: Glenbow Ranch Visitor Centre
Lat: 51.1685° N;
Long: -114.3928° W
Tel: (403) 678-0760
Website: albertaparks.ca/glenbow-ranch
Open: visitor centre hours vary with season, see website for details.
Activities:

Surrounded by a working cattle ranch, this unique provincial park protects more than 1,300 hectares of rolling fescue grasslands along the banks of the Bow River. Golf cart tours on paved trails during peak season make it possible for even those with mobility challenges to appreciate the raw beauty of the foothills of the Canadian Rockies. Interpretive signage along the pathways explains the park's history and describes the flora and fauna.

Glenbow Ranch was home for many years to the Harvie family. Eric Lafferty Harvie (1892–1975) originally established Glenbow Ranch. The name is derived from a town in Scotland and reflects the location of a "Glen by the Bow." Other sites in Alberta also bear the name, including Calgary's Glenbow Museum which was created with the support of Eric Lafferty Harvie. The establishment of Glenbow Ranch Provincial Park was made possible when the children of Neil Harvie sold the land to the Government of Alberta for less than market value to conserve the land and protect it from development. The Harvie family also established a foundation to promote and develop the park.

Two major historical sites lie within the park—Glenbow Quarry and Cochrane Ranch. Cochrane Ranch was the first big Western Canadian cattle ranch and even though it was not successful, it led the way for future successes in the industry. Glenbow Quarry on the other hand was a very successful venture. In its day, the quarry provided sandstone for many important provincial buildings including the Alberta Legislature. More than 150 residents called Glenbow home during the height of the quarry's production.

The park preserves native rough fescue grasslands, an important habitat for many species of plants and animals—some of which are critically endangered. Watch for badgers, weasels, coyotes, deer, elk and cougars—especially at dawn and dusk. Plant and animal checklists are available at the visitor's centre.

The ecological and economic

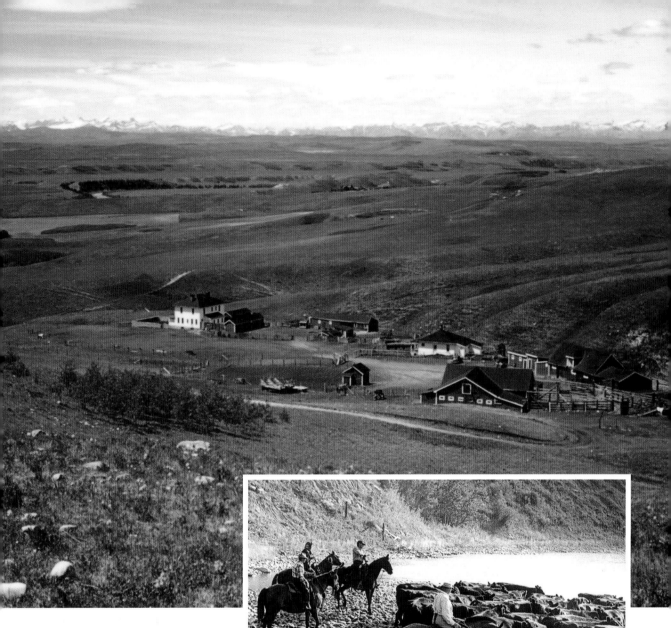

value of native grasslands has been recognized and important research into the preservation and restoration of these ecosystems is taking place inside the park. Interpretive programs help members of the public understand the importance of grassland communities and the need to conserve and restore these ecosystems.

↑ Cattle on Glenbow Ranch in 1946.

↑↑ Glenbow Ranch as it looked in 1958.

Inglewood Bird Sanctuary

A nature oasis just minutes from downtown Calgary

What Makes This Spot Hot?

- It's been a migratory bird sanctuary for over 85 years with over 270 species of birds sighted in that time frame.
- The sanctuary is home to 21 types of mammals.
- Family-friendly walking trails.

Address: 2425 9th Avenue SE, Calgary
Tel: (403) 300-1068
Website: www.calgary.ca/CSPS/Parks/Pages/Locations/SE-parks/Inglewood-Bird-Sanctuary.aspx
Open: The sanctuary is open from sunrise to sunset year-round. The Nature Centre is open daily from 10 AM – 4 PM from May until September, except statutory holidays. From October to April it's open Tuesday – Friday from 10 AM – 4 PM and from noon – 4 PM on Saturday.
Activities:

The Inglewood Bird Sanctuary, located just minutes from Calgary's downtown, is a great place to visit. It's a nice escape from the city and if you're lucky you'll see some of the more unusual types of birds that visit the area.

The bird sanctuary came into being through the efforts of Selby Walker, the son of the original owner, Colonel James Walker whose red brick house you still see on the property. In 1929 he petitioned the federal government to designate 59 acres on the west side of the Bow River as a Federal Migratory Bird Sanctuary. The government agreed, and the rest is history.

In 2013 the sanctuary was hit hard by the Calgary floods. Silt and debris were deposited all over the property; riverbanks were eroded and trails were either damaged or washed away. It's taken several years to recover but now there are new paths and signage along with lots of park benches though the north field remains closed for ongoing remediation.

The sanctuary is very family

↑ **Canada goose chick at Inglewood Bird Sanctuary.**

friendly. Stroll on approximately 2.5 kilometres of trails that meander up and down the sloughs, along a section of the Bow River and through the woods. There's plenty to hold everyone's interest, from catching sight of numerous deer to the antics of baby Canada geese and identifying the birds flying overhead. You'll probably see starlings, magpies and mallard ducks but if you look hard and listen you'll see a lot more. On a Saturday in spring we saw yellow-rumped warblers, Northern flickers, wood ducks, mergansers and hairy woodpeckers. Other birds you'll often see include bald eagles, ring-necked pheasants and Swainson's hawks. It's reportedly the best place in the

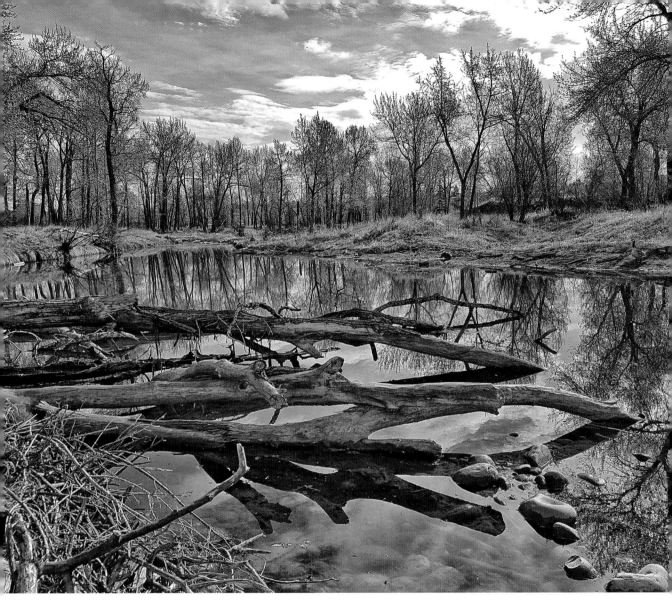

province to see wood ducks.

The Nature Centre offers interpretive exhibits with fun factoids. For example, did you know that magpies are the most intelligent animals in the world and are one of the few that can recognize themselves in a mirror? Bird and animal sightings are updated daily at the Nature Centre, and courses are offered especially for the younger crowd.

↑ The Inglewood Bird Sanctuary is a study in texture in the spring.

← Mule deer are frequently seen in the park.

JJ Collett Natural Area

Take a walk through grasslands, forests and meadows that support a wide variety of plant and animal life

What Makes This Spot Hot?

- Varied topography — hills, meadows, forests, grasslands and wetlands.
- 18 kilometres of maintained trails.
- 300 species of vascular plants, 100 bird species, 20 species of butterflies and 250 species of moths.

Address: Lat: 52.5578° N; Long: -113.6394° W
Tel: (403) 748-3939
Website: jjcollett.com
Open: Year-round
Activities:

▲ **Bunchberry carpet.**

In the heart of the Central Parkland Region, near the tiny hamlet of Morningside, this 635 acre natural area is a wonderful place for a day hike. There are 18 kilometres of maintained trails that take you through rolling grasslands, a wetland, meadows and mixed forests.

Every season has its special delights. Spring brings prairie crocuses on grassy hillsides, fawns in the meadows and ducklings in the marsh. Watch for butterflies and moths on summer walks. There are 20 documented species of butterflies and 250 species of moths in the area. Crisp fall days feature yellow leaves on deciduous trees that fall on the earth and crunch underfoot. In the winter, cross-country ski trails allow visitors to explore a sparkling winter wonderland.

More than 300 plant species have been documented in this natural area, as well as over 100 bird species. Visitors might also see mule deer, white tailed deer, beavers, moose,

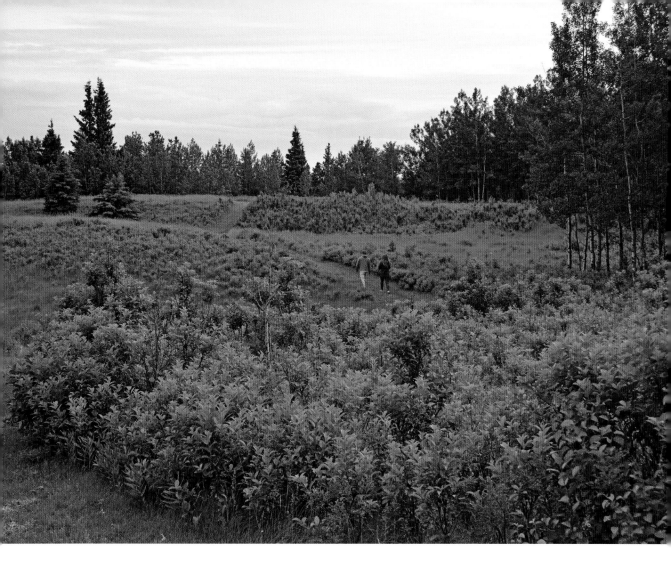

coyotes, porcupines and other animal species common to the parkland region.

JJ Collett Natural Area was established in 1985, on land once owned by John "Jack" Collett. The Collett family sold the land for less than market value to the Alberta government, on the condition that it be preserved as a natural area. The natural area was named after John Joseph Collett, a wildlife technician and the son of Jack, who died in a forestry accident after the land sale.

John Joseph grew up on the land, loved it, and wished for it to be preserved.

Today a volunteer board oversees the natural area and ensures that trails, picnic areas and other features are maintained. Over the years, volunteers have built picnic shelters, a gazebo and a lovely boardwalk that goes through the marshy area of the property.

↑ **A trail through the parkland.**

Lois Hole Centennial Provincial Park

Recognized as a globally significant Important Bird Area, this park protects the freshwater wetland ecosystem of Big Lake

What Makes This Spot Hot?

- More than 220 bird species have been sighted in the park.
- Nearly 1,800 hectares of protected area.
- Trails, an interpretive boardwalk and a wildlife viewing platform let you get close to nature.

Address: Lat: 53.6143° N;
Long: −113.6582° W
Tel: (780) 960-8170
Website: albertaparks.ca/
lois-hole-centennial.aspx
Open: Year-round
Activities:

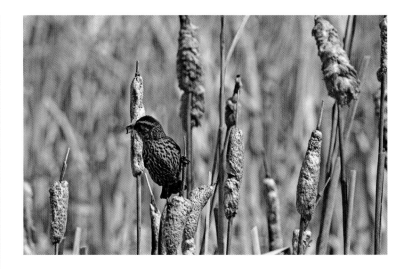

 Female red-winged blackbird eating lunch.

Lois Hole once said: "If we hope to preserve our way of life, the first thing we must do is rediscover our respect for the land, the water and the entire natural world. And if we do manage to regain that respect, then we must make sure that human beings never lose it again."

This unique provincial park was established on April 19, 2005 and named in honour of Alberta's 15th Lieutenant Governor. It was a fitting tribute for a woman who had a great love of nature, education and community.

The park is located 11 kilometres southwest of Hole's Greenhouses and Gardens, the business Lois and her husband Ted established outside St. Albert. Big Lake, about 8 kilometres in length and 3 kilometres at its widest point, makes up more than half of the area of the park. The wetlands provide important habitat for so many bird

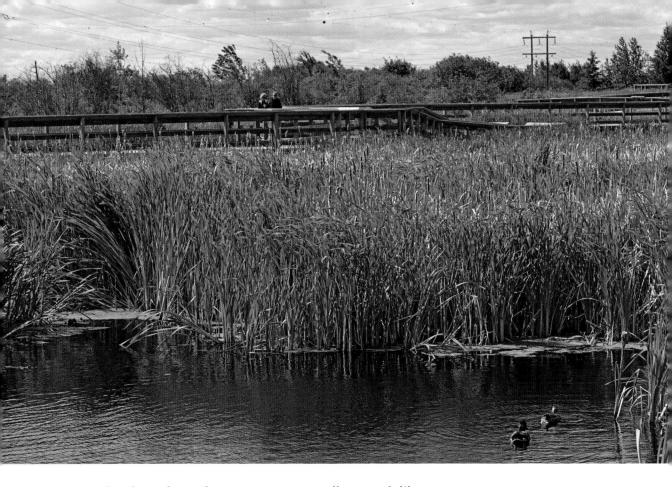

species that the park was designated a globally significant Important Bird Area. More than 220 species of birds have been sighted here. Notable species include the American avocet, black tern, dowitcher, eared grebe, Franklin's gull, loons, northern pintail, pectoral sandpiper, tundra and trumpeter swans, and yellowlegs. Osprey and great blue heron can sometimes be seen feeding on the lake fish which includes northern pike, goldeye, white sucker, walleye and sticklebacks.

As you walk around the lake, you'll see cattails, bulrushes, orchids, ferns and other kinds of vegetation. You might also encounter small mammals like beaver, muskrat, porcupine, red fox, red squirrel and coyotes. Deer and moose can also be seen occasionally.

Autumn is a wonderful time to explore this park. The lake serves as a staging area for migrating waterfowl and as many as 20,000 tundra swans have been seen in the fall. Stand on the viewing platform at the eastern shore of the lake near the mouth of the Sturgeon River and watch the birds. It's a great place to rediscover your appreciation of the natural world—something that would make the park's namesake very pleased.

↑ **The view from the boardwalk.**

Waskasoo Park

Outstanding trails wind their way through an expansive parkland area that includes Alberta's oldest federal migratory bird sanctuary

What Makes This Spot Hot?

- More than 110 kilometres of soft and hard surface trails traverse the Waskasoo Park System connecting a variety of natural and recreational areas.
- Alberta's oldest federal migratory bird sanctuary is found inside Waskasoo Park. 130 species of birds and 28 species of mammals have been spotted at the Gaetz Lake Sanctuary.
- Kerry Wood Nature Centre is Central Alberta's only year-round facility for nature interpretation and environmental education.

Address: Kerry Wood Nature Centre, 6300 45 Ave. Red Deer T4N 3M4
Tel: (403) 346-2010
Website: waskasoopark.ca
Open: Year-round
Activities:

⤴ **A beaver outside its dam.**

Waskasoo Park is a protected parkland inside the City of Red Deer that contains a wide array of habitats from boreal forest to native grasslands. An exceptional trail system links natural areas, historic sites, valleys, wetlands, tributary creeks and river escarpments.

Red Deer River Naturalists

Red Deer is home to a very active group of birders and naturalists. The Alberta Natural History Society organized a branch in Red Deer in 1909 and the group continues to operate to this day as the Red Deer River Naturalists (rdrn.ca). The society asked John Jost Gaetz, who owned the original homestead where Gaetz Lakes Sanctuary is located, to consider designating a portion of his land as a bird sanctuary. They also made the formal application in 1924 to the Commissioner of Canadian National Parks to have the land designated as a Federal Bird Sanctuary — Alberta's

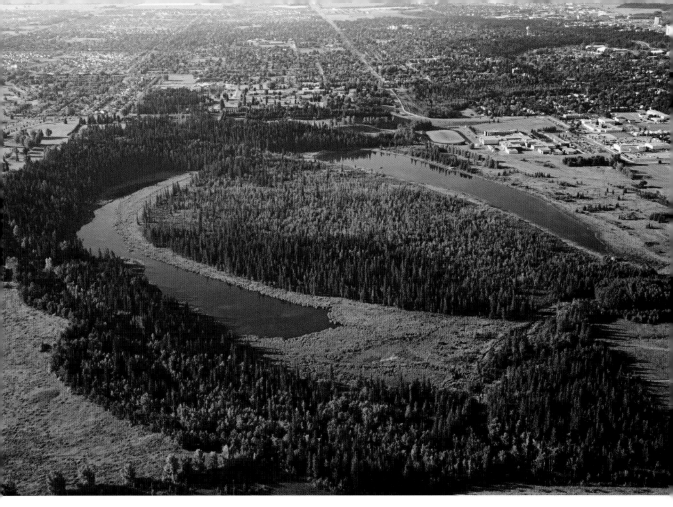

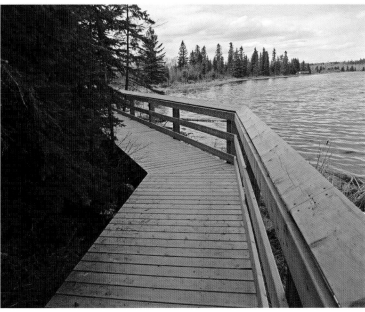

↑ Aerial view of Waskasoo Park.

← The boardwalk runs along
 the shores of the lake.

↑ **Children enjoy the playground equipment.**

→ **Snowshoeing is popular in winter.**

first. The group continues to actively support education, protection and cleanup of natural areas in the region. Visitors can join them in weekly birding and wildflower walks during warm weather months. You can also use their excellent free birding guide to find the best birding locales in Central Alberta (birdingtrailsalberta.com).

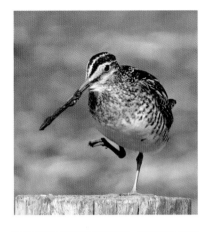

Gaetz Lake Sanctuary and Kerry Wood Nature Centre

The sanctuary is home to a wide variety of animal and plant species and there are trails that lead to viewing decks and a bird blind. One hundred and thirty species of birds and 28 species of mammals along with a wide variety of plants can be found here.

The Kerry Wood Nature Centre sits near the entrance of the sanctuary and has a permanent exhibit gallery, a discovery room and meeting rooms. Interpretive staff and volunteers offer extensive programs throughout the year—from guided snowshoe treks to nature walks and interpretive raft floats on the Red Deer River. The Nature Centre is also home to the Marjorie Wood Gallery, showcasing local artists, creating nature-based art.

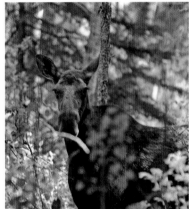

Other Highlights

Waskasoo Park weaves its way through the city and offers much to explore. Heritage Ranch is an 87 hectare natural area that contains a stocked lake, trails, a restaurant and facilities for wagon rides in summer and sleigh rides in winter. Fort Normandeau is a reconstructed fort that has an interpretive centre, a picnic site and a canoe launch. McKenzie Trail Recreation area is a large natural area of 67 hectares that was reclaimed from abandoned gravel pits and a former landfill site. It now has islands for nesting waterfowl and marvelous hiking trails. The Michael O'Brien Wetland is a prime spot for viewing waterfowl. Bower Ponds is a manmade lake stocked with trout for catch and release fishing. Visitors can rent canoes and paddleboats in summer or go skating in winter.

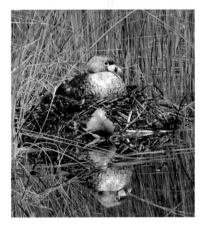

↑ Top to bottom: Wilson's snipe, moose, pied-billed grebe on nest.

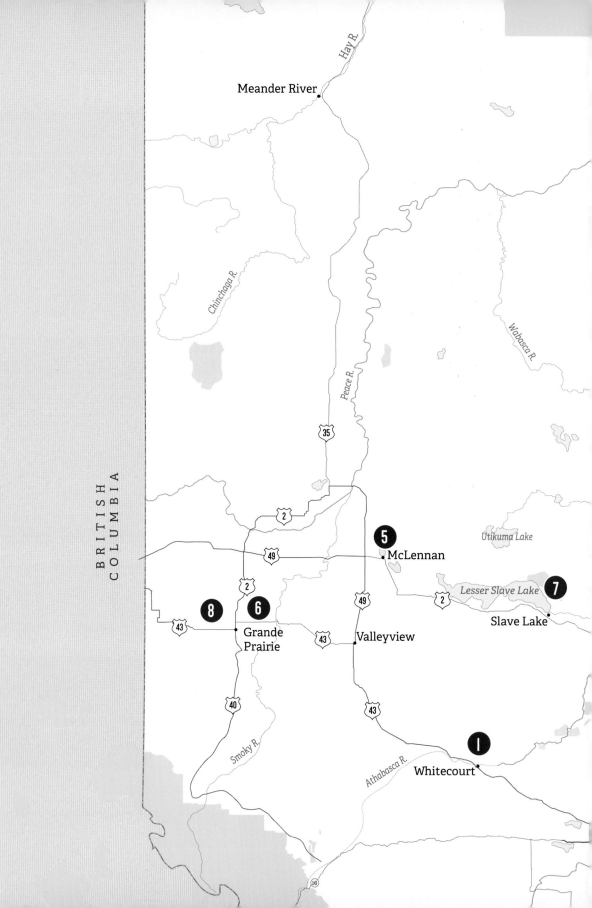

British Columbia

Hay R.

Meander River

Chinchaga R.

Peace R.

Wabasca R.

35

Utikuma Lake

2

49 **5** McLennan

Lesser Slave Lake **7**

2

49 Slave Lake

8 **6**

43

Grande
Prairie 43 Valleyview

40

43

Smoky R.

Athabasca R. Whitecourt **1**

16

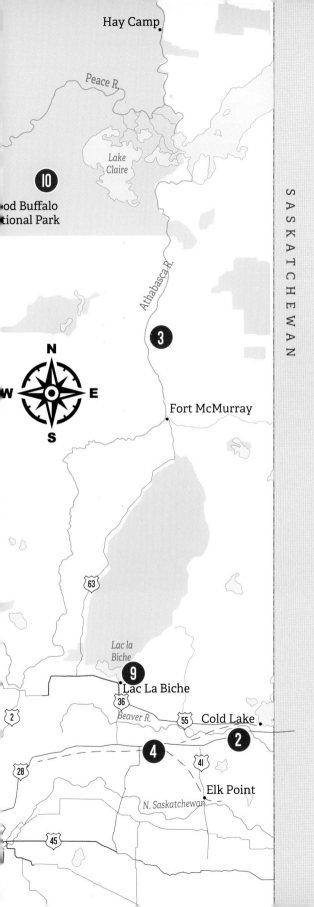

Northern Alberta

Carson-Pegasus Provincial Park

Two lakes and surrounding marshes, fens and woodland areas provide a diverse habitat for many plants and animals.

What Makes This Spot Hot?

- Excellent trout fishing in McLeod Lake from the dock, the seawall or from a boat.
- Great spot for birding and wildlife viewing. Spring and fall migrations are good for viewing waterfowl.
- Cross-country skiing, ice fishing, snowshoeing and snowmobiling in winter.

Address: Lat: 54.2973° N; Long: -115.6434° W
Tel: (780) 778-2664
Website: albertaparks.ca/carson-pegasus/
Open: Year-round
Activities:

↗ Carson-Pegasus has well-developed infrastructure including a sea wall along the edge of the lake where you can fish from a lawn chair.

If you're looking for a great place to take the kids for their first fishing and camping experience, this spot is ideal. Set at the southern edge of the Swan Hills just outside Whitecourt, the park offers a wide array of recreational activities. McLeod Lake is well known for its rainbow trout fishing and there is a sea wall along its edge, allowing for fishing from lawn chairs or even park benches.

Motor boats, rowboats, canoes, paddle boats and kayaks are also available for rent, and there's an onsite tackle shop. Little McLeod Lake is a deeper and colder lake, where you can catch lake whitefish, yellow perch and northern pike.

The park gets its name from the old names of the two lakes inside it. At one time, McLeod Lake was called Carson and Little McLeod was called

Pegasus—the present-day names were those used by early fur traders. The lakes reverted to the original names after the park was established.

More than 110 bird species have been seen in the park. Look for common loons, grebes, northern goshawks, ruffed grouse, great horned owls, four different species of woodpecker, blue jays, grey jays, black-capped chickadees, boreal chickadees, evening grosbeaks and white-winged crossbills.

Wildlife viewing and birding is excellent here. Mule deer, white-tailed deer, moose, black bear, weasel, mink, muskrat, beaver, snowshoe hare, chipmunk, red squirrel, porcupine, coyote and lynx are amongst the more than 40 different species of mammals found in the park.

The park lies within the native region of the extremely rare Swan Hills grizzly, a sub-species of the grizzly bear also known as the Great Plains grizzly. It is the last of the prairie subspecies; if you are fortunate enough to see one, stay well away from it.

The Carson-Pegasus campground is great for families and has well-treed campsites that are ideal for both RVs and tents. There are plenty of amenities, including small sandy beach areas for swimming, playgrounds, picnic sites and a boat launch.

↑ **Young riders enjoy biking in the park.**

→ **Benches invite visitors to rest and enjoy the view.**

There is a 1.7 kilometre trail that follows the lakeshore and a 5.2 kilometre trail through the aspen and spruce woodlands. The campground is open between mid-May and mid-October, but the park is open year-round. Cross-country skiing, ice fishing and offsite snowmobiling are popular activities in winter.

Cold Lake/Bonnyville Region

Surrounded by lakes, this region is one of the top birding destinations in Alberta

What Makes This Spot Hot?

- At least 292 species of birds are found in this area- including 23 warbler species.
- One of Alberta's largest western grebe colonies is found on Cold Lake.
- Muriel Lake is home to one of Alberta's largest breeding population of endangered piping plovers.

Address: Lat: 54.4676° N; Long: –110.1313° W (Cold Lake Provincial Park)
Tel: (780) 594-7856
Website: albertaparks.ca/cold-lake
Open: Year-round
Activities:

The Cold Lake/Bonnyville region lies in the transition zone between Alberta's Aspen Parkland and the Northern Boreal Forest. Numerous lakes, including one of the largest lakes in the province, provide habitat for nesting birds and act as a staging area for migrating species. More than 290 bird species have been spotted in this region making it a bird watcher's paradise.

Cold Lake

At 373 square kilometres, Cold Lake is one of the largest and deepest lakes in the prairie region of Canada. The lake straddles the Alberta/ Saskatchewan border, but almost 250 square kilometres of it is in Alberta. Cold Lake Provincial Park sits on the southern and northern shores of the lake protecting habitat and providing facilities that enhance recreational opportunities on the lake. Spring and fall migrations are popular with birders. As many as 23 different species of warblers have been recorded during the spring migration in late May and early June. There are also a wide variety of waterfowl on the lake including one of Alberta's largest western grebe colonies. Pelicans, cormorants and gulls can also be seen.

↗ **The entrance sign welcomes visitors to the park.**

→ **Kinosoo totem poles near the marina at Cold lake.**

↑ **Cold Lake Peace Grove.**

Ethel Lake

This small lake west of Cold Lake has a campground, a playground, horseshoe pits, a boat launch, a swimming area, a camp kitchen, and a dock. It's a popular destination with anglers and with birders who come to see the provincially uncommon yellow rail and the sedge wren.

Jessie Lake

This shallow kettle lake borders the town of Bonnyville and is home to a wide variety of bird species. Retreating glaciers created depressions, known as kettles, that when filled with water create shallow lakes like this one. A walking path and viewing platforms provide good views of nesting waterfowl and shore birds. Look for ducks, Canada geese, American coots, American avocet, short-eared owl and other species as you walk around the lakeshore.

Muriel Lake

This small lake near Bonnyville has long been home to Alberta's largest breeding populations of endangered piping plovers as well as large colonies of gulls, terns, and cormorants. In recent years water levels in this lake have dropped dramatically. If the trend continues, bird populations could suffer.

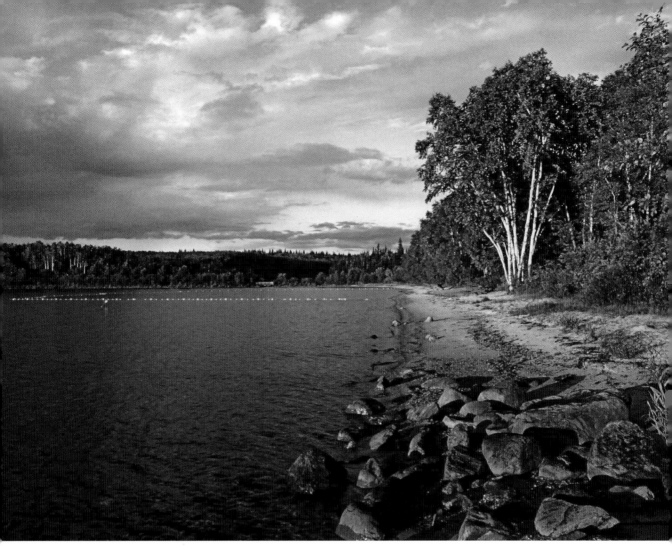

↑ Beach area, Cold Lake Provincial Park.

← Ethel Lake wetland.

Fort McMurray Region

There's more than meets the eye when it comes to the natural beauty of the Fort McMurray region

What Makes This Spot Hot?

- There are 400 hectares of parkland inside the city of Fort McMurray, and more than 130 kilometres of trails.
- La Saline Natural Area contains what is probably the finest example of salt springs in Alberta.
- Gregoire Lake is a great spot for birding and enjoying a beach on a hot day.

Address: 515 MacKenzie Blvd., Fort McMurray, AB, T9H 4X3 (Fort McMurray Tourism)
Tel: (780) 791-4336
Website: fortmcmurraytourism.com
Open: Year-round
Activities:

For most people, two things pop into their minds when they think of Fort McMurray—the oil sands and the wildfire that devastated the city in 2016. Neither thought is very promising for nature lovers, but this region of Alberta has more to offer than most people realize. There are 400 hectares of parkland within the city, and more than 130 kilometres of trails. Within an hour's drive, you'll find a nationally significant provincial natural area and a provincial park that provides a variety of recreational amenities.

Birchwood Trails

This trail system is the pride and joy of the city of Fort McMurray. Residents and visitors alike can walk, run, cycle or cross-country ski along more than 130 kilometres of maintained trails. Even though some of the trail system was damaged in the fire, most of the trails have reopened.

↑ **Birchwood trails.**

→ **The beach at Gregoire Lake Provincial Park is wide and sandy.**

↑ **La Saline Natural Area.**

La Saline Natural Area

This natural area is reasonably close to Fort McMurray, but it's a little tricky to access—the best entry point is from the Athabasca River. A number of bird species are known to nest on Saline Lake, including coots, mallards, widgeons, buffleheads and green-winged teal. The saline springs are nationally significant and are the best-known and finest example of an upland salt spring in Alberta. You can see large tufa cones measuring 3 metres in diametre at the site. Tufa is a kind of calcium carbonate precipitate created when spring water flows through limestone.

Gregoire Lake Provincial Park

A 30-minute drive south of Fort McMurray, Gregoire Lake has a beautiful sandy beach and is great for boating, canoeing, kayaking, fishing and swimming. Trails lead through the aspen and spruce forest. More than 126 bird species have been sighted in the park. Look for waterfowl species on the lake and spruce grouse, gray jays, magnolia and palm warblers in the black spruce bogs. Moose, deer, caribou, beavers, lynx, minks, muskrats, red foxes, coyotes, wolves, otters and weasels might also be seen in the area.

↑ **Athabasca Sand Dunes.**

The Athabasca Sand Dunes Ecological Reserve

The Athabasca Sand Dunes Ecological Reserve lies 3.5 hours north of Fort McMurray. Alberta's moving desert shifts 1.5 metres per year, burying forests and lakes. These 12 metre tall sand dunes and 60 metre high kames are among the largest in the world. The dunes are tricky to access—you can get there by helicopter, ATV or on foot.

Iron Horse Trail

The longest section of continuous Trans Canada Trail in Alberta passes through small communities, historic sites and natural areas

What Makes This Spot Hot?

- 300 kilometres of continuous trail stretching from Waskatenau to Cold Lake, with a branch to Heinsburg.
- Explore the trail on foot, by mountain bike, on horseback, by ATV or snowmobile, or in a Red River cart.
- Enjoy spectacular views and see birds, wildlife, farms, rural communities and historic sites.

Address: Lat: 54.0954° N, Long: 112.7827° W (Waskatenau—western end of the trail)
Tel: (780) 645-2913
Website: ironhorsetrail.ca
Open: Year round
Activities:

↗ **Smoky Lake giant pumpkins.**

There are many special places along Alberta's Iron Horse Trail, a 300 kilometre trail in east central Alberta that was built on an abandoned CN rail bed. The trail passes through small rural communities, farms, and beautiful natural areas as it traverses the transition zone between Alberta's Aspen Parkland and Northern Boreal Forest biomes. Watch for deer, moose, coyotes, badgers, beavers and bears near the trail, and keep your eye on the skies for bird species—this part of Alberta is a bird watcher's paradise.

In Alberta's early years, railways were the backbone of transportation and communities were located near stops along rail lines. Over many years roads were built, and some rail lines became uneconomical. When the lines in east central Alberta were retired and the rails were pulled up, local stakeholders and community leaders recognized the opportunity

for trail development on the abandoned rail bed that was left behind. Local volunteers, businesses, groups and associations, municipalities and government organizations all worked together with the support of the Trans-Canada Trail Foundation (thegreattrail.ca) and Alberta TrailNet Society (albertatrailnet.com) to develop and maintain the magnificent recreational trail you see today.

There are 14 communities along the trail, which would take multiple days to explore in its entirety. Most people break the journey into smaller sections. There are 20 trail staging areas and three provincial parks along the way. In the small towns near the trail you'll find municipal campgrounds, motels, hotels and B&Bs. One of the highlights of the trail is the Beaver River Trestle Bridge near Cold Lake. At 1 kilometre long and 60 metres high, the view from the top is spectacular.

 Kolby Olsen at the Beaver River Trestle Bridge.

DID YOU KNOW?
People sometimes refer to this part of Alberta as the *Land of Big*. The world's largest pumpkins are in Smoky Lake, the largest mushrooms in Vilna, and the world's first UFO landing pad is in St. Paul.

Kimiwan Bird Walk and Interpretive Centre

A wheelchair-friendly boardwalk gets you up close to the largest concentration of waterfowl and shorebirds in northern Alberta

What Makes This Spot Hot?

- Internationally recognized wetland.
- Beautiful boardwalks for nature and bird viewing.
- Interpretive displays and educational programs.

Address: 302 3 Avenue NW, McLennan
Tel: (780) 324-2004
Website: www.kimiwanbirdwalk.ca
Open: May – September 10 a.m. – 5 p.m. Tuesday to Saturday; open every day in July
Activities:

Kimiwan Lake, located 4 hours northwest of Edmonton in the small community of McLennan in Alberta's gorgeous but largely unknown Peace Country region, is a must-visit destination for keen birders, nature lovers and families alike.

McLennan proclaims itself the Bird Capital of Canada. Since 1999, the lake has been acknowledged as a Globally Significant Important Bird Area, an Environmentally Significant Area in Alberta and a Migratory Bird Sanctuary, with three major flyways delivering 20,000 or more birds every day during peak migration. The lake is also at the intersection of Peace Parkland and Dry Mixedwood natural areas, which in turn contributes to a diverse bird community.

What this means for the visitor is that you can see a lot of birds if your timing is right. And even if it isn't, the beautiful and wheelchair-accessible boardwalk is a treat as it meanders through marshes and mudflats with some lovely views of the surrounding countryside. Viewing platforms and interpretive signage along the boardwalk add to the experience. Try to visit when the Kimiwan Interpretive Centre is open. It's staffed by the Kimiwan Lake Naturalist Society from mid-May until the end of August. Get insiders' tips, find out what you're likely to see, check out the displays and even borrow a pair of binoculars. When you've finished your walk, log your bird sightings. If the centre is closed, you can still access the boardwalk.

The bulk of the birds seen at Kimiwan Lake are waterfowl and shorebirds. During peak migration, 26,000 waterfowl have been counted in a single day. Surveys from the past suggest the most numerous species are pectoral sandpipers and long-billed dowitchers. Up to 5,000 non-breeding

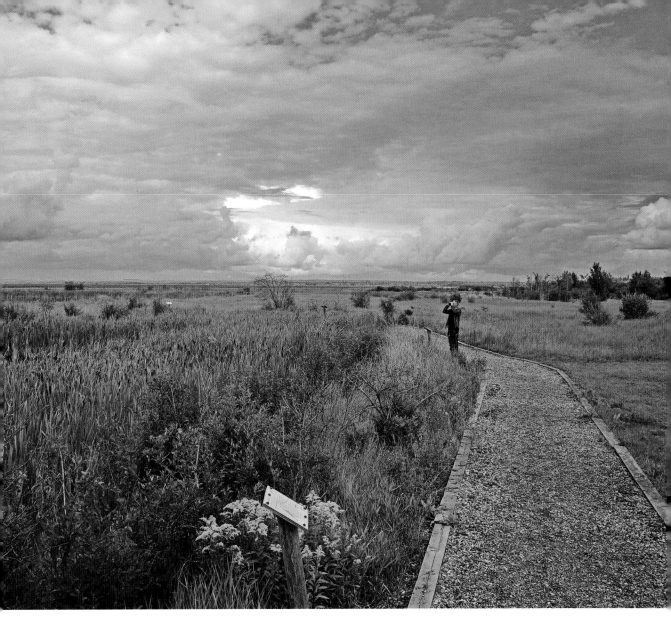

Franklin's gulls have been spotted in mid-summer. Come the first week of October, tundra and trumpeter swans can be seen in huge numbers, with 9,000 recorded in a single day.

But don't just come for the waterfowl; there have been 233 bird species counted within 15 kilometres of the lake. Sixty-six types of songbirds, including numerous warbler varieties, raptors, squawky sandhill cranes, the graceful American avocet and the more elusive sora have all been spotted in the area.

It's easy to find the Kimiwan Lake Interpretative Centre. It's located at the western edge of McLennan, on Highway 2, at the intersection of 3 Street NW on the south shore of the lake.

↑ **Birding on a summer evening.**

Kleskun Hill Natural Area

Explore Alberta's northernmost badlands area, 30 kilometres northeast of Grande Prairie

What Makes This Spot Hot?

- Dramatic eroded land formations.
- Some of the few remaining undisturbed native grasslands in the Peace River Region.
- Areas of bedrock exposure with fossil-bearing strata.

Address: Lat: 55.2615° N; Long: –118.5064° W
Tel: (780) 538-5350
Website: albertaparks.ca/kleskun-hill
Open: Year-round
Activities:

▸ **Prickly pear cactus.**

Long before the first European settlers arrived, Kleskun Hill was a favourite Aboriginal campsite. The name Kleskun is likely of Beaver origin and means "white mud," referring to the bentonite clay found in the area. First Nations valued the area for the abundance of Saskatoon berries and the bison that grazed on the prairie nearby. Legend has it that a great battle between the Beaver and Sikanni Nations took place here, and that the remains of several Beaver warriors are buried in a mass grave at the end of the hills.

The area contains Alberta's northernmost badlands, which have been shaped by erosion and include rocks of the same age as fossil-bearing badlands in other regions of the province. The site also protects one of the few remaining areas of undisturbed northern grasslands. As you hike through the area, you'll see a variety of grassland and parkland plants. Prickly pear cactus grows on

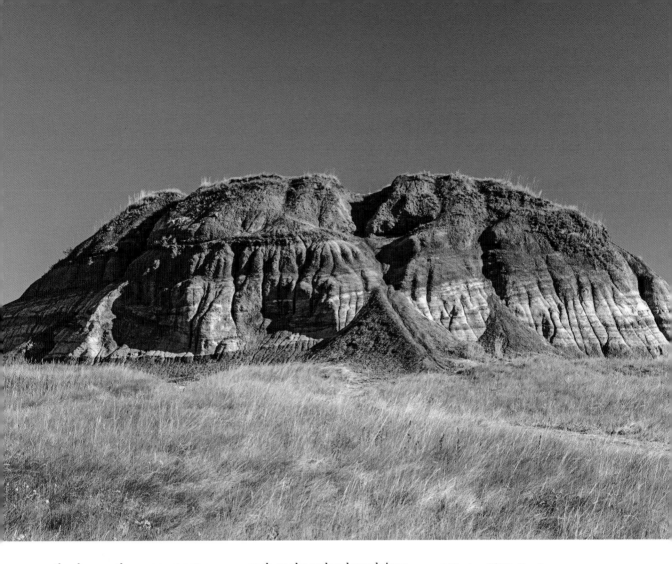

the dry south exposures at the very northern edge of its range. A variety of wildflowers can be seen in spring, including the prairie crocus, purple onion, wood lily, blue flax and three-flowered avens. Large patches of juniper and kinnikinnick grow in low areas, and patches of trembling aspen and shrubs like saskatoon berry, honeysuckle and prickly rose are interspersed throughout the area.

The native grassland supports a variety of bird species, such as the upland sandpiper, western meadowlark and vesper sparrow. Prairie butterflies include the common branded and Garita's skipper and the Alberta arctic.

A small campground with showers, a playground and a historic village is operated by the municipality. The local historical society has attractions at this site with a variety of historical buildings and implements.

↑ **Kleskun Hill Badlands**

Lesser Slave Lake Provincial Park

The largest auto-accessible lake in Alberta has beautiful beaches and is a designated Important Bird Area

What Makes This Spot Hot?

- Alberta's third-largest lake is rimmed with some of the finest beaches in the province.
- Nearly half of all North American bird species rely on the boreal forest region, and this area is an example of that region.
- The Boreal Centre for Bird Conservation is a great place to observe and learn about migratory birds.

Address: Lat: 55.4124° N; Long: -114.8049° W
Tel: (780) 849-8240 or 1-866-718-2473; Park Info Line (May long weekend to September long weekend): (780) 849-2111; off-season: (780) 849-7100
Website: albertaparks.ca/lesser-slave-lake-pp.aspx
Open: TK
Activities:

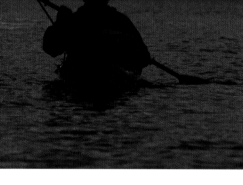

↑ **Canoeing at sunset, Lesser Slave Lake.**

When a strong wind blows waves across Alberta's third-largest lake, you can almost believe you're at the edge of the ocean as you gaze out from the sandy shoreline. At nearly 1,200 square kilometres, Lesser Slave Lake is rimmed by some of the finest beaches in the entire province and is a wonderful place to visit on a warm summer day. It's also a great place to see sand dunes, hike, watch wildlife and see birds.

Lesser Slave Lake is a prime fishing lake, and the forests that surround it teem with wildlife. For these reasons, the region was well known to the Beaver and Woodland

Cree, two tribes that lived and hunted in the region. David Thompson was the first European to reach Lesser Slave Lake, arriving in 1799. He commented on the abundance of moose, bison and waterfowl in the area, and he made detailed survey observations to map the area. Fur trading posts were eventually built on the shores of the lake by the North West and Hudson's Bay Companies, and Lesser Slave Lake became one of the most productive fur bearing regions in Canada.

A unique microclimate and the rich habitat of the boreal forest make this area a haven for nesting and migratory birds—especially songbirds. The area has been designated an Important Bird Area.

↑ **Whispering Sands Trail—Lesser Slave Lake.**

← Left, from top: Measuring the wing span of a sharp-shinned hawk; sunset on the lake; snowshoeing; wood lilies.

→ Rocky shoreline, Lesser Slave Lake.

Experts have dubbed the boreal forest region "North America's bird nursery" because so many bird species nest and raise their young in and around the Lesser Slave Lake district.

Many birds pass through during the spring and fall migrations, and it's estimated that up to 20 percent of the western population of tundra swans stops to feed on the lake. Flocks of up to 3,500 swans have been documented in the spring and fall. Reeds around the lake provide nesting habitat for a globally important western grebe population. The area also has an incredible concentration and diversity of migrant songbirds, including the yellow warbler, bay-breasted warbler and red-eyed vireo, to name a few. Visitors with a particular interest in songbirds should hike the Songbird Trail or attend the Songbird Festival, held in the park each spring.

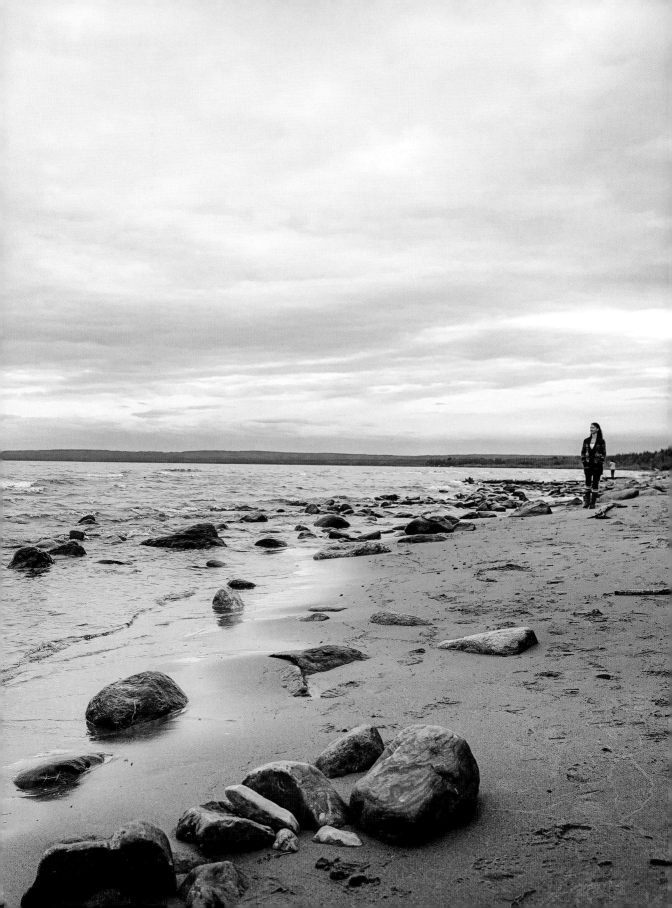

Saskatoon Island Provincial Park

One of the most accessible places to view rare trumpeter swans, this provincial park is one of Alberta's top birding destinations

What Makes This Spot Hot?

- Large numbers of grassland, waterfowl, forest and shore birds—including rare trumpeter swans.
- Saskatoon berries grow abundantly in this area during the summer months.
- Year-round recreation area offering an exceptionally wide variety of activities.

Address: Lat: 55.2052° N; Long: –119.0854° W
Tel: (780) 538-5350
Website: albertaparks.ca/saskatoon-island
Open: Year-round
Activities:

↗ **Bohemian waxwing.**

West of Grande Prairie, Saskatoon Island is one of Alberta's oldest provincial parks. The area has long been appreciated by the Cree First Nations for the abundance of Saskatoon berries that grow wild here. The Cree people would set up camp in the summer months and gather the berries they called *Sâskwatôn* (Saskatoon) to make pemmican. The berries once grew abundantly on a small island, but when water levels dropped in 1919, the island became part of the mainland.

Saskatoon Island Provincial Park was established in 1932 and covers an area of more than 100 hectares. Berries are still abundant in July and August, but the birds are the biggest attraction for most visitors. More than 120 species of birds have been spotted inside the park, and rare trumpeter swans can be observed from the viewing platform

on Little Lake. The park is one of the most important waterfowl habitats in Alberta, and is a designated federal migratory bird sanctuary that is part of the Grande Prairie Important Bird Area. Look for tundra swans, Canada geese, northern harriers and yellow warblers—to name just a few. Moose, snowshoe hares, weasels, muskrats, beavers, deer and coyotes are some of the mammal species that may also be seen in the park.

The park offers year-round camping and a wide variety of recreational opportunities. There are 4.2 kilometres of maintained hiking trails on the former island, including 1.2 kilometres of wheel-chair-accessible trails. In the winter, you'll find 6.4 kilometres of cross-country ski trails and several open and forested areas to enjoy snowshoeing.

↑ **Little Lake.**

Sir Winston Churchill Provincial Park

The only island park in landlocked Alberta has beautiful sandy beaches and old growth forests

What Makes This Spot Hot?

- An island with protected sandy beaches and plenty of recreational options.
- One of the top spots in the province for viewing boreal forest birds.
- Old growth mixedwood forest.

Address: Lat: 54.8320° N; Long: –111.9761° W
Tel: (780) 623-7189
Website: albertaparks.ca/sir-winston-churchill
Open: Year-round
Activities:

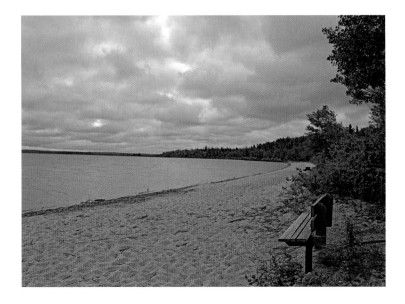

▸ **The wide sandy beach of Lac la Biche is a great place to relax on a hot summer day.**

At 236 square kilometres, Lac la Biche seems huge when you are standing on its sandy shoreline. It's one of the largest lakes in the province and Sir Winston Churchill Provincial Park is located on the biggest island on the lake, fittingly named Big Island. There's a campground and cabins on the island as well as a playground, beaches and other facilities. Located at the east end of Lac la Biche, the island is accessed by a 2.5 kilometre long causeway making it one of the most unique campgrounds in the province.

Birding is one of the most popular activities at this park and Lac La Biche has been designated an Important Bird Area. In addition to large populations of red-necked grebes

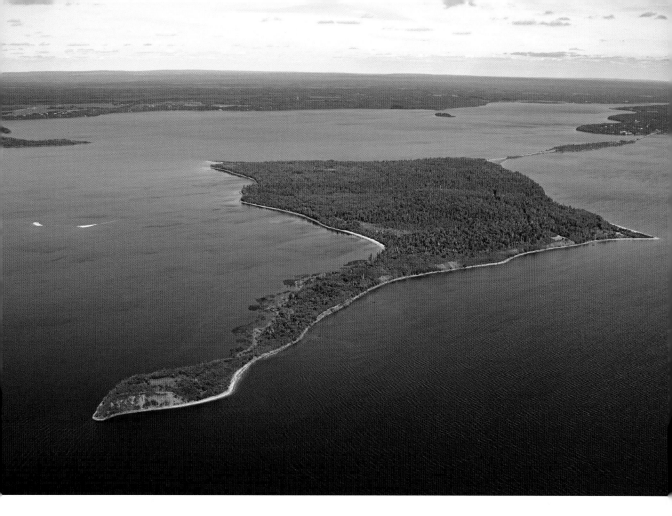

and California gulls, at least 224 of the 330 bird species in Alberta have been observed within the park. Some of the most sought after species include black burnian, Cape May, black-throated, green and bay-breasted warblers, olive-sided flycatchers, white-winged crossbills, Swainson's and hermit thrushes, sharp-tailed, Le Conte's and swamp sparrows, osprey, bald eagles, northern saw-whet, barred, great grey, boreal and great horned owls. There's a viewing platform at Pelican Viewpoint where you can see water birds such as American white pelicans, double-crested cormorants and Franklin's gulls.

The island is criss-crossed with hiking trails. You can walk to the westernmost tip of the island on the 2.5 kilometre Long Point Trail. Along the way, you'll pass a remote beach and many different species of plants. The 1.2 kilometre Boardwalk Trail goes through old-growth boreal forest that has been untouched by forest fires for at least 300 years. Old Growth Alley connects Long Point and Boardwalk trails and goes around the edge of the island.

↑ **Aerial view — Sir Winston Churchill Provincial Park**

DID YOU KNOW?

Sir Winston Churchill Provincial Park is 11 kilometres away from the town of Lac La Biche. One capital letter distinguishes the name of the town from the name of the lake, Lac la Biche.

Wood Buffalo National Park

Canada's largest national park is a UNESCO World Heritage Site that also has one of the world's largest inland deltas

What Makes This Spot Hot?

- Home to North America's largest population of free-roaming bison.
- Natural nesting area of endangered whooping crane .
- World's largest dark sky preserve.

Address: 149 MacDougal Road, Fort Smith, NT (Main Visitor Information Centre) or Mackenzie Avenue Fort Chipewyan, AB (Satellite Visitor Information Centre)
Tel: (867) 872-7960
Website: parkscanada.ca/woodbuffalo
Open: Mid-May to early September
Activities:

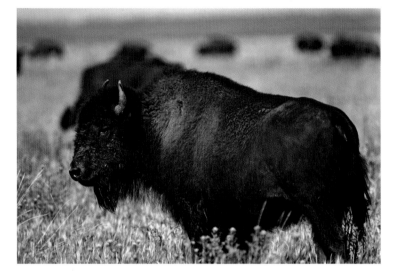

↗ **Wood bison.**

Wood Buffalo National Park was established in 1922 and spans 44,807 square kilometres in northeastern Alberta and the southern Northwest Territories. It's Canada's largest national park and is the second-largest national park in the world. To put it in perspective, the park is a bit larger than Switzerland.

The park was declared a UNESCO World Heritage Site in 1983, in part for the biological diversity of the Peace-Athabasca Delta, one of the world's largest freshwater deltas. Within the many ecosystems of the park, you can find some of the largest undisturbed grass and sedge meadows left in North America. The world's largest herd of free-roaming wood bison is found here, and it's the only place where the predator–prey relationship between wolves and bison has continued unbroken over time.

In addition to the bison that the park is most famous for, many species of wildlife are found here. Bears, wolves, moose, lynx, martens, wolverines, foxes, beavers and snowshoe hares are a few of the wild mammal species

found. The park protects the only wild nesting area of the endangered whooping crane, as well as some nesting sites of the threatened peregrine falcon, but there is no public access to these areas.

The prime area for birding is the Peace-Athabasca Delta. During the spring and fall, millions of migratory birds from all four North American flyways pass through the delta. Snow geese, sandhill cranes, hawks, eagles and owls are often seen. The delta can be accessed by water from the tiny community of Fort Chipewyan. The only way to reach this area of the park in summer is by boat or by plane. In winter, an ice road connects the community with Fort McMurray, AB to the south and Fort Smith, NT to the north.

The payoff for the remoteness of this place is its wildness. Wood Buffalo National Park is the world's largest dark sky preserve. The dark night sky makes the constellations come to life, and aurora viewing can be spectacular. The annual Dark Sky Festival in mid-August is a good time to visit if you're interested in stargazing.

↑ **Wetlands in the park.**

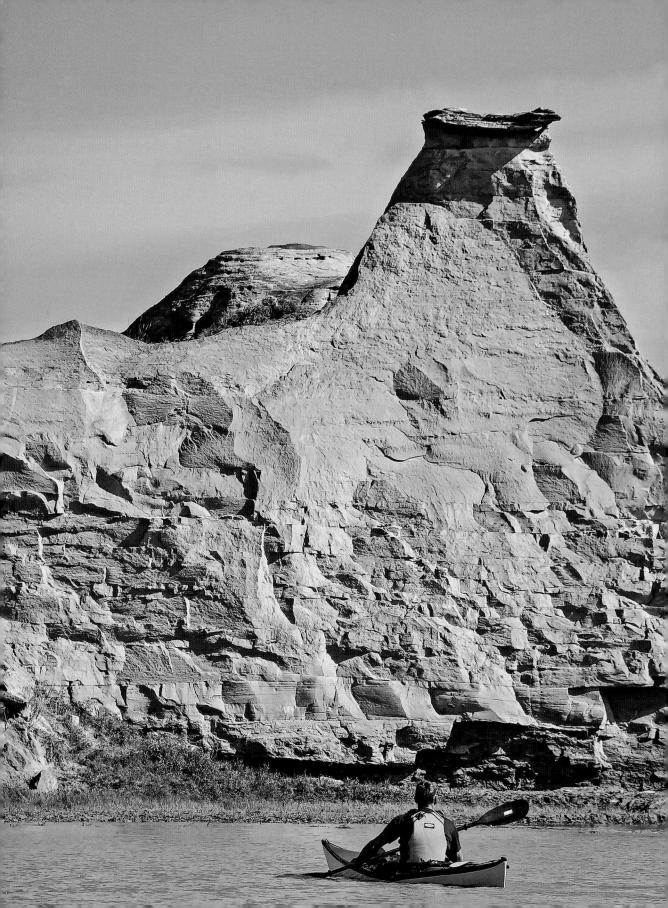

Special Interest

← **Paddling the Milk River through Writing-on-Stone Provincial Park.**

Caves

Alberta is home to some of the longest and deepest caves in Canada, providing thrilling adventures for caving enthusiasts

What Makes These Spots Hot?

- The lure of the unknown and the thrill of discovery.
- Fascinating geological features like stalactites and stalagmites.
- Fragile ecosystems that provide homes for bats and other creatures.

↗ **Kelsey Olsen going down the laundry chute, Rat's Nest Cave.**

Caves are the gateway to another world, and exploring them is fun and challenging. Like any sport, caving requires a degree of basic fitness, proper equipment and training, common sense and an experienced guide to ensure safety. Caves can be dangerous, and very few Alberta caves are suitable for novice cavers to explore on their own. If you hire a guide, be aware that there are currently no legislated cave guiding standards in Alberta. It's important to ask questions and ensure that your guide is qualified and properly equipped, so you have a safe and enjoyable experience.

You can visit the Alberta Speleological Society website (caving.ab.ca) for a list of guiding organizations in Alberta and tips on how to cave safely.

Rat's Nest Cave

Located on the south-facing slope of Grotto Mountain, about six kilometres east of Canmore, this cave was officially designated as one of Canada's Historic Places in 1987. There are more than 4 kilometres of tunnels and a variety of interesting geological features, including stalactites and stalagmites and deposits of animal remains. Paleontological specimens of birds, snakes, fish, and several amphibians have been discovered in the cave, along with the remains of more than 30 mammalian species. Prehistoric tools and pictographs establish a human presence dating to roughly 3,000 years ago. This cave is gated, and you must be accompanied by a guide to visit it. Canmore Cave Tours (canmorecavetours.com)

↑ Fungus in Rat's Nest Cave.

↑↑ Bushy-tailed wood rat in Rat's Nest Cave.

BATS AND WHITE NOSE SYNDROME

Some caves are home to bats, and cavers must take precautions to ensure they don't disturb the delicate ecosystem inside a cave they are exploring. Bats are fascinating mammals that play an important role in controlling populations of mosquitoes and other insects. A very serious disease known as White Nose Syndrome has been decimating bat populations in the northeastern United States and eastern Canada. The disease has not yet been identified in Alberta, but Alberta Environment and Parks has been taking steps to protect Alberta bats by temporarily closing some caves. In addition to avoiding closed caves, it is recommended that cavers decontaminate their cave gear after every trip into a bat-populated cave. More information can be found on the Alberta Environment and Parks website.

offers year-round cave tours for explorers ages 12 and up. Participants need to be physically fit, but no previous caving experience is necessary.

Crowsnest Pass Caves

Some of the best caving in the Canadian Rockies lies within a 4 kilometre radius of the Municipality of Crowsnest Pass. The three best-known caves are Gargantua, Cleft and Yorkshire Pot. Booming Ice Chasm is one of the most recently discovered caves in this area. Cleft Cave is the only one that is relatively safe for novices to explore, as it does not require technical climbing experience. It's also one of the most photogenic caves, because its walls are coated in ice crystals.

Gargantua is a massive cave system that contains the largest natural cavern in Canada, and is one of the top caving destinations in the nation. The main entrance is on the Andy Goode Plateau, and there is about a 1000 metre elevation gain to reach it. Exploring the cave involves five rappels and hikes through massive chambers and passages along with a narrow passage known as the birth canal. The lower exit comes out behind a waterfall. Novice cavers can easily become lost or injured inside this cave, and an experienced guide is essential.

Yorkshire Pot is one of the deepest caves in Canada. This interprovincial cave has been connected with seven other caves on the Andy Goode Plateau, and is the second-longest cave in Canada. Only very experienced cavers should attempt to explore it.

Booming Ice Chasm is the newest cave to have been discovered in this area. This massive chasm was discovered in 2008 by Chas Yonge. It is a "cold-trap" cave, because cold air sinks to the bottom of the cave and is unable to circulate. This means the cave is filled with several metres of clear, smooth ice year-round.

Castleguard Cave

Canada's longest cave is located at the northern end of Banff National Park and stretches under the Columbia icefield. It's a gated cave, and a permit from Parks Canada is required to explore it. It is very remote and, due to flooding concerns, can only be accessed in winter by helicopter or a 20 kilometre ski with towed sleds. It is internationally renowned and is the subject of a film and a book. At approximately 21 kilometres in length, it is not yet fully mapped.

→ **Middle entrance, Gargantua cave.**

Dark Skies

Alberta is home to some of the world's largest dark sky preserves for stargazing and watching the legendary Northern Lights.

What Makes These Spots Hot?

- Nothing can match the grandeur or the sense of wonder that comes from witnessing an unobstructed night sky filled with countless stars.
- Light pollution is so prevalent that an estimated 85 percent of Canadians can't see more than a few stars.
- The Aurora Borealis (Northern Lights) is a light show like no other—a magical, even spiritual experience.

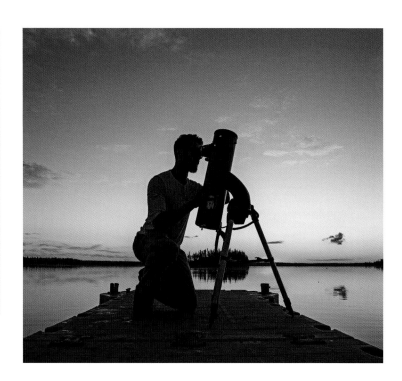

⇗ **Elk Island National Park.**

There is something almost primal about a completely dark sky. Since the dawn of time, men and women have searched the stars for signs to help them understand their place in the universe. You can't help but feel a sense of your own smallness as you gaze up at a vast canopy of magnificent stars or watch the dancing colours of the Aurora Borealis. The Royal Astronomical Society of Canada (RASC) has established extensive requirements for dark sky preserves—areas that are kept free of artificial light pollution. This designation protects plants and animals and preserves habitats for nocturnal species. It also causes the constellations to come to life—a rare occurrence in a world filled with light pollution.

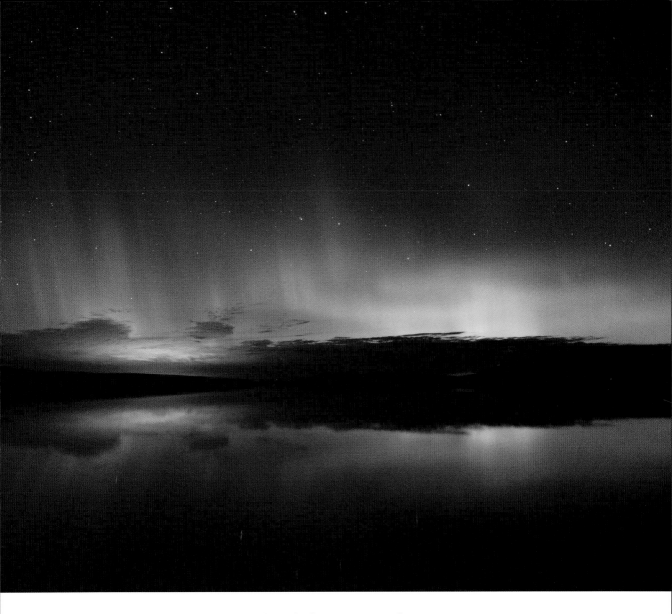

Cypress Hills Interprovincial Park

**Lat: 49.660965;
Long: -110.29290
albertaparks.ca/cypress-hills**

The world's first interprovincial dark sky preserve encompasses 396 square kilometres. There's an observatory on the Saskatchewan side of the Cypress Hills Interprovincial Park Dark Sky Preserve, and each August they hold the five-day Saskatchewan Summer Star Party near the observatory. At a maximum elevation of 1,468 metres, the Cypress Hills are the highest point in mainland Canada between Labrador and the Rockies. This high elevation, combined with the darkness of the skies, makes this a wonderful spot for stargazing.

↑ **Aurora Borealis, Cypress Hills Provincial Park.**

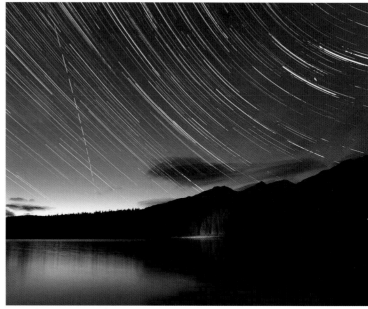

Beaver Hills

Lat: 53.5830° N;
Long: −112.8365° W
pc.gc.ca/pn-np/ab/elkisland/ne/ne4.aspx

About 40 minutes east of Alberta's capital city, the Beaver Hills Dark Sky Preserve is one of the most accessible preserves in the province. The total protected area is 293 square kilometres and encompasses both Elk Island National Park and Cooking Lake-Blackfoot Provincial Recreation area. The RASC hosts an annual two-day star party in September at this site that includes star viewing opportunities, educational workshops and conference speakers.

Jasper National Park

jasperdarksky.org

At more than 11,000 square kilometres, the Jasper Dark Sky Preserve is the second-largest dark sky preserve in the world and one of the only ones with a town inside it. The RASC made the designation in March 2011, and the Town of Jasper started celebrating soon after by holding the first ever Jasper Dark Sky Festival. The event has become an extremely popular annual occurrence, and attracts astronauts, celebrities and scientists who give fascinating presentations. There are also food and wine events, interactive children's activities, concerts and stargazing parties.

↑ **Jasper National Park Dark Sky Festival.**

↖ **Time exposure made in Jasper National Park Dark Sky Preserve.**

Jasper has its own planetarium (jasperplanetarium.com), where visitors can gaze through the largest telescope in the Rockies or take an indoor star tour in the Planetarium Dome Theatre. The best locations for accessible year-round stargazing within the national park are Pyramid Island, Maligne Lake, Old Fort Point and the toe of Athabasca Glacier. The backcountry, though less accessible, is spectacular for stargazing year-round.

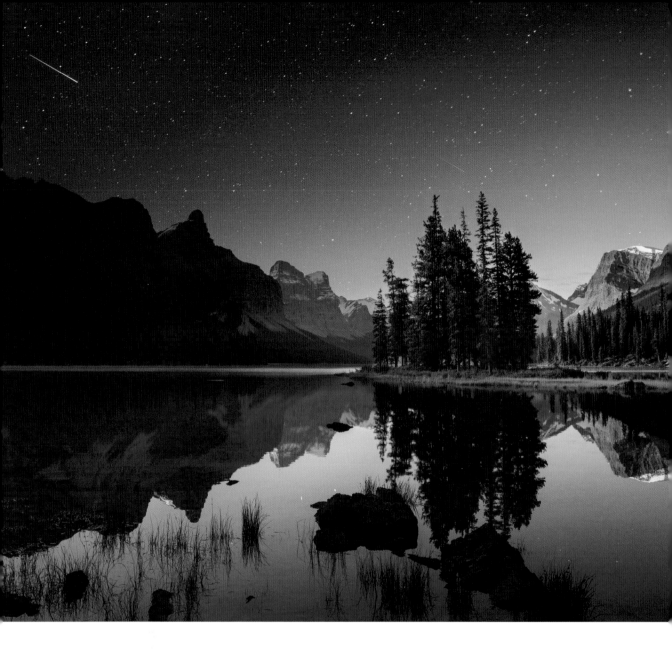

Wood Buffalo National Park
pc.gc.ca/eng/pn-np/nt/wood-buffalo/index.aspx

The world's largest dark sky preserve straddles the Alberta/Northwest Territories border. At 44,807 square kilometres, Wood Buffalo National Park Dark Sky Preserve is bigger than all the other Canadian dark sky preserves put together. The park is situated in an area of intense auroral activity and it's common to see spectacular light shows throughout the year, but especially during the long dark winter months. Each August, Parks Canada hosts a four-day Dark Sky Festival that includes activities and events for all ages. There are night sky observations with local astronomical societies, fun science activities and feature presentations.

↑ **Spirit Island, Jasper Dark Sky Preserve.**

Hot Springs

The healing powers of thermal mineral springs are legendary. It was the discovery of hot springs at the base of Sulphur Mountain that led to the establishment of Canada's first national park

What Makes These Spots Hot?

- There's something magically therapeutic about soaking in naturally hot mineral springs.
- Alberta's natural hot springs are surrounded by some of the world's most awe-inspiring peaks.
- Cave and Basin National Historic Site was the birthplace of Canada's national park system.

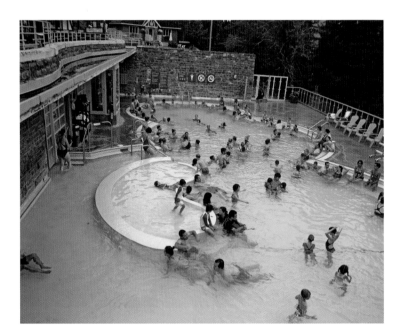

↗ **Banff National Park, Upper Hot Springs.**

The lure of natural mineral hot springs brought the first tourists to what is now Banff National Park. They came to "take the waters," and while they soaked away their aches and pains they took in the spectacular scenery. The Canadian Rockies hot springs remain top tourist attractions even today.

Cave and Basin National Historic Site

pc.gc.ca/eng/lhn-nhs/ab/ caveandbasin/index.aspx

Canada's National Park system began at this site in 1885. You can see the original hot springs that were discovered inside a cave, and tour others outside in an emerald-coloured basin. The story of the development of Canada's first park is told

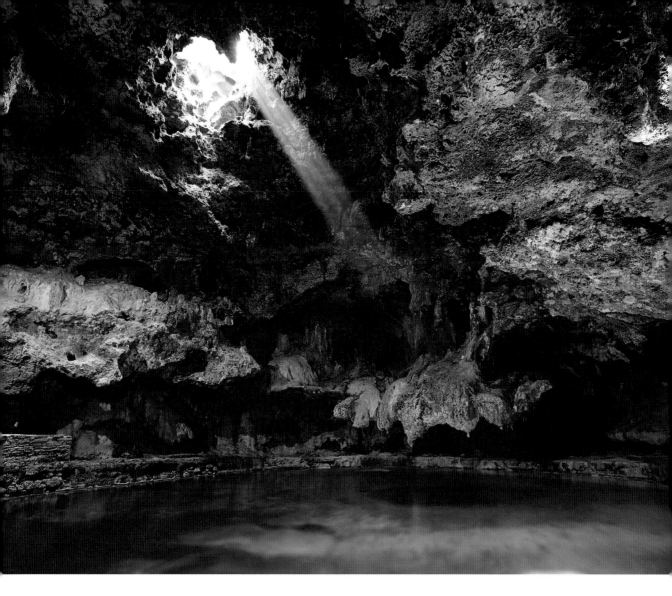

through interactive displays and exhibits. You'll also learn about Banff's most at-risk species, the endangered Banff Springs snail, which is found nowhere else in the world.

Banff Upper Hot Springs

In the late 19th century and early 20th century, "taking the waters" was thought to be a cure-all for whatever ailed you. Though that line of thinking doesn't hold water today, it's still magical to soak in steaming waters that are naturally heated deep within the earth. Banff Upper Hot Springs is operated by Parks Canada. There's a spa, a bath house, a café and a large outdoor pool. It's open year-round and winter can be a wonderful time to visit — especially when the snow is falling.

↑ **Banff National Park, Cave and Basin.**

Miette Hot Springs

pc.gc.ca/eng/voyage-travel/
sources-springs/miette/
miette.aspx

Water from the hottest hot springs in the Canadian Rockies flows from the mountain at 54°C and is cooled to a comfortable temperature of 40°C as it enters the hot springs pool. Parks Canada operates the hot springs, which are open from early May through early October. Miette is located about 45 minutes outside the Town of Jasper, and the winding mountain road that leads to it passes through the Fiddle Valley. It's common to see elk, deer, bighorn sheep and other wildlife along the road. The road passes Punchbowl Falls, an old coal mining site, and Ashlar Ridge Viewpoint. There are several nice hikes near the hot springs. Of these, the 8 kilometre Sulphur Skyline trail features some of the most beautiful panoramas in the park. It's a steep trail with a 700 metre elevation gain and it usually takes 3 to 4 hours to complete. Most hikers stop for a soak in the hot springs afterwards.

Mist Mountain Warm Springs

The hike up Mist Mountain is almost 12 kilometres, involves a lot of scrambling and covers an approximately 1,300 metre elevation gain. It takes about 7 hours to complete (return). It should not be undertaken by novice hikers and should be avoided during thunderstorms. (At the summit is a memorial plaque for hiker Stash Minasiewicz, who was struck by lightning in 1989.) It's also prime grizzly bear territory. But all that aside, the views from the top are fantastic and there's a chance to soak your toes in two very small natural mineral springs on the descent. The springs are located on the lower east slope of Mist Mountain.

→ **Miette Hot Springs, Jasper National Park.**

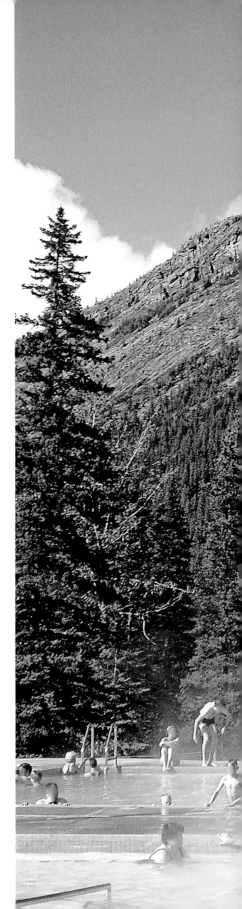

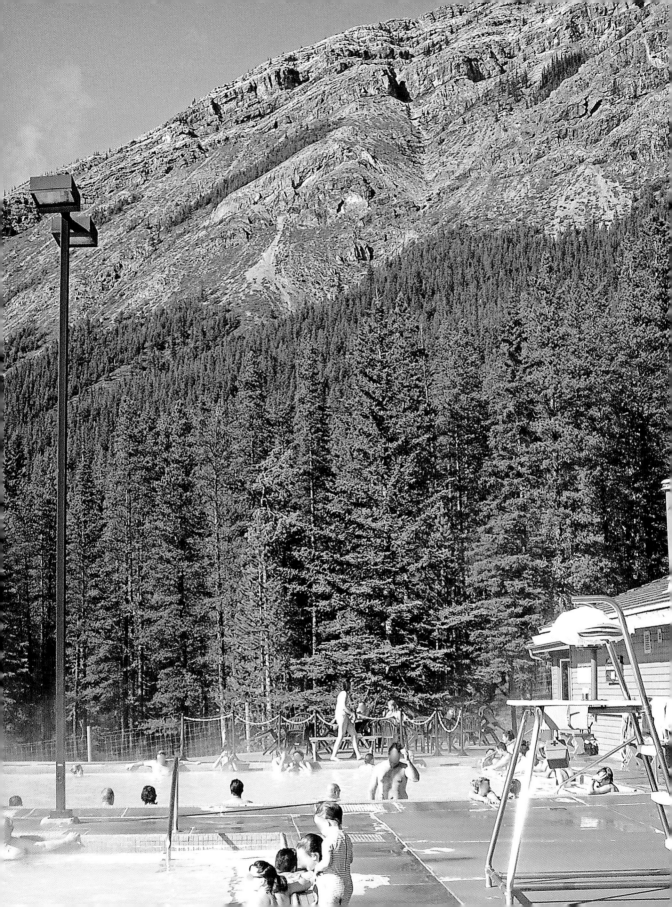

Larch Hikes

The golden fall foliage display put on by Alberta's larches rivals anything in eastern Canada

What Makes These Spots Hot?

- Yellow needle-like fall foliage of larch trees is very beautiful.
- The larch season is short, two to three weeks, starting in mid-September.
- Larches are found in beautiful mountain settings.

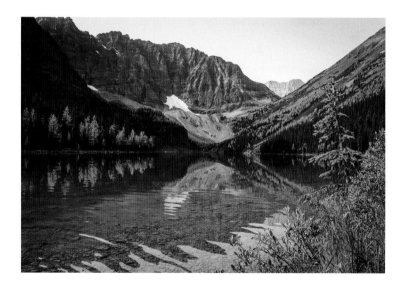

⬈ **Taylor Lake gets only a fraction of the crowds that visit Larch Valley.**

The glorious yellow needle-like fall foliage of the larch tree (Larix lyalli) is to the Rocky Mountains what the maple tree's red foliage is to eastern Canada: a feast for the eyes. Larches are coniferous trees, but also deciduous in that they lose their needles every fall. You find larches primarily in the mountains, at an altitude between 1,800 and 2,100 metres.

It's the lead-up to the larches' needle drop that is so spectacular. Starting around the second week of September, the larch begins its transformation, turning from green to a golden-yellow. Their peak varies from year to year, but it's usually around September 20th. By the first week of October, it's all over.

Larch viewing is bucket-list worthy. Some of the best larch viewing spots like Larch Valley get overrun with tourists—but there are plenty of places, especially if you go early or late in the day, where you just might be the only person. The best larch viewing places in Alberta are in Banff National Park and Kananaskis Country.

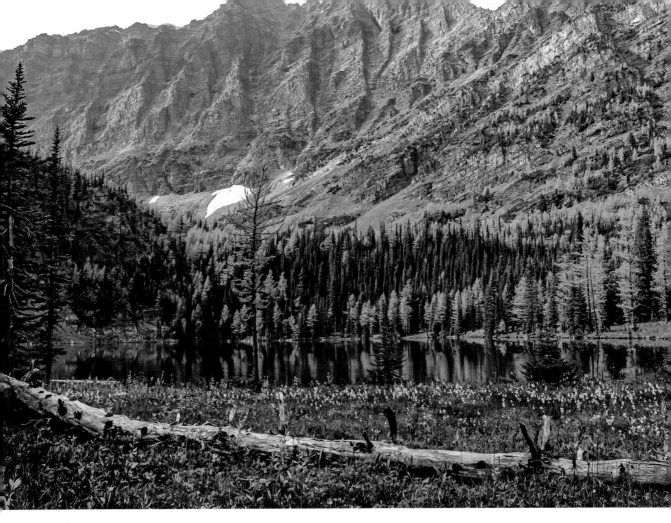

Larch Valley and the Sentinel Pass Area, Banff National Park

As one of the premier larch viewing areas in Alberta, you can be sure that unless you visit at the crack of dawn, you'll have company. In fact, a shuttle operates in peak larch season as the crowds get thick. Here's why: in late September, Larch Valley is a riot of gold and yellow in one of the most glorious settings in the Rockies. If you can possibly visit on a weekday, do so. Otherwise, get up really, really early to beat the crowds.

There are several solid alternatives nearby. You can do the Little Beehive — Lake Agnes Teahouse hike starting at Lake Louise. For a solitary hike, head up the trail towards Mount St. Piran, where there are some truly lovely stands of larch in a very picturesque setting. Another alternative that starts on the shores of Lake Louise is to climb Fairview Mountain. There's a great stretch of trail that goes through multiple stands of larch before heading for the rocky summit.

↑ **Words can't do justice to the beauty of O'Brien Lake in the fall.**

↗ **Miniature larches at O'Brien Lake.**

Taylor and O'Brien Lakes, Banff National Park

Accessed via the Taylor Lake Trailhead on the Trans-Canada Highway, west of Banff, both Taylor and O'Brien Lakes are magnificent in the fall and devoid of the crowds that you'll find at Lake Louise. Plan on a full-day hike if you visit both lakes. If you include O'Brien Lake—and you really should—it's a 16.6 kilometre return hike. Plan on a picnic lunch by the lake so that you can bask in the beauty of the area.

The Boulder Pass — Skoki Lakes Area, Banff National Park

It's a 17 kilometre return hike to reach Boulder Pass, but because of its length you'll hardly see a soul. Start at the trailhead near the Lake Louise Ski Resort. Once you're off the Temple fire road, the scenery and the larch display just keeps getting better and better the higher up you go. Allow for a full day of hiking.

Gibbon Pass, Banff National Park

Park at the Vista Lake Trailhead, accessed off of Highway 93, and be prepared for a long but rewarding day. You need

to hike most of the way to the pass—a distance of almost 11 kilometres—before you're into larch-dominated forest. The beauty is surreal once you arrive. Fortunately, there are pretty meadows and lots of mountain views on route.

Sunshine Meadows and Healey Pass Area, Banff National Park

Sunshine Meadows and Healey Pass put on a spectacular fall show. Take the shuttle up from the parking lot at Sunshine Village—a repeat of what you do to see wildflowers in the summer—and start walking towards Rock Isle Lake.

Spend a day hiking around

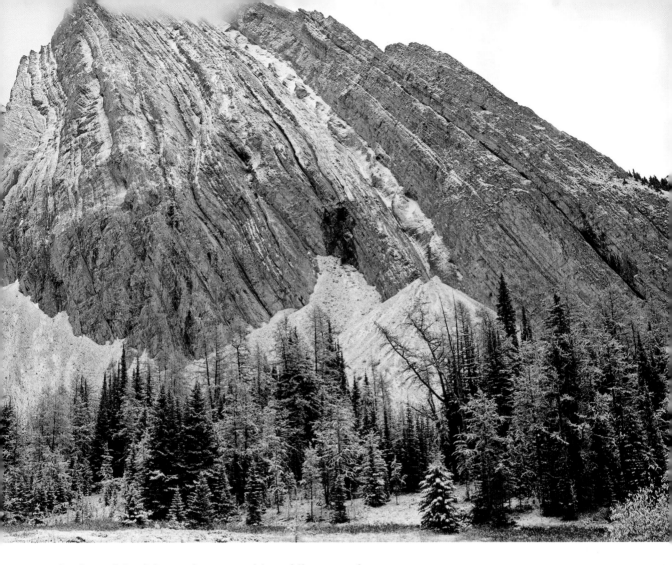

the three alpine lakes and admiring the larches. If you're a hardcore hiker, enjoy the larches via a full-day hike to Healey Pass and back from the Sunshine Ski Resort parking lot.

Chester Lake, Kananaskis Country

Located in Spray Valley Provincial Park, about 43 kilometres from Canmore via the Spray Lakes Road,

this 9.8 kilometre, 4 hour round-trip hike can get busy on a weekend. The lake at the end of the trail is the prize, surrounded by larches and the cliffs of Mt. Chester. It's an Alberta classic.

Arethusa Cirque, Kananaskis Country

Drive 1.25 kilometres south of Highwood Pass to reach the informal trailhead for Arethusa Cirque. Although the

↑ The hike into Chester Lake takes you through some glorious stands of larches.

trail itself isn't signed, it's obvious and easy to follow. After you exit the woods, larches start to pop into view. Stay on the trail past larch trees scattered randomly across the landscape. When you reach the top of a talus-filled slope, the larch trees die out and are replaced with superb valley and mountain views. You can accomplish the hike and larch viewing in under 2 hours.

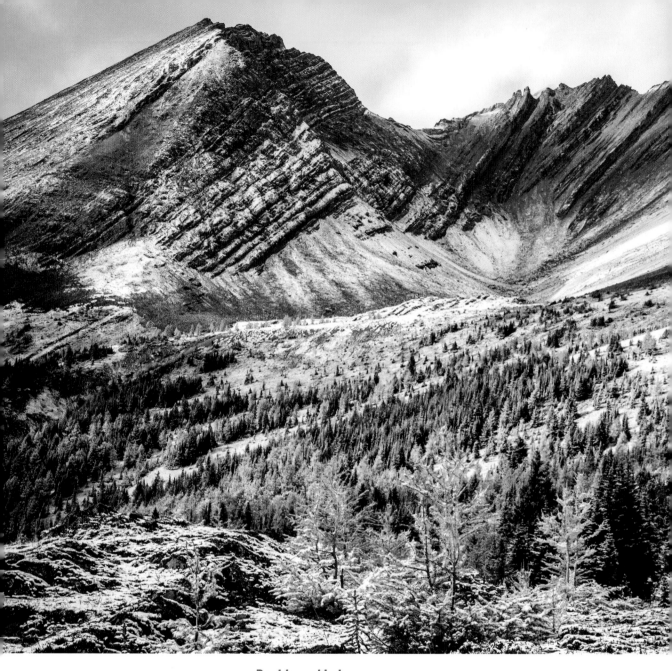

↑ **Little known Arethusa Cirque is in a spectacular setting.**

Rockbound Lake, Banff National Park

Accessed via a trailhead just east of Castle Village, the 16.8 kilometre return hike to Rockbound Lake is another hike without people. Once you've dispatched with the section of trail on an old road, you'll be rewarded with meadows dotted with larch trees. From here through to the lake they'll offer bursts of colour.

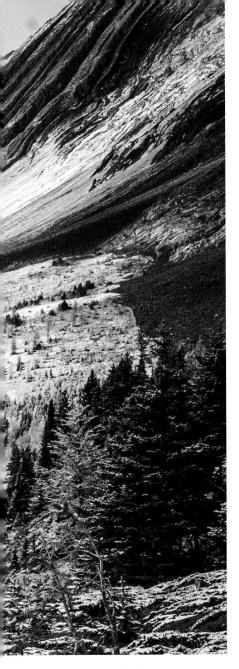

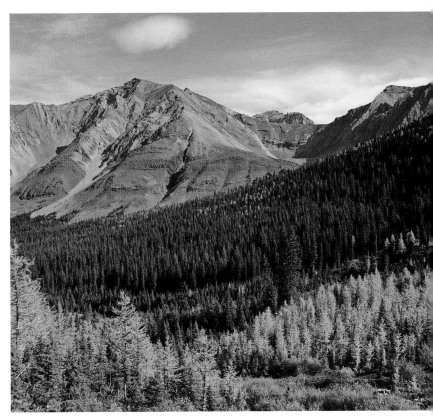

Save the Pocaterra Ridge hike for larch season when it's truly magnificent.

Pocaterra Ridge, Kananaskis Country

The Pocaterra Ridge hike is a local favourite in larch season. It's best done with a car shuttle, so that it's a manageable day hike. Start at the Highwood Pass parking lot and finish 11 kilometres later at the Little Highwood Pass parking lot. Enjoy some of the best views in Kananaskis Country. The standout sections for larches on the hike are in the valley at the beginning of the hike and between Peaks 2 and 3 along the ridge, where there is an especially dense larch forest. As well, there are magnificent, expansive views of larch trees in the valley below. The shorter, easier and nearby Pocaterra Cirque hike is also a good choice.

Buller Pass, Kananaskis Country

On the moderate 7.3 kilometre hike to Buller Pass, you reach the stands of larches about 45 minutes into the hike. They'll be with you until you reach the tree line. The trailhead is directly across from the Buller Mountain day use area, about 31 kilometres from the Canmore Nordic Centre.

Nature Festivals

If you love wildlife, birds, wildflowers and nature, then a nature festival is an opportunity to embrace your wild side and fuel your passion

What Makes These Spots Hot?

- With a range of workshops and nature presentations, nature festivals provide an opportunity to learn from experts.
- Fun activities help you explore the outdoors and meet other people with similar interests.
- Festivals are held in beautiful destinations at premium viewing times like during seasonal migrations or peak wildflower season.

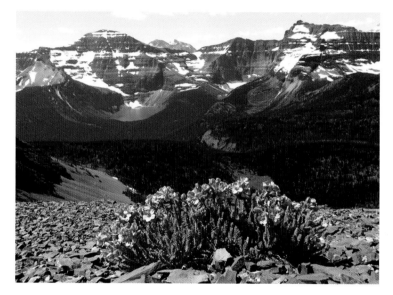

↗ **Wildflowers are abundant in Waterton Lakes National park, and the annual Waterton Wildflower Festival is a great time to visit if you want to see and learn more about wildflowers.**

A nature festival can open your eyes to different ways of enjoying our natural world and the plants and animals that are in it. They usually include a variety of different activities ranging from lectures by experts to nature walks, tours and photography or painting workshops. It's a way to learn more about an aspect of nature that is interesting to you and to discover new ways of exploring that interest.

Snow Goose Chase
April
snowgoosechase.ca

For almost two decades, the Edmonton Nature Club and the Town of Tofield have been celebrating the marvels of spring migration with an annual Snow Goose Chase. Beaverhill Lake is an important staging area for more than 270 species of birds including snow geese, sandhill cranes, hawks, waterfowl and song-birds during spring migration. Many of the activities of the

two day event are coordinated through the Beaverhill Lake Nature Centre. Visitors can go on guided hikes or bus tours, listen to speakers and visit the wildlife trade show and nature market.

Waterton Wildflower Festival

June
mywaterton.ca/events

Home to half of all the wild-flower species in Alberta, Waterton Lakes National Park is a wildflower wonderland in late spring. Of the wildflowers that grow inside the park, 175 species are listed as rare in Alberta. There are 20 species that can be found nowhere else in Alberta and at least two species found nowhere else in the world. The Waterton Wildflower Festival takes place annually in mid-June, the peak wildflower season for the park. It's a chance to learn to identify different species of wildflowers, enjoy them on different types of tours and for the artistically inclined to photograph and paint them.

Camrose Purple Martin Festival

June
facebook.com/Camrose PurpleMartinFestival

The purple martin is North America's largest swallow and for some time now, North American populations of this migratory species have been declining. Alberta is at the northern edge of its range and many backyard birders are assisting in the recovery of the species by installing specially designed condomini-um-style nest boxes in their backyards. In Camrose, there are more than 100 purple martin houses—some on city land and many more on

⬆ **Camrose Purple Martin Festival**

↑ Snow Goose Chase Wetland Walk.

↑↑ Lesser Slave Lake Songbird Festival.

first weekend in June, the Boreal Centre for Bird Conservation is at the epicentre of the event. The festival features a pancake breakfast, guided birding hikes, workshops and tours of the migration monitoring station. There are also kid-friendly activities like birdhouse building, crafts, games and face painting.

Bluebird Festival
July
ellisbirdfarm.ca

If you want to celebrate nature and Canada's birthday at the same time, Ellis Bird Farm is the place to go. The annual Bluebird Festival on July 1 is the farm's longest running event. Festival goers enjoy live music, family activities, crafts, garden tours, and the opportunity to talk to experts who can explain the cutting-edge purple martin and mountain bluebird migration research that takes place on the farm.

private property. Scientists at the Augustana Campus of the University of Alberta have done extensive research on the species. Every June, the city hosts an annual festival to celebrate the return of nesting pairs to the region. The day is filled with guest speaker presentations, Question and Answer sessions, field trips, and activities for children.

Songbird Festival
June
**lslbo.org/education/
songbird-festival**

The Lesser Slave Lake Bird Observatory held the first Songbird Festival in 1994 and since then it has become an annual celebration of the spring migration. Held the

Waterton Wildlife Weekend
September
mywaterton.ca/events

Waterton Lakes National Park is the place where prairies meet mountains. Situated in the southwest corner of the province at the Crown of the Continent, this quiet mountain park is a convergence

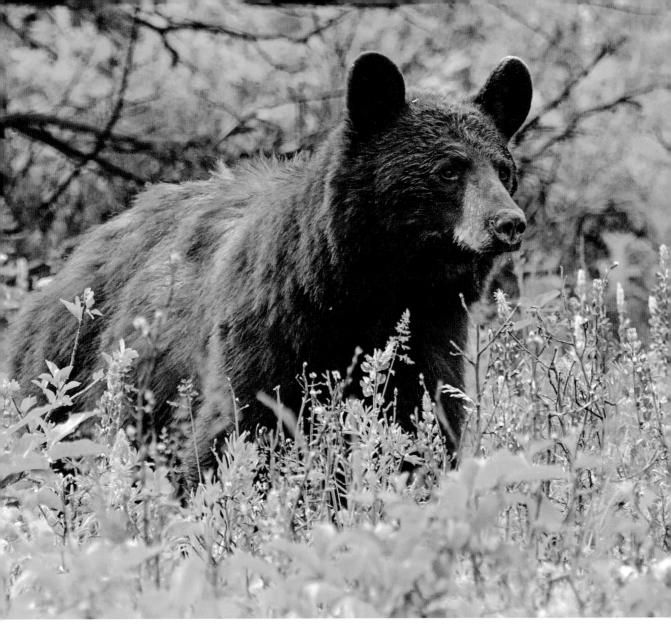

of multiple ecosystems and one of the best places in the world to view wildlife. No other Canadian national park protects so much wildlife in such a small area. More than 250 species of birds, 60 species of mammals and 10 species of amphibians have been documented in the park. It's one of the few places in North America where all the native carnivores can be found and it is common to see bears—especially in the late summer to early fall. Waterton Wildlife Weekend takes place annually in late September. Over the course of a weekend, naturalists and photographers lead fascinating wildlife workshops and nature tours.

↑ **Waterton Wildlife Festival.**

Paddling

Paddling allows you to access the wilder, more remote and more beautiful areas of the province that most people never see

What Makes These Spots Hot?

- Access to a variety of ecosystems that would otherwise go unseen.
- Fantastic opportunities to see wildlife.
- Landscapes that include the Rocky Mountains, badlands, hoodoo and prairie country, big valleys and pastoral scenery.

Website:
www.paddlealberta.org

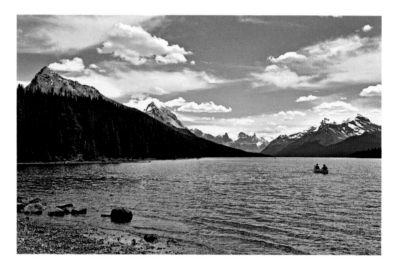

↗ **A truly phenomenal backdrop awaits the paddler on Maligne Lake.**

↦ **Maligne Lake boathouse and canoe rental.**

Nine river basins in Alberta provide a surprising number of paddling opportunities, especially for a province that isn't thought of as a paddling mecca. There are a couple of fantastic lakes to paddle in, along with numerous rivers. Most are easy to moderate paddles, with only some sections of the Milk River and North Saskatchewan River requiring more advanced skills. Campsites are filled on a first come, first served basis apart from Maligne Lake, which can—and should—be booked 90 days out.

Maligne Lake

The world-famous Maligne Lake is take-your-breath-away beautiful. Ringed by the Rocky Mountains, there's a grandeur and majesty to the lake that puts it in the world-class category. While most appreciate its beauty via a boat-ride tour to Spirit Island, adventuresome folks can explore the lake via canoe or kayak and camp at one of the three campgrounds. Hidden Cove is a family-friendly 3.5 kilometre paddle from the launch site, all in protected waters. Fisherman's Bay, 13 kilometres from the launch site, and the Coronet

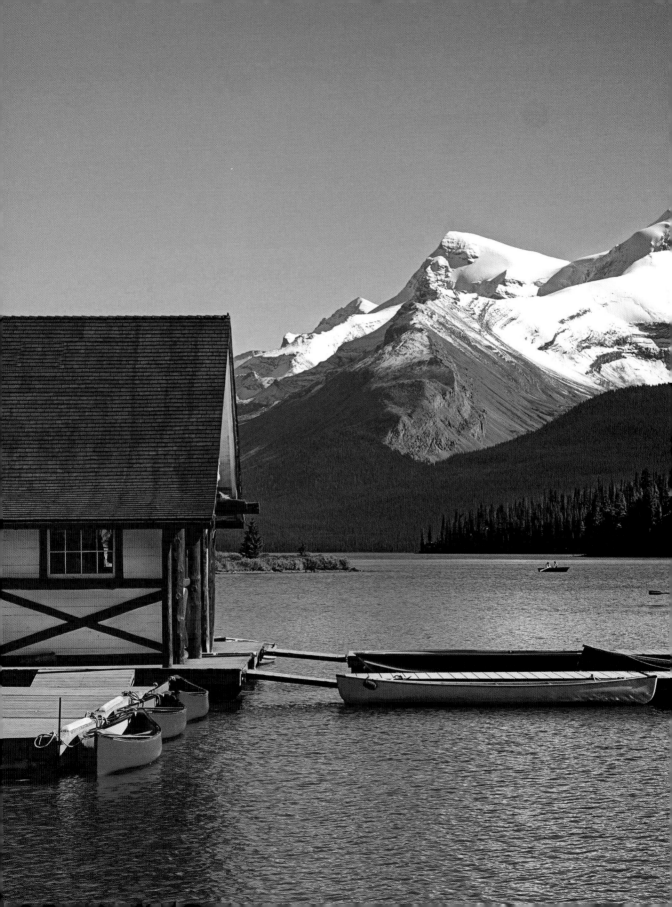

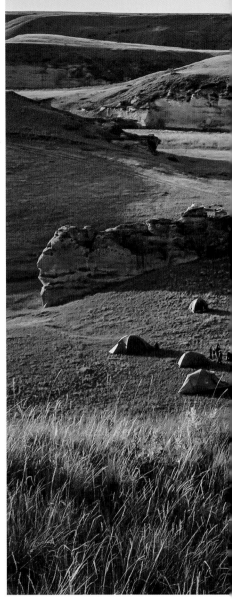

↑ There is a good chance you won't see another soul when you paddle the Peace River.

↑↑ Swallow nests are a common sight along the Milk River.

↗ This rustic campsite on the Milk River is typically reached on the second night out.

Creek Campground—21.3 kilometres away, at the far end of the lake—are the other choices. The further you go, the wilder and more dramatic the scenery. Just be aware that these waters are icy-cold and winds can blow up out of nowhere. There's a very good chance of seeing wildlife, even on the drive to the launch.

Peace River

The Peace River has been a corridor of travel for literally thousands of years. It's a huge river, more prairie-like than mountain-like, that cuts dramatically across Alberta for over 1,000 kilometres through a landscape of grasslands, boreal forest and rolling hills. Allow one to seven days to paddle the

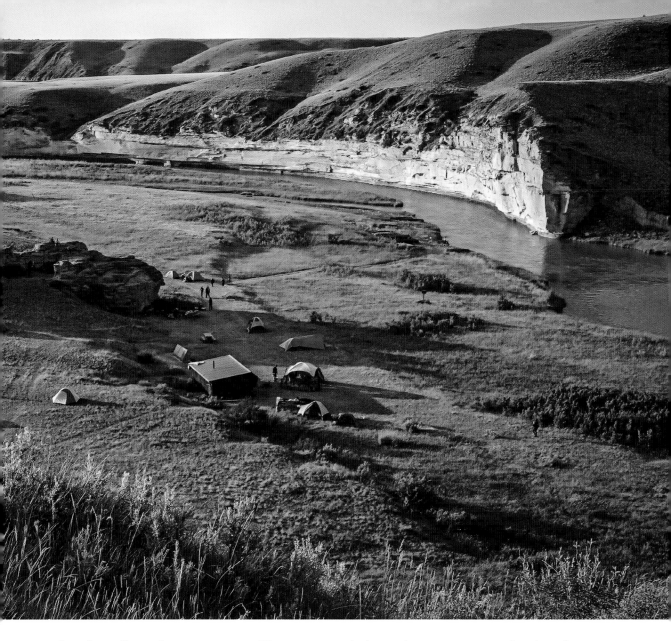

river, depending on how many kilometres you want to cover. It's a Class I river, so you don't have to worry about any rapids or portages, though flow rates can vary dramatically depending on what's discharged from the W.C. Bennett Dam. The only other hazards are occasional errant boulders and shallow gravel bars.

Plan to camp at designated campsites, or you will be exhausted and muddy from trying to lug your gear up steep, slippery banks. Along the route, stop at the historic Dunvegan Bridge, Alberta's only suspension bridge for vehicle traffic, to see buildings from the time of the Hudson's Bay Company along with

a rectory, a church, and beautiful gardens. Though you may not see a single soul on the river, there is a high probability of seeing black bears (maybe even swimming in front of your canoe!), moose, deer, wolves and coyotes. It's a leisurely river that's tamer than it first appears.

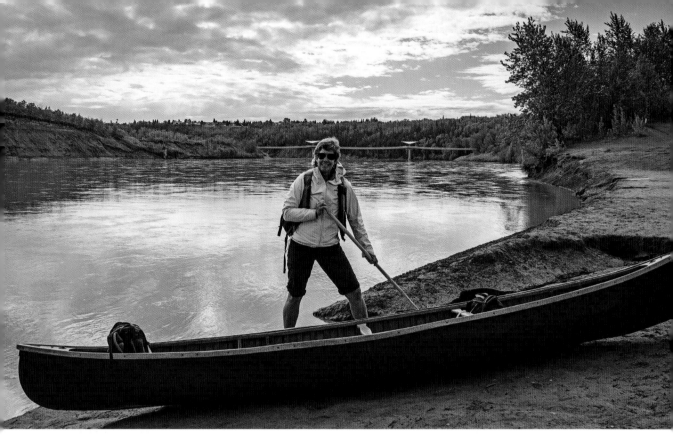

↑ **Getting ready to launch on the North Saskatchewan River on the outskirts of Edmonton.**

Red Deer River

The gentle Red Deer River is a great choice for novice canoeists, kayakers and even rafters. Many people start at Content Bridge, east of Red Deer, and finish four days later in Drumheller's dinosaur country, though there are lots of variations on this theme depending on time and shuttle arrangements. It's even possible to continue all the way to Dinosaur Provincial Park. The river offers history, badlands scenery, wildlife and great birding, along with easy access. Fossil hunters might get lucky, too, especially as you get closer to Dinosaur Provincial Park—one of the premier places for dinosaur bones in the world. The Red Deer River is family-friendly, with wild camping possible on gravelly shorelines in the shade of giant cottonwood trees; otherwise, choose dedicated campgrounds.

Milk River

The Milk River, named for its milky colour by Lewis and Clark in 1805, flows north out of Montana into southern Alberta and then back into Montana again. Over its 1,173 kilometre length, there is a fantastic 73 kilometre section that can be easily paddled over three days, beginning in the town of Milk River and ending in Writing-on-Stone Provincial Park.

Be prepared for lots of Class I rapids, some Class II rapids, and occasional Class III rapids depending on river conditions. One section of the river is aptly named the Rock Garden—so you may get banged around a bit. Campsites are located at Gold Springs and Poverty Rock, where you can stretch your legs on a beautiful hike. Enjoy the incredible bird life, including lots of swallows and great-horned owls. You won't be able to take your eyes off the weirdly shaped hoodoos on the final, easy stretch into Writing-on-Stone Provincial Park. The Milk River is best paddled in June and early July, before the flow drops off.

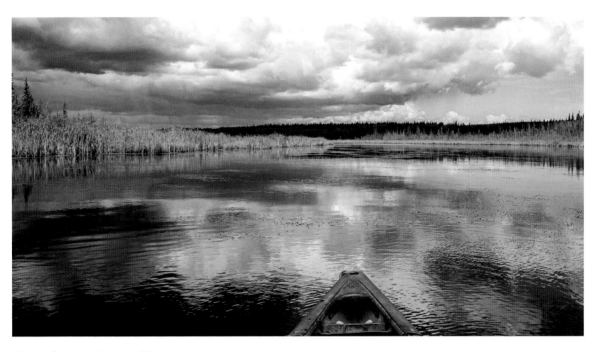

North Saskatchewan River

You can paddle the North Saskatchewan River, an important link on Canada's fur trading route, from Nordegg all the way to the Saskatchewan border, though most people bite off smaller chunks. The river is rated novice to inter-mediate, with the Nordegg to Devon section having some small rapids. Lots of people opt to paddle over a couple of lazy days between Genesee and Edmonton, while others put in at one of the numerous launch spots close to Edmonton for a completely different look at the city. The river changes consid-erably over its length, starting off almost turquoise-blue in colour and ending up a muddy brown near the Saskatchewan border. There is plenty of wildlife to be seen, including beavers, coyotes, moose, lynx, mule deer, black bears and even mountain lions. Listen for saw-whet and barred owls. Mallard ducks and many gull species, as well as a huge range of songbirds, can also be seen along the river .

Lac la Biche

The Lac la Biche canoe circuit in Lakeland Provincial Park is the only one in Alberta. The main 38 kilometre route covers three lakes in a wilderness set-ting, and can be comfortably paddled in three days. Portage carts make the portages, especially the initial 3 kilome-tre portage, a lot easier. There

↑ **The Lac la Biche canoe circuit is family friendly.**

is no moving water, though wind can be an issue. Wildlife, birding and stargazing under black skies are all excellent. Lucky paddlers might see moose, wolves or a woodland caribou. Everyone will see deer and beavers. At night, listen for the hooting of a host of owls, including the northern saw-whet, barred, great grey, great horned and boreal owls. If you're looking for sparrows, you might get lucky and see the swamp, sharp-tailed and Le-Conte's sparrows.

Waterfalls

Waterfalls are abundant in Alberta. Stand at the base of one and feel its mist on your face. Let the sound of flowing water bring peace to your soul

What Makes These Spots Hot?

- Waterfalls are beautiful and awe-inspiring.
- The sound of flowing water is relaxing and even therapeutic.
- Waterfalls are almost always surrounded by spectacular scenery. Hiking to a waterfall is half the fun.

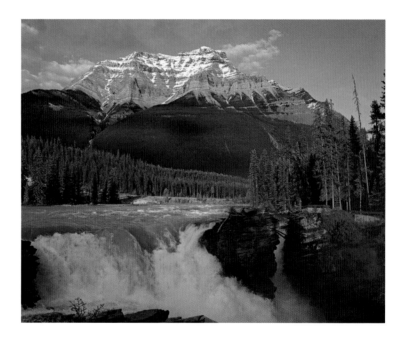

↗ Athabasca Falls.

→ Crescent Falls.

Be they trickling mountain streams, weeping walls or massive torrents, waterfalls are a wonder to behold. In 1995, the American recording group TLC produced the popular song *Waterfalls* that included the memorable line: "Don't go chasing waterfalls." Their warning hasn't affected human behaviour. People still flock to Niagara Falls to celebrate honeymoons and engagements. They hike high mountain passes to witness spectacular cascading falls. They travel halfway around the world to see the most spectacular falls on the planet.

Those in Alberta do not have to go very far to witness this marvel of nature. Alberta has an abundance of breathtaking waterfalls, here are 15 of the best. If you do go chasing waterfalls, remember to stay on the designated trails. Rocks beyond the railings can be slippery and dangerous.

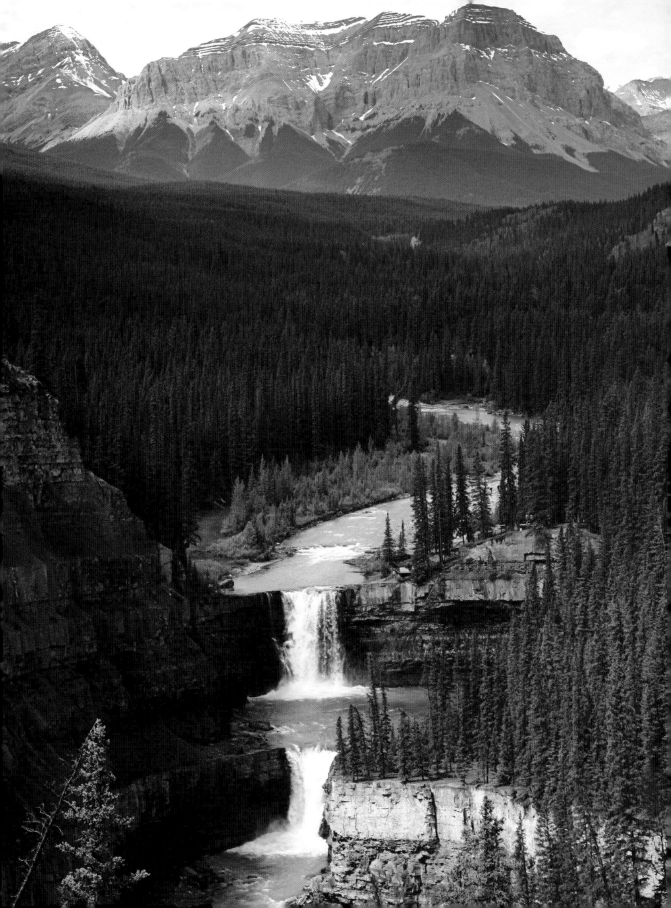

↑ Bow Falls.

Athabasca Falls

Lat: 52.6644° N
Long: -117.8838° W

At 23 metres high and 18 metres wide, these are not the tallest or widest falls in the Canadian Rockies, but they are some of the most powerful. You can feel the spray as the Athabasca River thunders into the exquisitely carved canyon below. About 30 kilometres south of Jasper, this spot is incredibly popular with tourists, so you may want to go early to avoid the crowds. A paved trail leads across a wide bridge with plenty of lookouts on the south side of the falls. Uneven steps lead to the bottom of the falls.

Bow Falls

Lat: 51.1680° N
Long: -115.5615° W

Located near the Fairmont Banff Springs Hotel, these falls were featured in the 1953 Marilyn Monroe film *River of No Return*. The falls are about 9 metres in height and are very wide. Their close proximity to downtown Banff and the famous "Castle in the Rockies" make them a popular stop for tourists. The stunning mountain scenery that surrounds them adds to their photogenic appeal. An easy 3 kilometre trail leads to several nice viewpoints.

Bow Glacier Falls

Lat: 51.6783° N
Long: -116.4673° W

Witness the birth of a river. These falls don't look very big from the road, but at 154 metres in height they are the largest falls along the Icefields Parkway. Created from the meltwater of the Wapta Icefield, the falls form the headwaters of the famous Bow River. You can feel their power when you are standing near their base. About 40 kilometres north of Lake Louise on the Icefields Parkway in Banff National Park, the trail to the falls offers wonderful views of Bow Lake, Bow Glacier, some roaring rapids, Bow Glacier Falls and the Wapta Icefield. Park your car near the trailhead at Simpson's Num-Ti-Jah Lodge and follow

the lakeshore trail to get to the falls. There are separate trails for hikers and cyclists. The hike is about 9 kilometres and can be crowded in July and August. The falls are popular with ice climbers in winter.

Blakiston Falls
Lat: 49.0509° N
Long: -113.9085 ° W

Located in the southwest corner of the province in Waterton Lakes National Park, these 11 metre high falls are an easy 2 kilometre return hike from the parking area at Red Rock Canyon. Head downstream and cross two bridges to reach the falls. The Red Rock Canyon area is wheelchair- and baby stroller-friendly, but the hike to Blakiston Falls follows a dirt trail. You'll often see bears along the roadside on the drive up to Red Rock Canyon.

Bridal Veil Falls
Lat: 35.0720° N
Long: -83.2293° W

These falls are a series of cascading plunges that drop more than 85 metres along the Icefields Parkway. Located 11 kilometres south of Icefields Centre, the falls begin with a prominent plunge, followed by a series of stepping slides and tiered plunges. The waterfall

⬆ **Crescent Falls ice climbing.**

can be seen from the roadway and is also visible from the trail that leads to Panther Falls, which is close by.

Cameron Falls
Lat: 62.4963° N
Long: -113.5525° W

When the water is high, you can stand on the bridge in front of Cameron Falls and feel a fine mist on your face. It's the best natural facial in the world. This unique 23-metre-high waterfall is located right in the heart of the town site in Waterton Lakes National Park. The main falls are wheelchair-accessible. A steep trail along the side of the falls takes you to

viewpoints above it. These falls are particularly pretty thanks to the eroded rock layers making the waters of Cameron Creek fall in several different paths across the rock face.

Crescent Falls
Lat: 52.3874° N
Long: -116.3570° W

Formerly known as Bighorn Falls, these two spectacular crescent-shaped waterfalls flow into the deepest gorge in Alberta. Located on the Bighorn River in west-central Alberta, this area is called

David Thompson Country because it follows the fur trading trails of the fearless explorer who mapped many parts of Canada. The trailhead is located 3 kilometres off the David Thompson Highway (Hwy 11), between Abraham Lake and Nordegg. The 6 kilometre return hike follows the Bighorn River Canyon and offers good views of the falls and gorge. There are two railed viewpoints near the falls.

Geraldine Falls

Lat: 52.5704° N
Long: -117.9485° W

Exploring the remote Geraldine Valley in Jasper National Park is not for everyone. Those with the stamina to handle rock hopping across talus fields and scrambling up steep headwalls are rewarded with views of the Geraldine Lakes and the Upper and Lower Geraldine Falls. The trailhead is located just off the Geraldine Fire Road, about 7 kilometres from the Athabasca Falls. The lower falls begin as a series of cascades that end in one massive 105 metre drop. The trail ends at the end of the first lake, where the upper falls can be seen from a distance.

Johnston Canyon Falls

Lat: 51.2454° N
Long: -115.8399° W

A scenic trail winds its way through the depths of Banff National Park's Johnston Canyon, passing seven sets of waterfalls—the most spectacular of which are the Upper and Lower Falls. It's an easy 1.2 kilometre walk to the Lower Falls. From there, the trail switchbacks up a string of waterfalls to the 30 metre high Upper Falls at 2.4 kilometres. If you continue further, there's a great viewpoint at the top of the falls. Another 3 kilometres of moderate climbing brings you to the Ink Pots, a series of emerald-coloured mineral springs that bubble to the surface.

Lundbreck Falls

Lat: 49.5859° N
Long: -114.2001° W

Not far from Pincher Creek, the Crowsnest River plunges more than 12 metres into a foaming pool that exits through a tight gorge. Some locals call it "Little Niagara" because it splits into two falls—one that flows straight and one that is crescent-shaped. You can watch the powerful falls from an observation platform and then walk down into the limestone gorge for a closer look.

Panther Falls

Lat: 52.1821° N
Long: -117.0566° W

Most people who drive the Icefields Parkway pass by completely oblivious to the existence of these falls, which are the mysterious neighbour to Bridal Veil Falls. From the Bridal Veil Falls pullout, about 11 kilometres south of the Icefields Centre, take the 1-kilometres trail that leads to these powerful 66-metre-high falls. You'll know you're almost there when the trail starts to get muddy from the spray. Panther Falls is a popular spot for ice climbing in winter.

Ram Falls

Lat: 52.0879° N
Long: -115.8411° W

Located 95 kilometres west of Rocky Mountain House in David Thompson Country, these powerful falls are easily accessible from the nearby provincial campground. A viewing platform offers wonderful views of the Ram River Valley and the Ram River as it plunges 20 metres over a layer of hard sandstone. It's a great spot to see wildlife and it's common to see birds of prey here, especially in the fall months. Look for golden eagles, bald eagles, merlins and American kestrels. Bighorn sheep are found in the Ram

Mountain Range, and they are often spotted near the falls. Anglers enjoy the river for its cutthroat trout fishing.

Siffleur Falls

Lat: 51.8996° N
Long: -116.3921° W

Three separate waterfalls are collectively known as Siffleur Falls—one of the most popular and scenic hikes in David Thompson Country, 210 kilometres west of Rocky Mountain House. It's a 4 kilometre hike on a well-worn trail to get to the first viewpoint overlooking a massive waterfall. You cross a boardwalk and a suspension bridge to get there. It's another 2.5 kilometres to the second set of falls, and another 1.5 kilometres from there to reach the third set of falls. The scenery is amazing along the way, but be sure to stay inside the guard rails. The rocks are more slippery than they look.

Sunwapta Falls

Lat: 52.5323° N
Long: -117.6451° W

Sunwapta is the Stoney First Nations word for "turbulent river." This waterfall is 55 kilometres south of the town of Jasper. Though it is not as powerful as the nearby Athabasca Falls, it is every bit

as photogenic. A small island splits the tumultuous waters of the Sunwapta River just upstream from the brink, and then the two channels merge and plunge together for about 6 metres into the gorge below. The river then flows under a foot bridge and the lower falls plunge another 10 metres to an even deeper gorge. It's an easy 1 kilometre hike from the parking lot to the first viewpoint overlooking the upper falls. It's an extra 100-metre hike to the viewpoint for the lower falls.

Tangle Falls

Lat: 52.2673° N
Long: -117.2865° W

At 35 metres in total height, this is not the tallest waterfall in Jasper National Park, but it is certainly one of the most photographed. These falls begin as multiple lacy lines that cascade down a broad cliff, before converging and plunging down three more tiers. The cascading water over the steps makes for beautiful photographs. The falls are located about 6.5 kilometres north of the Icefield Centre, right off the Parkway. The easy access makes it a popular stop. Further downstream are the Lower Tangle Falls, which require a short hike but are much less visited than the upper falls.

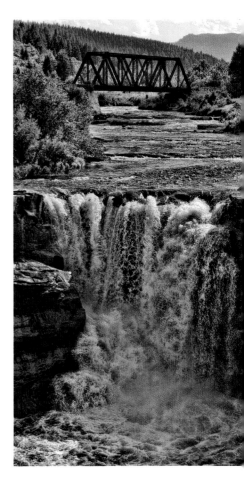

↑ **Lundbreck Falls.**

Photo Credits

Index